Chris Marker

Chris Marker
Memories of the Future

Catherine Lupton

REAKTION BOOKS

For Donald Richie

Published by Reaktion Books Ltd
33 Great Sutton Street
London EC1V ODX, UK

www.reaktionbooks.co.uk

First published 2005, reprinted 2006, 2008
Copyright © Catherine Lupton 2005

Printed and bound in Great Britain by Cromwell Press, Trowbridge, Wiltshire

British Library Cataloguing in Publication Data
Lupton, Catherine
 Chris Marker: memories of the future
 1. Marker, Chris – Criticism and interpretation
 I.Title
 791.4'3'0233'092

ISBN-13: 978 1 86189 223 2
ISBN-10: 1 86189 223 3

Contents

Introduction: Free Radical

Chris Marker is a towering and seminal figure in the field of contemporary visual culture, but until very recently one of its best-kept secrets. In an astonishingly diverse career that now spans more than half a century, Marker has embraced writing, photography, filmmaking, videography, gallery installation, television and digital multimedia in order to probe the deep cultural memory of the twentieth century through the filter of his own utterly distinct sensibility, at once erudite and funny, tender and incisive. Marker emerged in late 1940s Paris as a writer already alert to the formal qualities and cultural significance of cinema and the visual image. He then proceeded to bring to filmmaking the style and analytical powers of the literary essay, in a series of groundbreaking travelogues released in the late 1950s and early 1960s, among which *Lettre de Sibérie* (1958, *Letter from Siberia*) remains the most famous. Two films made in 1962 broke open this mould: *La Jetée*, the haunting science-fiction fable told in still photographs and an instant of movement that remains his best-known film; and *Le Joli mai*, which upturned Marker's reputation as the master of voice-over commentary by making interviews the central plank of its topical investigations. The human exchanges of *Le Joli mai* paved the way for Marker's immersion in militant left-wing film collectives for a decade after 1967. He went on to take stock of the revolutionary upheavals of the 1960s in the epic *Le Fond de l'air est rouge* (1977), then in 1982 brought together his passion for travel and his abiding concern with history and cultural memory in the landmark *Sans soleil* (*Sunless*), a masterpiece of the personal essay film genre that Marker has made his own. By incorporating images that had

been manipulated with a visual synthesiser, *Sunless* served notice of Marker's enthusiastic adoption of new electronic media technologies. During the 1980s and '90s he began increasingly to work with video and the computer, and to diversify from film into television projects and multimedia gallery installations. Today, aged 83 (or thereabouts), Marker is the grand old man of new media, a still-active pioneer who has recently used digital hypermedia and the storage capabilities of the CD-ROM to create *Immemory* (1998): a virtual map of a lifetime's memory, drawn from his capacious personal archives.

The singularity and diversity of Marker's achievements set him at a remove from most other filmmakers and artists, even though close collaboration with friends and contemporaries has been a constant element of his work. Marker has drawn significant inspiration from the innovative chroniclers and observers of the early Soviet cinema, Dziga Vertov and Esfir Shub, and paid direct homage to the influence of Shub's successor in the compilation documentary genre, Nicole Védrès.[1] Among the celebrated directors who formed the nucleus of the French New Wave at the end of the 1950s, including Jean-Luc Godard, François Truffaut, Alain Resnais and Agnès Varda, Marker alone bypassed the route of entry via a transition to the narrative fiction feature film. The starkly original short *La Jetée* remains his sole foray into pure fiction, and was itself undertaken during the production of *Le Joli mai*: a novel exploration of new possibilities in direct documentary recording. When the iconoclastic force of the New Wave receded in the second half of the 1960s, and many of its directors settled safely back within known cinematic bounds, only Marker and Godard stood out in their parallel, if very differently manifested, commitments to both media innovation and political efficacy. The paths of these two veterans continue to hold out intriguing comparisons: Godard chiselling away at the edifice of cinema from within, Marker skirting through and across it in his protean engagements with other media.[2] In more recent years, Marker's move into creating gallery installations that recycle elements of his film work has anticipated a wider export of cinematic traces and fragments into the space of the gallery, evident in exhibits by directors such as Chantal Akerman, Atom Egoyan, Isaac Julien and Harun Farocki that press at the distinctions between cinema and installation art.[3]

For all his abundant and remarkable achieve-
ments, Chris Marker remains a notoriously
elusive figure around whom legends proliferate.
He will not be photographed; he never gives
interviews; he never makes public appearances to
promote his work (though none of these claims is
entirely accurate). His name is a long-standing
pseudonym (for many years written as Chris.
Marker), and he much prefers to appear via the

signature presence of his favourite animals, the cat and the owl, and a
dizzying array of disembodied *alter egos*. To compound the enigma, only
a tiny fraction of Marker's work is known by more than whispered repu-
tation or distant memory, particularly outside his native France. Marker
himself will no longer endorse public screenings of most of the films he
made before 1962 – a constant source of frustration to Marker enthusiasts
keen to see more of his work and reach their own conclusions as to its
worth.

The aim of this book is to provide the first comprehensive study in
English of Chris Marker's work. It is written in response to, and as a
product of, an exponential growth of interest in Marker's achievements
that has developed over the last few years among scholars, thinkers and
creative artists in a range of disciplinary fields. In France, where Marker
has always been a fairly constant presence in the post-war cultural land-
scape, and where the existence of exemplary public-access audiovisual
archives has meant that his works are more readily available to interested
viewers than they are elsewhere, two substantial publications devoted to his
work have recently appeared: Guy Gauthier's *Chris Marker: écrivain multi-
média* (2001) and *Théorème*, VI, 'Recherches sur Chris Marker' (2002). In
Germany, a well-developed interest in the essay film and personal docu-
mentary created the context for Birgit Kämper's and Thomas Tode's indis-
pensable edited collection *Chris Marker: Filmessayist* (1997). There was
clearly space for a comparable book to be written in English, which would
cover all the different phases of Marker's career and provide a systematic
discussion and analysis of his works, and this is the gap that *Chris Marker:
Memories of the Future* sets out to fill.

Establishing the parameters of Chris Marker's work is not a straightforward task. The various published filmographies of his work differ in content, and a degree of confusion or uncertainty surrounds his involvement in a number of projects.[4] Marker has also adapted and modified several of his works (notably *Le Joli mai*, *Le Fond de l'air est rouge* and the installation of 1990, *Zapping Zone*) to accommodate historical developments and (in the case of the last) new elements. The different media that Marker has traversed with such breathtaking ease do not provide stable grounds for classifying him, since they are in an important sense only the support, not the essence, of his defining qualities as an artist. In his celebrated essay on *Letter from Siberia*, André Bazin astutely grasped that the primary matter of Marker's work was intelligence, and that his operative mode was the personal essay, which combines stylistic flair with a process of reflective enquiry into its subject.[5] Intelligence is a quality of mind that may choose to express itself through whatever medium is at hand, whether it be a typewriter, a Rolleiflex, a 16mm-film camera, a Sony Handycam or an Apple Mac loaded with image processing software. Marker himself made the point in a discussion of another trans-media artist, his friend William Klein:

> The trouble with people like this is that we tend to cut them into pieces and to leave each piece to the specialists: a film to the film critic, a photograph to the photographic expert, a picture to the art pundit, a sketchbook to nobody in particular. Whereas the really interesting phenomenon is the totality of these forms of expression, their obvious or secret correspondences, their interdependence. The painter does not really turn to photography, then to the cinema, he starts from a single preoccupation, that of seeing and communicating, and modulates it through all the media. As if he were emitting a particularly intense beam which screens of different material and

form translate into their own code, a sort of Brighton laser.[6]

Although often classified as one, Marker is not a director in the 'Lights! Camera! Action!' sense of the commercial film industry – that figure whom the impact of *auteur* theory has conspired to make the exclusive and often tyrannical creative force behind a film – and not simply because he has worked expansively in other media. Marker is more an image-scavenger, one adept at editing, reprocessing and commenting on representations that already exist. He typically seems to stand at one remove from his own projects, like someone who is faced with an enthralling tangle of pre-existing texts and images (many borrowed from other people's works, including his own), and whose role is to sort through it all, pondering aloud all the while about what this process of sorting out entails. These same characteristics enter into many of Marker's numerous collaborations with other filmmakers. It is relatively easy to establish when he has co-directed films, provided commentaries or lent a hand with editing; but Marker's role has often been of the kind for which there is no exact job description: a fixer or facilitator who steps in to help friends and colleagues shape or complete a project that needs assistance.

Few concrete details exist about Chris Marker's life before he emerged as a published writer after the Second World War (apart from what he has recently revealed, quite possibly in the guise of fiction, in *Immemory*); and this book makes no attempt to delve into the truth or otherwise of stories that he was in the non-aligned French Resistance, and served as a parachutist with the US Army in the closing stages of the war. Since Marker has long since mastered the trick of disappearing completely into his work, this book is content to accept the assorted guises in which he chooses to appear, mindful of the observation made in his novel of 1949, *Le*

Cœur net: 'We exist in a world of mirrors: if we break them, we disappear at the same stroke.'[7] The reality that Marker offers for our contemplation has nothing to do with the bald biographical fact of a man named Christian-François Bouche-Villeneuve, of Russian and American extraction, born in July 1921 in Neuilly-sur-Seine, a comfortable suburb of Paris. It is that of the human imagination, in which it is perfectly possible to be born in two or more places at once – Ulan Bator, Belleville, Neuilly-sur-Seine – to appear and disappear at will in every corner of the globe, to be Chris Villeneuve, Fritz Markassin, Sandor Krasna, Jacopo Berenzi, Chris. Marker and Chris Marker; to be a global traveller, the man with the camera (the only image of himself that Marker will willingly publish), a cat, an owl, a man of the Left, and what the film scholar Ian Christie so aptly calls a techno-shaman. Even, as Marker's friend Alain Resnais suspected early on, to be a benign emissary from another planet, or our own future. Through all these different masks and personae, Marker has spend more than fifty years sharing his observations, insights, enthusiasms and dazzling intellect with wit, verve and the good grace and modesty never to pass himself off as anything other than an individual. 'Contrary to what people say, using the first person in films tends to be a sign of humility: "All I have to offer is myself."'[8]

1.
The Invention of Chris Marker

The figure of Chris Marker first emerged in Paris in the late 1940s, within the ferment of hopes for cultural renewal and political revolution that transported France following the symbolic Liberation of Paris from Nazi occupation in August 1944. During this period Marker became involved with a group of affiliated ventures that included the cultural and political journal *Esprit*, the publishing house Editions du Seuil, and two new organizations dedicated to popular education and the dissemination of culture: Peuple et Culture and Travail et Culture. He took on multiple roles as a writer, translator, editor, secretarial assistant, occasional broadcaster and *animateur* (popular educator). Memoirs and accounts of the period contain sporadic yet vivid recollections of Marker as a warmly respected but fundamentally elusive presence. Benigno Cacérès, the indefatigable popular educator and one of the founding members of Peuple et Culture, sketches a memorable portrait of Marker as 'this secret and unpredictable man, dressed unlike anyone else, always ready to defend lost and difficult causes'.[1] Cacérès recalls Marker frequently turning up at the Peuple et Culture offices with some extraordinary character in tow, or an amazing gadget brought back from his travels.

During this period writing dominated Chris Marker's creative output, freely traversing a wide range of registers and idioms. In *Esprit* and other periodicals he published poetry, a short story, political and cultural essays, book and film reviews. For the topical commentary section of *Esprit*: *Journal à plusieurs voix* (Journal of Many Voices), he produced short, pithy reflections on current events and debates that were sometimes transposed as

imaginary fables. He wrote a well-received novel, *Le Cœur net* (1949, *The Forthright Spirit*), and an extended critical essay on the French playwright Jean Giraudoux, alongside contributions as writer and editor to a number of anthology works. These included *L'Homme et sa liberté* (1949), a collection of texts intended as a basis for popular theatrical performances, and a number of volumes in the *Regards neufs* series. This collection, produced by Peuple et Culture and published by Editions du Seuil, examined diverse cultural topics such as tourism, sport, cinema and popular song, with the aim of stimulating discussion and engagement in the popular education movement.

Surveyed as a whole, Marker's early writings are striking not only for their diversity, but for their permeability to the influence of other media; their desire to reach beyond writing and embrace other potential forms of reflection and enquiry. The brief biography on the jacket of his novel announces that he 'likes radio more than literature, cinema more than radio, and music most of all'.[2] Many of Marker's longest and most developed articles in this period were dedicated to film and popular music, at a time when these subjects were only just beginning to be regarded as fit for intellectual attention and serious analysis. He also drew from the cinema a repertoire of formal techniques that he began freely to incorporate into his writing. Two of his short commentaries in 'Journal à plusieurs voix' are presented as imaginary newsreels,[3] while *Le Cœur net* uses the parallel scene construction and abrupt transitions and juxtapositions of cinematic editing. This interest in transposing conventions and techniques across media would continue to engage Marker, leading him among other projects to cast one of his later books, the photo-text album of 1959 *Coréennes* ('Korean Women'), as a short film, and to compose several films, the best-known of which is *La Jetée*, using still photographs.

The closing remarks of Marker's essay on *chanson* clarify the philosophy behind his consistent enthusiasm for the most up-to-date media developments. For Marker, artistic media and techniques 'live and die like civilizations',[4] and he sees little mileage in contemporary debates over abstract versus figurative painting, or the state of post-war poetry, when photography and film exist, and there is living poetry to be discovered in the rhythms and lyrics of popular song. Yet this professed impatience with

traditional literary and artistic practices belies the extent to which Marker remains steeped in their culture, even as his writings promote newer media and technical innovations as better suited to conveying and exploring the character of the contemporary world. His ideas are closest in spirit to those of Alexandre Astruc, whose celebrated essay of 1948, 'The Birth of a New Avant-Garde: *Le Caméra-stylo*',[5] announced the possibility of a cinema that would follow literary models of individual and expressive creation. Echoes of Astruc sound in Marker's article 'Corneille au cinéma', which investigates the apparently trifling topic of how a group of schoolgirls would go about adapting Corneille's play *Horace* (1640) for the screen.[6] He closes by anticipating a future when it will be as natural to possess a film camera as a pen, and as natural for these *lycéennes* to turn to cinema as literature in order to express their ideas. Marker's conclusion heralds his own shift into film at the beginning of the 1950s, as director of *Olympia 52* (1952) and co-director with Alain Resnais of *Les Statues meurent aussi* (1950–53, 'Statues Also Die'), while hinting at the extent to which writing would persist as a founding principle of his cinema.

Chris Marker began to publish his writing in *Esprit* in January 1947. At this time the journal occupied offices in the same building as Editions du Seuil, at 27 rue Jacob, in the heart of Saint-Germain-des-Prés. The headquarters of Travail et Culture and Peuple et Culture were close at hand, at 5 rue des Beaux-Arts and 14 rue Monsieur le Prince respectively, easing the movement of a network of individuals who, like Marker, were involved in some capacity with all of them. Saint-Germain in the late 1940s was the centre of Parisian intellectual life, the physical location that anchored the mythic geography of the Left Bank. Its most visible aspect was existentialism, prominently associated with Jean-Paul Sartre, Simone de Beauvoir and Albert Camus. Sartre and de Beauvoir wrote and held court in Saint-Germain's Café Flore and Les Deux Magots, and with Maurice Merleau-Ponty published the influential journal *Les Temps modernes*. Populist manifestations of their new philosophy of personal freedom, commitment and conscious action thrived in cellar night-clubs like Le Tabou, frequented by students and bohemians who gathered to listen to bebop jazz and iconic singers such as Juliette Gréco.[7]

Esprit had been founded in 1932 by the philosopher Emmanuel Mounier, who continued to edit the journal until his death in 1950. Mounier was the

primary intellectual force behind personalism, a philosophical and social movement that developed in France during the 1930s as an effort to reconcile Catholicism with left-wing political ideals. Personalism focused on the nature and potential of the human person, conceived as an amalgam of material, social and spiritual dimensions. It aimed to foster human development on all these fronts: through political change, interaction with other individuals in human-centred social communities, and inner spiritual conviction. As a political philosophy it opposed the ideological conformity of totalitarian states, the alienation of modern mass industrial capitalism, and the bourgeois liberal democracy of the Third Republic.

During the war, Mounier shifted his activities from Paris to Grenoble in the unoccupied zone, continuing to publish *Esprit* until August 1941, when it was suppressed by the Vichy authorities. He subsequently developed close ties to the Ecole des Cadres at Uriage, a centre of Resistance activity significantly inspired by personalist beliefs, which was incubating the ambitious project of renewing French culture and society after the war had ended. The leaders of Uriage believed that a highly trained and cultured professional elite would be needed to spearhead this renewal and unite the nation within a shared framework of moral values and common cultural inheritance. Their experiences at Uriage directly inspired Benigno Cacérès and Joffre Dumazedier to found Peuple et Culture in Grenoble in December 1944, to carry forward the cultural and class solidarity that they believed had been forged in the Resistance, by creating a mass movement of popular education and undertaking to train a dedicated and effective body of popular *animateurs*. Other 'graduates' of Uriage included Paul Flamand, director of Editions du Seuil, and Hubert Beuve-Méry, who founded the newspaper *Le Monde* after the Liberation in 1944.[8]

Esprit resumed publication in December 1944. The journal quickly gained prominence as a focus for Roman Catholics looking to dissociate themselves from the disgrace of the Church's conservative right, which had openly collaborated with Vichy. Their wartime experiences certainly gave a renewed sense of energy, commitment and conviction to Mounier and the other members of the editorial group, who included the drama critic Pierre-Aimé Touchard, the philosopher Paul Ricœur, the writer and literary critic Albert Béguin, the novelist Jean Cayrol, who would later draw on his expe-

rience of deportation to write the commentary for Alain Resnais' landmark documentary *Nuit et brouillard* (1955, *Night and Fog*), and the film critic André Bazin. In the combative and optimistic editorial statement for the re-launch of the journal in December 1944, *Esprit* strongly emphasized its ambition to forge a link between personalism's spiritual principles and the political acuity and engagement demanded by the contemporary world; to make *Esprit* 'a synonym for engagement as well as intellectual and moral standing'.[9]

Mounier's editorial policy for *Esprit* advocated eclecticism, inclusiveness and open debate. He was willing to accept alliances with any groups or individuals who broadly shared the values of personalism and could contribute something to it. A later policy statement would conclude: '*Esprit* caters to no single orthodoxy; a free journal, addressed to free men, it seeks the truth without claiming always and in all matters to be correct.'[10] The principle of open debate was fostered through the 'Round Table' meetings held every Monday evening at the *Esprit* offices, and attended by between ten and twenty-five people, including regular contributors, noted intellectuals and visitors drawn to the discussion. These freewheeling debates were an example of personalist ideals in practice: an open exchange of opinions among people, without the imposition of authority or a fixed agenda for discussion. Participants were encouraged to express ideas on any subject, without being confined to their professional specialism. 'Philosophers talk about the movies, art critics argue about urban planning, and everyone discusses politics and religion.'[11] A typical meeting would drift from topic to topic, touching on current events and opinions, until a focus was generated. If the chosen subject seemed especially compelling, one of the contributors might be asked to organize a special issue and commission articles from those present at the discussion or others suggested by the group. Even if no consensus was reached, each month the 'Journal of Many Voices' would reproduce selections from the Round Table debates.

Most the writings that Chris Marker published in *Esprit* are to be found in the 'Journal of Many Voices'. They suggest a relish for the eclecticism and open-ended drift of the Monday meetings, and show complete mastery of their literary transformation into this *Esprit* variant of the *feuilleton*, which required an agile responsiveness to the ephemeral flow of current events,

and the ability to draw out their significance in brief and arresting sketches. Marker's contributions to the Journal cover a breathtaking range of topics: from religious questions to cinema, *chanson* to Cold War ideology, cat shows to literary scandals. Some are no more than a few lines long, crafting from some apparently trivial event or observation a concise, elegant meditation on political or philosophical questions. Democracy and the classless society are tackled via musings on why all Paris Métro carriages are second class.[12] Longer articles reflect on recent events that have engaged Marker's interest, including the death of the legendary American gangster Al Capone,[13] or file trenchant reports on contemporary political topics, such as the inexorable emergence of the Cold War and the disputed legacy of the French Resistance.[14] Marker often slyly transposes current events into the realm of imagination, as the Soviets prepare to fire a cosmic ray through the ozone layer, and the Yugoslav crisis of 1948 is complicated by the existence of four Yugoslavias, led by four different President Titos.[15] He assumes fantasy to be the logical barometer of the contemporary political climate, since, as his later essay on Jean Cocteau's *Orphée* would observe, life does not imitate art, but rather comes to fulfil its prophecies.[16]

During the period of Marker's regular involvement with *Esprit*, French political and intellectual life was dominated by the repercussions of the Cold War and the division of the post-war world into two competing and rigidly opposed power blocs. The collective impulses towards national unity and political and social revolution that had surged up after the Liberation quickly gave way to the polarization of Communist and capitalist ideologies, and the adoption of increasingly doctrinaire and intransigent positions on both sides. At the Liberation, the Soviet Union was lauded for its role in the defeat of the Nazis, and the French Communist Party (Parti Communiste Français, or PCF), enjoying tremendous national prestige for its active role in the Resistance, was invited (along with the Socialists and Christian Democrats), to join the provisional coalition government that drew up the constitution of the Fourth Republic. But in 1947 the PCF was expelled from government, leaving a power gap that would be gradually filled by the resurgence of the conservative right. With France reliant on US economic aid and a *de facto* member of the Western bloc (confirmed in 1949 when it joined NATO), Communists came to be regarded as the internal

enemies of the state. The PCF for its part remained loyal in its allegiance to the Soviet Union, which from 1948 demanded complete conformity to Party doctrine on all political and cultural questions. The stage was set for a corrosive ideological stand-off between advocates of US-led Western capitalism and supporters of Stalinist Communism, in which the middle ground of alternative political allegiances or more nuanced intellectual and cultural perspectives became increasingly difficult to sustain and justify.[17]

In this charged context it is unsurprising to find Marker's *Esprit* writings much exercised by the varieties of ideological and cultural freezing occasioned by the Cold War climate. The position he adopts is that of a lively and irreverent dialectician, who deploys archly ironic humour and dazzling erudition to expose the contradictions, double standards and mental laziness that sustain the cherished dogmas of all political persuasions. In his very first *Esprit* article, he lampoons the blind faith of both early Christian and orthodox Stalinist believers in the proclaimed eradication of human evils, by inventing a witty and learned exchange between Laurel and Hardy that rattles the ideological edifice of Hollywood into the bargain, with its subversive final image of Oliver Hardy reading *Pravda* and believing what it says.[18] One of Marker's longer essays, 'Sauvages blancs seulement confondre',[19] which opens the special issue of *Esprit* devoted to 'The Civilization of the Digest' of July 1948, begins its reflections on the phenomenon of the literary digest with an amusing foray through the ideological minefield of anti-Americanism. Marker unravels the simplistic vision of America expounded by the PCF ideologue Jean Kanapa, as he ironically extends Kanapa's totalizing and negative focus on the Church, trusts and the Ku Klux Klan to include such stalwart backers of Christian morality and big business as Henry Miller and John Dos Passos, and such a loyal supporter of the Ku Klux Klan as the black American novelist Richard Wright. Later in the essay Marker reverses his target, showing himself equally alert to the universal demonization of the Soviet Union in all the Western variants of the *Reader's Digest* that accumulate on his desk. Although Marker shares widespread reservations about the banality and complacency of the existing digests, he refuses to condemn the form itself, arguing that it is possible to imagine a digest that would stimulate and provoke the curiosity of the reader. 'Sauvages blancs' thereby challenges the self-protective edifice of

French high culture, which sneers at the very form that could allow non-specialists to gain a foothold on its hallowed terrain.

> We, who have never wished for an Anglo-Saxon novel of less than 665 pages . . . for us it is obviously difficult to accept these processes, which threaten to give non-specialists misguided access to an unfamiliar field, like those which literary experts themselves demand of popular scientific tracts and anthologies of Black writing.[20]

This quotation neatly illuminates Marker's approach to the undermining and questioning of ideological clichés, one that would extend from these early writings into his films. Rather than adopt an exterior position of earnest condemnation convinced of its own rightness, Marker proceeds by entering into the very texture of received opinions, articulating them in a first person plural that encompasses both writer and reader ('we' the enemies of America; 'we' the defenders of the French literary canon), but then ironically admitting the exclusions and double standards on which they are based, and finally juxtaposing the various 'truths' of opposed ideological camps to striking and often humorous effect. Marker's writings are evidently impatient with the unthinking rigidity of political dogmas, and seriously dismayed by their capacity to inhibit curiosity and independent critical thought. Yet in choosing to combat received ideas by inhabiting them, exposing how they take shape as articulated beliefs and representations, Marker avoids imposing the truth of a correct argument.

Among the many and varied subjects covered in Marker's *Esprit* articles, cinema retains the special interest of foreshadowing the path that he would shortly choose to follow. As he made his first forays into filmmaking in the early 1950s, cinema increasingly focused his energies as a writer.[21] In addition to substantial articles for *Esprit* on Laurence Olivier's *Henry V*, Cocteau's *Orphée*, Carl Dreyer's *La Passion de Jeanne d'Arc*, Elia Kazan's *On The Waterfront* and Robert Montgomery's *The Lady in the Lake*,[22] Marker was an early occasional contributor to *Cahiers du cinéma*, the journal founded by André Bazin and Jacques Doniol-Valcroze in 1951, which would become the major critical forum of the French New Wave. He also contributed to two significant anthology texts on cinema. One was *Regards*

neufs sur le cinéma, for which he wrote on the early French avant-garde, on *La Passion de Jeanne d'Arc*, and about current developments in widescreen and 3-D technology. The second was *Cinéma 53 à travers le monde*, which he co-authored, contributing essays on Cinerama, Hollywood and animation.[23]

These writings approach cinema from odd angles. Marker champions its under-acknowledged margins, and firmly advocates a popular cinema of ideas and distinctive authors, against routine and derivative commercial production. When Italian neo-Realism was enjoying widespread critical attention in Europe, Marker devoted articles to the fortunes of East and West German cinema, which were then barely seen outside their countries of origin.[24] A great enthusiast for animation, Marker countered what he viewed as the slick sentimentality of Walt Disney productions with praise for the breakaway animation studio United Productions of America (UPA) and the Czech Jiri Trnka.[25] Some of UPA's innovative animation work, such as the fake television commercials made for Claude Binyon's film of 1952, *Dreamboat*, directly anticipated the animated sequences that Marker would later have made for his own travel films, notably *Letter from Siberia* and *Cuba si* (1961). Marker was also a keen observer of contemporary developments in cinema technology: the widescreen and 3-D processes then being developed by Hollywood to counter competition from television. The visceral horror of André de Toth's *House of Wax* (1953) – the film Marker dubs the *Jazz Singer* of the 3-D era – and the tourist clichés of the showcase Cinerama films did not sustain his interest (although he did link the popularity of horror films and comics with US involvement in the Korean War), but Marker maintained a belief in the creative potential of these

new developments, once they had ceased to be commercial novelties and had entered into the service of ideas.[26]

Marker discusses cinema with technical confidence and a lucid, inclusive conception of its nature and relationship to the other arts. In his review of *Henry V*, he positions cinema

Lettre de Sibérie (1958).

as the inheritor and destiny of both theatre and painting, come to 'finish their conquests, and fulfil their prophesies'.[27] He sees Cinerama as a new kind of 'theatrical cinema', and accepts with equanimity that what it loses in established cinematic techniques, such as montage and virtuoso camera movement, it gains in the grand projection of the 'theatre of the world' as a space of action and contemplation.[28] The preamble to his essay on Jiri Trnka's *Prince Bayaya* pushes aside the false opposition of painting or cinema with a vision of cinema as the art of time and movement, capable of taking painting as its subject (he had in mind the celebrated art documentaries of Alain Resnais), and restoring to it the duration of looking. Writing on *La*

Passion de Jeanne d'Arc, which at the time he believed to be the most beautiful film ever made, Marker locates the nature of cinema in the perpetual conflict or exchange between space and time. These two dimensions are reconciled in his notion of a temporal grammar of film shots, where long shots correspond to the past and close-ups to the present. His analysis of Dreyer's film, renowned for its use of extreme close-ups of the human face to carry the drama, goes beyond con-

Carl Dreyer's *La Passion de Jeanne d'Arc* (1928).

La Jetée (1962).

ventional psychological readings to correlate the close-ups (along with the minimal, austere decor and costumes) to a tangible experience of historical events made to seem eternally present.

Within this intricate relay of space and time, a further significant aspect of cinema's fascination for Marker is what he regards as its capacity for revelation: the power to unveil deeper realities that expand and enrich the significance of the everyday world, but remain firmly grounded in its objects and appearances. This notion of the ordinary physical world as a medium of revelation was shared by the neo-Bergsonian critics and philosophers who had gravitated to *Esprit* from its foundation, notably Albert Béguin. Béguin's interest in the French poets Paul Claudel and Charles Péguy (a touchstone for the *Esprit* group) stemmed from the dual sense of reality he found manifested in their work, connecting 'things of this earth' to the realms of 'mystery and the mind'.[29] Catholicism played a crucial role in motivating and interpreting this poetic vision of the world, and in Marker's reading of *La Passion de Jeanne d'Arc* the object of revelation is indeed divine: the metaphysical struggle of the soul to attain grace through suffering and the confrontation with evil, incarnated in the physical play of expressions across the actress Renée Falconetti's face, in 'the grain of the skin, the tear, the drool, the hair, the glint of the eye'.[30]

In Cocteau's *Orphée*, however, what Marker discerns is a subjective journey into the poetic imagination, traced in a web of concrete signs such as the motorcycles and radio broadcasts. Marker reads *Orphée* as a map of an interior world, every bit as tangible as the physical environment. 'In this story, each word echoes from the other side of the wall, and without losing anything of its own architecture it builds at the same time an invisible itinerary where the adventures of the soul are found.'[31] This developed sense of the physical world in film as the bearer of an inner imaginative reality sheds light on the way that Marker's own films have used documentary footage of the actual world to map a subjective consciousness, via incisive dialogues between the spoken commentary and the assembled images. Even Marker's engagements with political and historical subject matter would uphold this principle of revelation, by scrutinizing archival images for evidence of hidden historical realities.

When Marker chided the elitism of the French cultural establishment in 'Sauvages blancs seulement confondre', he displayed his allegiance to the

democratic cultural and educational ideals of the sibling organizations Travail et Culture and Peuple et Culture, for which he worked in various capacities as an administrator, editor and *animateur*. Travail et Culture was formed in Paris soon after the Liberation, with the aim of bringing culture into factories and industrial organizations. In 1945 its vice-president, Joseph Rovan (who also served as editorial secretary of *Esprit* in 1945–6), was despatched to Grenoble to forge links with Peuple et Culture, whose radical educational ambition was 'to bring culture to the people and the people to culture'.[32] The links between the two organizations were strengthened when Peuple et Culture shifted its head offices to Paris in 1946, and Rovan came to occupy senior administrative roles in both.

The Travail et Culture offices at 5 rue des Beaux-Arts buzzed with activity and fertile exchanges between the different workshops and offices. The theatre studio was among the most active, attracting well-known actors and stage directors such as Jean-Louis Barrault and Louis Jouvet, who hoped to

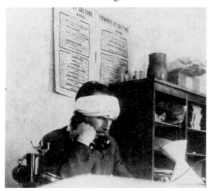

start a popular theatre movement. But the magnet for the entire organization was André Bazin's cinema office, which also drew in the wider cinephile community of Paris as its reputation spread. As well as mobilizing traditional cultural forms such as theatre, puppetry and music, Travail et Culture was alert to the potential of the modern mass media for engaging working-class audiences, and as early as December 1944 it had invited Bazin to run a 'centre for cinematographic initiation'. Bazin quickly found himself organizing screenings and debates for huge and diverse audiences of workers, students and engaged intellectuals, as well as writing film reviews and articles for the daily newspaper *Le Parisien libéré* and for *Esprit*. Chris Marker, who according to Dudley Andrew was then a young actor attached to the Travail et Culture theatre workshop, became a regular visitor to Bazin's office, and was so drawn to Bazin's personality that he eventually left the workshop to assist him with the day-to-day running of the film section. It was through the Travail et Culture film office that Marker became close friends with another of Bazin's regular visitors, the young actor and burgeoning filmmaker Alain Resnais.[33]

André Bazin in his office at Travail et Culture.

Resnais himself recalls making Marker's acquaintance on the basis of a groundless rumour that he was the son of a wealthy businessman based in South America, who might be able to produce a film that Resnais was working on.[34]

A short distance away, in the Peuple et Culture offices at 14 rue Monsieur le Prince, the ties between the two organizations were further consolidated by the establishment of a joint documentation and research centre for popular culture, the 'Centre national de documentation de la culture populaire', which produced dossiers, bibliographies and articles for the parent organizations. Joseph Rovan was the director of the centre, and he employed Marker as an assistant, putting him in charge of a group of 'unemployed intellectuals' who were given the task of writing educational dossiers in the Peuple et Culture house style. Rovan's memoirs recall the contrast between the intellectuals and Marker, who was a great deal younger than his charges and very exacting in the literary standards he expected of them, but whose abrupt manner frequently melted into expressions of friendliness. Rovan also remembers Marker sleeping on the office table when he had nowhere else to live.[35]

Towards the end of 1947 Marker took on the job of editing (under the name Chris Villeneuve) the first issues of *DOC*. This was a publication designed for popular *animateurs* that contained a selection of literary extracts or short poems and songs, background information on works of literature, music, art and film, and tips on how to work successfully with these materials in a popular education context. For *DOC*, 1, a loose-leaf dossier with inserts on theatre, cinema, music and letters, Marker/ Villeneuve wrote a commentary on Beaumarchais' *Le Mariage de Figaro* (1784, *The Marriage of Figaro*), to help amateur theatre directors mount their own productions. The production of the second issue, *DOC*, 2/3, however, drew Marker and Rovan directly into the ideological conflicts of the period. Under the presidency of Maurice Delarue, Travail et Culture had become closely aligned to the PCF, and consequently the publications produced by the joint documentation centre were routinely submitted for the scrutiny of a PCF committee member, Mrs Thomas. On this occasion, she strongly objected to the inclusion in *DOC*, 2/3, of an extract from André Malraux's novel of 1937 about the Spanish Civil War, *L'Espoir* (*Hope*). The

PCF regarded Malraux as a fascist, because he supported General de Gaulle's Rassemblement du Peuple Français (RPF) party. Marker had already commented in *Esprit*, with characteristic irony, on the misfortune of having this crucial literary testament to the Republican struggle written by a fascist.[36] He and Rovan refused to accept the PCF's censorship: Marker resigned the editorship of *DOC* and Rovan reduced his commitments to Travail et Culture (although he remained as nominal head of the documentation centre).

The *DOC* educational dossiers were designed to inspire curiosity, insight and critical reflection in popular education meetings and debates. Other publishing ventures in which Marker took part extended this notion of the popular critical anthology. *L'Homme et sa liberté*, 'a play that is not a play' on the theme of freedom, blends literary extracts and poems by (among others) Malraux, Jacques Prévert, Jean Giraudoux, Henri Michaux, John Dos Passos and Jean Cocteau with popular songs, street cries and black spirituals. In the introduction, Marker pronounces his conviction 'that you express yourself much better through the texts of others, among which you have complete freedom of choice, than by your own'.[37] Users of the book are actively encouraged to adapt and expand its content when organizing their own performances. The same principles of combining diverse source materials, and promoting their creative transformation and adaptation, also inform the anthology *Regards sur le mouvement ouvrier*, which Marker co-edited with Benigno Cacérès in 1952.[38] The authors' introduction addresses the problem of a lack of suitable material about working-class experience in conventional history, which has led them to seek other resources: letters, reports, factory regulations, songs, poems, street cries, newspaper articles and trial proceedings. The book is organized in chronological sections, and the principle of arranging texts is akin to cinematic montage, with a theme or idea introduced in one text being picked up and relayed in subsequent extracts.

Although Marker's involvement with these projects is not of great significance in itself, it does anticipate the major role that the art of editing would play throughout his work and across different media. The editor's job is to select, shape and combine existing materials, bringing out what is relevant or significant in them for a particular purpose, knowing when to

cut and how to link together discrete sources to best effect. As the introduction to *L'Homme et sa liberté* hints, Marker would make a creative philosophy of his talent for selection and compilation, and it is significant in this context to register the extent to which his work contains or consists of material that has actually been shot by other filmmakers, and to note that the credits of many of his best-known films and videos list him as responsible for 'conception and editing' (or words to that effect), rather than as director.

Joseph Rovan had grown up in Germany, and despite being deported to Dachau during the war for his Resistance activities, developed a strong commitment to working for the post-war reconciliation of France and Germany. Rovan saw the common legacy of popular education movements in the two countries as the ideal means of promoting this reconciliation, bolstered by a widespread contemporary faith in culture as a medium of mutual exchange and understanding. From the spring of 1946 Rovan was invited by the authorities in the French-occupied zone of Germany to hold regular education conferences and train *animateurs*. He was frequently accompanied on these trips by Cacérès, Bazin and Marker. Marker's *Esprit* report 'Croix de bois et chemin de fer'[39] recounts an experience from one visit to Germany that affirms the importance of this enterprise, but also conveys the enormous difficulties that faced it. Marker falls into conversation with a German train conductor who fought in the Wehrmacht, and finds himself insisting (in his faltering German) on the urgent need to remember the war collectively, against the conductor's wish to forget everything, and the contradictory arguments he puts forward to justify his own conduct. Rovan meanwhile remembers Marker in Germany in a rather different light, recalling in his memoirs how Marker's piano playing captivated the participants in a Franco-German popular education exchange that took place in the town of Mölln (close to the northern border of East and West Germany) in 1949.[40]

In tandem with the topical engagements of his *Esprit* articles and essays, Chris Marker began to emerge as a distinctive literary voice. His first appearance in *Esprit* was as the author of a vivid, disquieting short story, 'Till the end of time'.[41] Set after the war in an unspecified location, 'Till the end of time' hallucinates the dissolution of the world in the mind of a shop-

keeper, who becomes transfixed by the mouth and voice of a mysterious woman after she has taken shelter in his shop during a rainstorm. With its descriptive economy and abrupt shifts of viewpoint, the story anticipates the cinematic construction of *Le Cœur net*. Marker also published four poems in the late 1940s: dense invocations of richly populated inner land-scapes that all seem ultimately to trace an itinerary through the land of the dead.[42] The poems distil the terrible losses of the war, shadowed as they are by the ranks of the dead and the unbearable disappearance of friends and loved ones, to whom the poems endeavour to speak their fractured memo-ries. 'I live in the house of the dead / For a time we are chained together / Only you have lost all the hours / And me, I remember'.[43]

The burden of remembering the dead also lies at the heart of *Le Cœur net*, which remains to date Marker's only novel. Set in Indo-China in the aftermath of a major war (the Second World War is never named directly), it centres on a pioneering airline mail service and five central characters brought together by its work: the head of the airline Van Helsen, the young pilot Kelso, his lover Hélène, Van Helsen's journalist friend Jerry, and Agyre, guard of a remote jungle landing strip. In the first part of the book, Kelso is caught in an unexpected storm and tension mounts as Van Helsen, Hélène and Jerry hope for his return, revealing through their largely private antici-pation the significance of Kelso to each of their own lives. After Kelso has finally landed safely in a jungle post, he is shot by Agyre, the guard who has succumbed to schizophrenic hallucinations. In the second part, the memory of Kelso begins to consume and transform the other characters as they await his inevitable death. This intimate coexistence of death and remembrance, as Kelso's death unleashes the full force of a memory galva-nized by loss, sets out a theme that would recur across many of Marker's later films. 'When death tightens the thread and makes the final loop, it is through these memories that you will gauge your route, that you will meas-ure your gain or your loss.'[44]

The action of *Le Cœur net* takes place over a few days, but the plot is essentially an armature around which to mould the primary matter and interest of the novel, namely the vivid interior life of its protagonists, variously manifested as memory, dream, reverie and hallucination. The title, rendered in the English translation as *The Forthright Spirit*, expresses

the quality of absolute and even reckless devotion to their chosen lives possessed by each of the central characters. The solitary pilot Kelso, with his innocence, intensity and daring, is the axis around whom the other characters revolve, the defining absence who for the others seems to hold the key to their own individual fates and inner lives. Kelso is a secular Christ, whose death redeems the others by committing them to their own human destinies. Hélène consecrates her life to his memory, Jerry crosses the threshold to adulthood, and Van Helsen affirms his existence by acknowledging the place of Kelso's death within it.

The narrative of *Le Cœur net* cuts back and forth between the viewpoints of the different protagonists, with an economy and precision indebted to cinematic editing. Even within individual scenes, the focus can shift fluidly between characters, in a manner irresistibly suggestive of successive shots in film. One chapter deploys the rhythms, crescendos and formal affinities of montage to compose a sustained relay of connections between the main characters, mediated by radio signals and periodically expanding to embrace the rest of humanity. Separated in space and circumstance, the protagonists are united by memory, the inventive serendipity of the narration and the benevolent intervention of technology. Jerry meets Van Helsen in his office and together they listen to a radio broadcast of a Mozart piano concerto, performed by Jerry's brother Joel in Swizerland. Hélène attends a performance of the same concerto in Saigon. Kelso is caught in the storm; Agyre hallucinates in the jungle.

> Jerry listened. Van Helsen listened . . . Hélène listened. Seven hundred listeners in Saigon, four thousand at Lucerne, a million throughout the world, listened. Joel listened, his eyes half-closed, his hands poised on the keys, waiting for his cue to enter the lists. Kelso listened, observing with amusement that in the tumult of the storm certain sounds grouped together; it seemed almost to take on a definite shape, one could almost hear violins.[45]

Similar transitions convey the abrupt shifting of the characters' inner worlds from the conscious present into memory, dream and hallucination. Caught in the storm, Kelso drifts in and out of sleep, and between fragments

of memory, the literal present and vivid interior landscapes that imaginatively transfigure his perception of the storm:

> Kelso closed his eyes. Soho. The yellow-eyed woman who stared continuously . . . With all this pulling back on the stick, I ought to be at twelve thousand feet and out of all this filth. She used to look at me and laugh. The roar of charging bulls. Legions grouped and broke up again in the shadows.[46]

This fluid interior narration is familiar territory for the modern novel, but in terms of cinema the closest approximation is perhaps the radical treatment of memory and subjectivity found in the films of Alain Resnais, notably *L'Année dernière à Marienbad* (1961, *Last Year at Marienbad*) and *Je t'aime je t'aime* (1967). Marker himself would eventually take film as an opportunity to liberate the flux of inner life and memory from the defined states of writing and the limits of individual characters (before eventually turning to multimedia as yet another liberation, this time from the linearity and fixed projection rate of conventional films). Yet writing, transposed into spoken commentaries, would remain the central index of subjectivity in his films, tracking the nuances and shifts of inner experience in a transient, inquisitive dialogue with the flow of images.

Le Cœur net was the beginning for Marker of his long-standing association with the publishing house Editions du Seuil, which maintained close affinities with *Esprit* and Peuple et Culture by publishing dedicated collections that carried their names. Marker undertook a range of translations for Seuil (some published under pseudonyms),[47] and in 1952 contributed an essay on the French novelist and playwright Jean Giraudoux to their series 'Ecrivains de toujours'. Entitled *Giraudoux par lui-même*, the essay accompanied selected extracts from Giraudoux's writings: a series format that gave free rein to Marker's taste and talent for quotation and compilation. Giraudoux, who died in 1944, represented the heyday of mainstream French theatre in the inter-war period, and the subtext of Marker's essay suggests that by the early 1950s he was regarded respectfully, but as a somewhat outmoded and even reactionary figure. Marker sets about reclaiming Giraudoux for his own generation (when the essay addresses its readers, it

is as 'we'), and emphasizing his continuing rele-
vance for the post-war era.

Marker admits to drawing the Giraudoux
whom he loves out of himself, and more than one
commentator has read the Giraudoux essay as a
source of disguised opinions and reflections on
Marker's own work.[48] The elective fraternity of
Marker with Giraudoux rests in part on a shared
discretion: a desire to exist through their creative
works that leaves few other traces, and freely
embellishes those that do exist with the resources
of imagination. Marker writes that, for Girau-
doux, imagination was 'such an important part
of reality, that to deprive oneself of its services
seemed to him the worst alienation'.[49] When
Marker singles out Giraudoux's absolute serious-
ness as the condition of his noted playfulness
and frivolity, he articulates the principles that

animate his own capacity to fuse serious political analysis with light-
hearted imaginative digression.

Marker reads beyond the grain of established critical opinion on
Giraudoux's work to discover fresh significance. The conservative, well-
mannered and hermetically sealed worlds of Giraudoux's novels and plays
become secular paradises of human freedom, innocence and the impulse of
self-realization. Giraudoux's characters share with the protagonists of *Le
Cœur net* an innocence derived from what Marker calls 'complete adapta-
tion to the universe they inhabit'.[50] By refusing to compromise the joy of
their existence in the face of established authority, they are harbingers of a
better world in which human potential is realized, and the whole of cre-
ation, even its most humble and mundane elements, is redeemed. Marker
cherishes in Giraudoux a love of enumeration that extends to the most
banal and overlooked aspects of the world: 'abandoned objects, old nails,
useless bits of string, heads of broken pickaxes'.[51] Such litanies of the trivial
and ephemeral abound in Marker's own works: assembled photographs,
the clamorous signs of urban popular culture, museum exhibits, passing

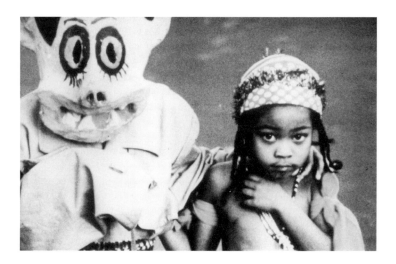

Sans soleil (1982).

faces, favourite animals and accumulated mementos, whose seemingly haphazard drift reveals patterns of deeper harmony and significance.

Cinema figures in the conclusion to Marker's Giraudoux essay as the most promising contemporary source of images of humanity 'that can be looked at without disgust'.[52] Marker consolidates his belief that the values found in Giraudoux's work are passing from literature and theatre into film, and also claims a particular quality for the cinematic image: the 'miracle of a world in which everything is both absolutely familiar and completely strange'.[53] Whenever Marker's own films, from *Le Joli mai* to *Berliner ballade* (1990), invoke the name and writings of Jean Giraudoux, it is as a touchstone of this miraculous disorientation, this secret promise of a world shaped according to human capacities and desires, which we have within our grasp the power to create, and which is the only kind of utopia worth having.

In the same year that *Giraudoux par lui-même* was published, Marker undertook his first completed venture into film directing. *Olympia 52*, a record of the Helsinki Olympic Games of 1952, was produced by Peuple et Culture and aimed at audiences within the popular education movement. The organization took a keen interest in sports and physical activities, and its co-founder Joffre Dumazedier even advocated sport as a form of cultural

32

expression, which would encourage moral and philosophical development in addition to improving health and fitness.[54] The Helsinki Games, which were widely viewed as marking the post-war renewal of the Olympic tradition and saw the Soviet Union competing for the first time, offered Peuple et Culture a golden opportunity for promoting these ideals. It decided to organize a temporary sports university and hatched a plan to travel to Helsinki and film the Games. The Secretary of State for Youth and Sports stepped in to provide the film and obtain the necessary permissions from the Finnish authorities. Marker, who among the Peuple et Culture membership had expressed particular interest in the project, was one of four camera operators who filmed the Games. He also directed the finished film and wrote the commentary, after working with Joffre Dumazedier on an initial synopsis.[55]

Olympia 52 is no early masterpiece, being primarily a functional record of the different Olympic competitions, shot with amateur equipment in difficult conditions and lacking technical polish. Yet it does succeed in putting the Games into a concise and illuminating historical context, and places a striking emphasis on the humanity of both athletes and spectators, in a manner that both reflects the values of Peuple et Culture and displays the respectful fascination with human behaviour that would become a defining quality of Chris Marker's subsequent work. The commentary consists largely of factual information about the contests, but this is sporadically leavened with observations that already display Marker skilfully interweaving whimsy and political insight. One example derives from the observation that both the American and Soviet competitors in the steeplechase are detectives in professional life. The race is then cast as an investigation, in which both confront the same set of obstacles.

The Olympic Games are cast in the film as a utopian realization of human potential. This extends beyond the obvious level of the competitors' physical prowess, to incorporate political, social and moral dimensions. Competitors of different ethnicity are represented as equals, and the bitter ideological conflicts of the Cold War are redeemed, as athletes from the United States and the Soviet Union participate amicably together. *Olympia 52* emphasizes the extent to which this ideal is a creation of collective human effort, by showing the build-up to the Games and preparations in

the stadium, followed by a sequence of the athletes in training. The atmosphere of informal camaraderie before the Games complements the focused efforts of the actual competition, and contributes to the human and down-to-earth view of the athletes that the film adopts. In contrast to the stylized physical fetishism of its notorious predecessor, Leni Riefenstahl's *Olympiad* (1938), *Olympia 52* does not depict the competitors as heroic machines who simply perform without apparent effort, but as people who also read, relax and interact with each other. The Czech long-distance runner Emile Zatopek is singled out as the hero of the 1952 Games – his victories in the 10,000 metres and the marathon bracket the coverage of the actual event – but he is also shown off the track in the company of his wife.

This ideal human community of the Games in *Olympia 52* emerges through a dialectical perspective, which also reveals the darker sides of Olympic history and a concern for overlooked and repressed aspects of the past. A concise montage of still photographs and film extracts summarizes the evolution of the modern Olympics and their complex implication in the political history of the twentieth century. The sinister portent of the swastika flying over the Berlin Olympic Stadium in 1936 may be an obvious inclusion, but the film also unexpectedly shows brief footage of a forgotten former Olympic champion now living in poverty. Interviewed by Simone Dubreuilh in 1957, Marker recalled that he had had problems including this sequence, perhaps (although he does not say so) because it conflicted too sharply with the affirmative Olympic ideals of youth, success and moral exaltation that Peuple et Culture espoused.[56] In the footage of the competitions *Olympia 52* balances glory against loss, with montage sequences that show a group of successful clearances in events like the high jump, pole vault and showjumping, followed by a clutch of failures. The effect is not cheap humour at the expense of the competitors who bring down the fences or bars, but a respect for the fallibility of human endeavour, and a recognition of failure and success as equal parts of the Olympic experience. In a women's hurdle final, the film singles out not the victor, but an athlete who pulls out of the race. The commentary informs us that she is likely to retire after these Games, and there is a moment of melancholy compassion for the ex-champion whose career is now over.

The largely competent but undistinguished coverage of the competing athletes in *Olympia 52* is considerably enlivened by its treatment of the

audience. The film favours frequent and adroit cutaway shots that home in on particular spectators, rather than panoramas that depict the stadium audience as an undifferentiated mass. Close-ups individualize the audience by depicting a rich variety of responses to the Games – tension, excitement, euphoria, boredom – and create a sense of personal experience and partic-ipation that makes the spectators as integral to the meaning of the Olympics as the competitors. They also reveal a palpable fascination with individual human behaviour, the habits of looking and spectatorship in particular, that would recur time and again across Marker's photographs, films and videos. The attention and curiosity devoted to the Olympic spec-tators is one instance of what the critic Georges Guy saw as the individual presence of Chris Marker sporadically breaking through the otherwise rigid mask of amateur reportage of *Olympia 52*.[57]

Begun two years before *Olympia 52* but completed the year after, *Les Statues meurent aussi*, co-directed by Marker and his friend Alain Resnais, stands at the beginning of Marker's public career as a filmmaker, although for many years its significance would rest on the notoriety of the total ban imposed upon it by French government censorship. Marker was originally commissioned to make a film about African art by the organization Présence Africaine. He had already demonstrated a sympathetic and informed interest in African and Afro-American culture, through his collaboration on a radio programme in 1949 that surveyed contemporary black poetry and its cultural roots.[58] Marker invited Resnais, who was already known for his inventive documentaries on art, to collaborate on the project. Resnais is credited as editor, Marker wrote the commentary, and as co-directors they worked closely together on the scenario and overall shape of the film. Their

approach led them beyond the aesthetic limits of their brief, to question the appro-priateness of Western notions of art for understand-ing their subject, and to con-front the negative impact of colonialism upon African art and the traditional ways of

life that had sustained it. Although Resnais would later play down the idea that the film was deliberately anti-colonial, Marker's commentary was unmistakably sceptical about France's cherished *mission civilisatrice* towards its colonial subjects.

> We are the Martians of Africa. We arrive from our planet with our ways of seeing, our white magic, our machines. We will cure the black of his illnesses, that is certain; and he will catch ours, that is certain too. Whether he loses or gains from the change, his art will not survive.[59]

Both directors clearly conceived *Les Statues* as a film with an opinion: the equal of a literary pamphlet or essay that would have been honourably accepted as a work of literature, but, by daring to exist as a film (medium of mass entertainment and persuasion), brought down the wrath of government censorship. When in 1953 the film was submitted to the censorship commission of the Centre Nationale de la Cinématographie (CNC), it was banned outright, with no indication of what should be cut or altered, the authorities inscrutably claiming that they did not wish to take the place of the directors. Marker and Resnais laboured for several months over a new version, but this too was refused a visa. In 1957 a truncated version of the film, missing the last reel, was authorized, but Marker and Resnais would not permit it to be distributed. In 1960 the producers Présence Africaine and Tadié Cinéma decided to ignore their objections, and the shortened version went on release until the complete film finally received a visa in 1965.[60]

A magisterial example of the film essay, *Les Statues* shapes powerful arguments about its subject through the distinctive sensibilities and styles of its two directors. The film offers prescient insights into the damaging cultural impact of colonialism and the consequences of imposing a white imperial gaze upon African art and culture. Marker and Resnais explicitly challenge the white colonizers' appropriation of African art as a diverting novelty, by insisting that African artefacts do not exist solely for the entertainment of white viewers, and will have an entirely different meaning for people of African origin. 'Where we see the picturesque, a member of the black community sees the face of a culture.' The contention that statues die

 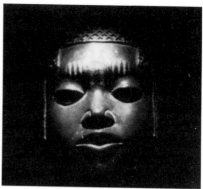

once they are entombed in museums, no longer looked at as part of a living culture, is imaginatively reversed as an African statue in a display case meets the gaze of a black woman museum visitor. Through the animating force of her look, the film magically resurrects African art, using a fluid repertoire of zooms, pans and sharp cuts to show objects liberated from their display case coffins and infused with life and movement. This sequence is clearly indebted to the techniques that Resnais had developed in his earlier art documentaries. His award-winning film of 1948, *Van Gogh*, used the Dutch artist's paintings as material to narrate the story of his life, employing montage to link different paintings together, and fades, zooms and steady pans to lend the static objects a dynamic narrative force. The method proved so successful that Resnais would use it again for *Gauguin* (1950) and *Guernica* (1950–51). In *Les Statues*, this lucid editing style goes on to relay the vision expressed in the commentary of the organic integration of African art with everyday life, as it rediscovers boundless affinities between the forms of woodwork, tree bark, woven cloth, pottery and the textures of earth and black skin.

The vision of the seamless unity of African art and ordinary life in *Les Statues*, the idea that the fabric of God's creation is naturally imitated and augmented by human beings, invokes that state of natural and ordinary grace that Marker admired in the works of Giraudoux. 'The most humble activity works towards the unity of a world where all is good, where man affirms his dominion over things by imprinting them with his mark, and

sometimes his face.' *Les Statues* mourns the loss of this everyday Eden through the Fall imposed by colonialism, but it also imaginatively resurrects it, by using the techniques of film to bring sculptures back from the dead, and rediscovering the glories of African art by simply looking elsewhere for them. In a cosmology where art and life are one, it makes sense to rediscover African art in the movements of a black athlete or the rhythms of a jazz drummer. In his essay 'Du Jazz considéré comme une prophétie' for *Esprit*, Marker had already lent his support to the argument that the origins of jazz lay in the polyphonic sophistication of African ritual drumming, against critics who claimed it as a white musical form.[61] This essay anticipates a tactic employed in *Les Statues*, and which would crop up consistently in Marker's later films, of reconciling its audience to unfamiliar cultures by comparing them to what they already know. African drums create baroque fugues, and African sculptures echo the arts of ancient Greece, Japan, Roman Christianity and modern Europe.

Les Statues argues that colonialism murders African art by severing its roots in traditional ways of life, consigning it to the graveyard of Western museums and degrading its forms into mass-produced tourist kitsch that no longer expresses a cultural purpose – a prayer, as the commentary puts it – for the people who make it. The film suggests that the Western reverence for art as a sphere separate from everyday life is a reflex designed to conceal the fact and the consequences of this death. *Les Statues* is particularly fascinated by what it sees as a different way of accommodating death in African cultures: the habit of keeping death close at hand in order to profit from its wisdom and power, and making of death a mask to be worn, so that its very visibility will keep annihilation at bay. 'It is [death] that is fixed in its legendary transformations, to pacify it, and in order to make these victorious faces which repair the fabric of the world.' Here again, a theme is established that will resonate and recur throughout Marker's subsequent work: the need to come to terms with the presence of death in life, and a consuming interest in those cultures that have managed to do this more successfully than the West.

When in 1961 Marker published the commentary of *Les Statues meurent aussi* in the first volume of *Commentaires*, the film still languished unseen in its entirety. Clearly anticipating the imminent capitulation of the censors,

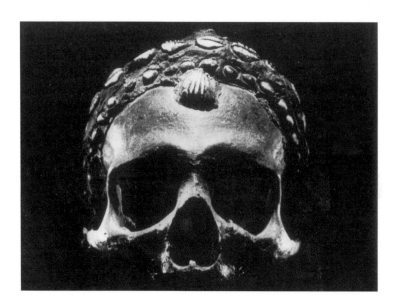

Marker commented dryly in his introduction to the film that if it took ten years between the completion of *Les Statues* and the lifting of the ban, that would at least measure precisely the extent to which the official powers lagged behind reality.[62] In the event, it would take until 1965 for the ban on *Les Statues* to be removed unconditionally, and a further three years before it secured a public release in a Paris cinema. By this time, the worldview that outlawed the film had been outstripped by the break-up of France's colonial empire in West Africa, and the eventual resolution of the protracted Algerian War. In the charged political climate of 1968, the polemical argument made in *Les Statues meurent aussi* about the detrimental effects of colonialism found resonant echoes in contemporary struggles against Western imperialism and its legacy. One reviewer even saw the film's lyrical observation of black athletes find its apotheosis in the Black Power salute given by the American 200-metre medallists Tommie Smith and John Carlos at the Mexico Olympics of 1968.[63] Marker may have noted the distance between the mentality of the censors and the political realities suggested in the film; but when it was finally released, viewers of *Les Statues meurent aussi* were even better placed to measure how far reality had come to fulfil its prophecies.

2.
Travels in a Small Planet

One of Chris Marker's short reflections in *Esprit* of June 1947 is entitled 'Pôles'.[1] It imagines a map of the world with the North Pole at its centre: an icy crossroads where, aptly enough, the geographical distance between the two great superpowers of the Cold War would appear relatively small. Marker does not mention it, but it is likely that he had somewhere in mind the symbol of the fledgling United Nations organization, which had been adopted at the end of 1946. His article cannily points up the unconscious political underpinnings of a logo designed primarily to suggest global unity, equality and peace, with its foreshortened continents appearing to reach towards each other, and no inhabited territory visually dominating the design.

Along with its quietly satirical insight into the contemporary geopolitical order, 'Pôles' invites its reader to consider the world from a perspective different to that usually represented in French maps and atlases, to consign Europe to the edge and give centre stage to countries such as Greenland or Siberia. This desire to see and show the world from unexpected angles would become the defining impulse of Chris Marker's activities through the 1950s and the first years of the 1960s, as he began to establish a reputation as an inveterate globetrotter with a sequence of works based on journeys to countries and regions in transition. The films *Dimanche à Pékin* (1956, *Sunday in Peking*), *Letter from Siberia*, *Description d'un combat* (1960, *Description of a Struggle*) and *Cuba si* arose from visits to China, Siberia, Israel and Cuba, while a trip to North Korea resulted in the photo-text album entitled *Coréennes*, presented by Marker as a short film in a different medium. Travels in the United States inspired a commentary that was

adapted for François Reichenbach's film of 1960 *L'Amérique insolite*, but which Marker chose to publish in its original form in 1961 as an imaginary film, *L'Amérique rêve* ('America Dreams'), in his collected *Commentaires*. Sown across these journeys and extensive travels elsewhere are photographs. Some appeared at the time, in publications or as passages in the films, but only later would these photographs become the object of extended presentation and reflection, in the photo-film of 1966, *Si j'avais quatre dromadaires* (*If I Had Four Camels*), in the *Photo Browse* section of *Zapping Zone* (1990), and in the CD-ROM *Immemory*.

Marker's early travelogues typically fuse an engagingly personal response to the places visited with astute insights into the political forces and attitudes that have shaped their identity, and might also determine their destiny in the world. Disdaining the fanfare of clichés and national stereotypes, Marker seeks out the fugitive signs, embedded in the texture and habits of everyday life, that reveal how nations and cultures organize and express themselves, how they engage with the memory of their past and imagine their contributions to the future. He heralds the impending era of the global village already embodied in the UN logo by approaching distant and mysterious lands as familiar places that the viewer-reader is invited to imagine as home. Yet as 'Pôles' demonstrates, this impulse to domesticate the exotic, in the interests of greater understanding among the peoples of the world, is tempered by a keen awareness of the political and ideological faultlines that channel how it is received and understood.

While the 1950s saw Marker emerge decisively as a filmmaker and photographer, he remained involved in other spheres of activity. In an appropriate parallel to his global adventures, Marker founded, and from 1954 until 1958 was series editor for, the Petite Planète country guides imprint published by Editions du Seuil. His position at Seuil and talent as a layout designer also led him to work on a co-produced volume about Federico Fellini's *La Strada* in 1955,[2] and his own *Coréennes*. Marker personally secured the publication by Seuil of William Klein's raw, Dada-inspired photographs of New York, after they had been turned down by numerous American publishers. His association with Klein would lead to several future collaborations, including Klein's cameo appearance (along with his wife Janine), among the 'men of the future' in *La Jetée*.

William Klein in
La Jetée.

William Klein was part of a network of friends and creative associates whose importance to Marker is evident throughout his work, but which first attracted comment in the early 1960s. The flourishing of French documentary during the 1950s offered numerous opportunities for contact and collaboration with other filmmakers, so in addition to his own films, Marker began to write commentaries for other directors. Marker and his closest friends, namely Alain Resnais, Agnès Varda, the playwright and filmmaker Armand Gatti and Henri Colpi – who edited Resnais' *Hiroshima mon amour* (1959) and *Last Year at Marienbad* – were further singled out as a significant force in French cinema by a number of critics who were essentially trying to gain some purchase on the creative tumult of the French New Wave. In an article of 1962–3 in *Sight and Sound*, Richard Roud dubbed Marker, Resnais and Varda the 'Left Bank Group', in contrast to the 'Right Bank' allegiance of the young critics-turned-directors associated with *Cahiers du cinéma*.[3] Georges Sadoul gathered Resnais, Varda, Gatti and Colpi together for a round table interview (Marker naturally refused to take part), while Raymond Bellour produced a significant article on their circle.[4] Apart from a mutual love of cats, these individuals were identified with a shared background in the bohemian artistic and literary culture of the Left Bank, a commitment to experiment and innovation in cinematic and theatrical forms, and a desire to keep their work in touch with contemporary social and political realities. United by friendship and common sensibility rather

than forming an official movement, they helped out on each others' projects and slipped friendly allusions to each other into their works. A photo of the Varda hairdressing salon features in *Description of a Struggle*; while in *Toute la mémoire du monde* ('All the World's Memory'), Alain Resnais' documentary of 1956 about the French Bibliothèque Nationale, Gatti and Varda feature as extras and Marker surfaces in the proxy guise of a book.

As a cultured and ever-curious traveller setting out from France in the decades after the Second World War, Chris Marker inherited the mantle of a long line of European literary voyagers from Marco Polo to Henri Michaux, whose travel memoirs build up a picture of other lands and cultures through a vivid accumulation of personal impressions and random details of everyday life and customs. The 'Travel' zone of *Immemory* fondly acknowledges the influence of the lesser-known Comte de Beauvoir's *Voyage autour du monde* (1869), the adventure stories of Jules Verne and Christophe's *La Famille Fenouillard* (1889) on Marker's own

desire to see the world, and confesses that the impetus behind many of his journeys was to verify the descriptions of faraway places given in these childhood books.[5]

In *Coréennes*, Chris Marker observes that there are different ways of travelling: 'the Barnabooth way, the Ghengis Khan way and the Plume way'.[6] In other words, those of the gentleman traveller, the conqueror and the one who humbly accepts the random upheavals of the journey. Marker writes that his own preferred method is to submit, Plume-like, to the haphazard events that befall him: 'to accept in their disorder the rhythms, waves, shocks, all the buffers of memory, its meteors and its dragnets'.[7] This approach is reflected in the aleatory character of Marker's travelogues, which flit spontaneously from one fact or observation to another, without attempting an

orderly narrative account of the place being visited. The intensely personal quality of Marker's response to other countries brings out the subjective, imaginative dimensions of travel, captured in the Romantic poet Gérard de Nerval's famous maxim that the purpose of travel is 'to verify one's dreams'. The consequence of accepting the random shocks of the journey then becomes a perpetual disorientation of the self in the face of difference. Rather than fearing this difference, Marker's reaction is that of the 'exote' described by the French travel writer Victor Ségalen: 'the lively and curious response to the shock of a strong individuality encountering an objective world, and perceiving and savouring its distance'.[8] The distinctive, disembodied 'I' who speaks or is implied in Marker's travel commentaries measures this distance by tracing his own displacement in the effort to show and enter imaginatively into the living worlds of other nations and cultures, reversing expectations by perceiving strangeness as familiarity and depicting the routine habits of his own culture as bizarre and outlandish rites.

A potent sense of the prospective disorientation of world travel informs Marker's announcement of the Petite Planète series, which appeared in the Editions du Seuil house magazine *27 Rue Jacob*. He pinpoints a growing sense that the post-war world has come within reach as never before, but that as a subjective experience this prospect of increased access seems confusing and elusive: 'we see the world escape us at the same time as we become more aware of our links with it'.[9] To combat this disorientation, Seuil is launching a series of books that, to adapt one of Marker's metaphors, are intended to be user manuals for life on a small planet. He proposes that each volume is 'not a guidebook, not a history, not a propaganda brochure, not a traveller's impressions', but is intended to be like a conversation with an intelligent and cultivated person who is well-informed about the country in question.

Beginning with books on Austria and Sweden, by the time that Marker's name ceased to appear as series editor in 1958, the Petite Planète imprint had run to nineteen volumes.[10] Apart from the ambition to provide something different from run-of-the-mill guidebooks, histories or travellers' tales, the most innovative aspect of the Petite Planète guides was their lavish use of illustrations, which were displayed not merely as support to the text but in dynamic layouts that established an unprecedented visual

and cognitive relay between text and images. Marker himself provided photographs for two of the volumes – *Chine* by Armand Gatti (no. 12, 1956) and *URSS* by Jean Marabini (no. 23, 1959) – but it was his distinctive approach to layout design that set apart the series as a whole. The illustrations for the books are drawn from a wealth of sources – photographs, engravings, miniatures, popular graphic illustrations, picture postcards, maps, cartoons, postage stamps, posters and advertisements – all blended into a heady and heterogeneous mix of high cultural and mass-market sources. They are varied in size, shape and position on the page, placed to counterpoint and set off the blocks of text in a manner that engages knowingly and playfully with the parameters of the book. Marker also brought the principles of cinematic montage to the Petite Planète layouts, creating image sequences based on formal affinities that imply movement and the progressive accumulation of meaning, or isolating details that correspond to close-ups in film. *Chine* even contains two extended photo spreads titled as short films, one depicting the 1 October parade and the other images of the Chinese Revolution.

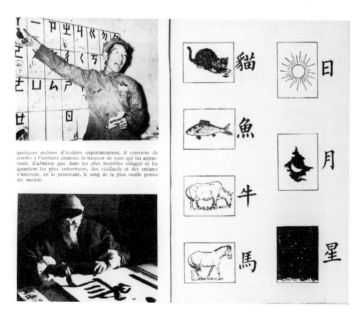

From Armand Gatti, *Chine* (1956).

As the first album in the Petite Planète collection, in 1956 Marker published William Klein's first photography book *Life is Good & Good for You in New York: Trance Witness Revels*.[11] Klein was then a young American artist, who had returned to New York in 1954 after spending eight years in Paris studying with Fernand Léger and working as an abstract painter. Deciding to make a photographic record of his impressions of New York, and waywardly inspired to create an absurdist Dada ethnography of the raucous and teeming life of the city, Klein made a virtue of his complete lack of photographic training by cultivating a gleefully raw visual style marked by extreme light contrast, haphazard framing, blurred and thick-grained images and messy, confrontational compositions. His proposed book was rejected by several American publishers, but when he contacted Seuil in Paris (having admired the Petite Planète books), Chris Marker took up the cause of the young photographer and apparently threatened to resign from Seuil if they refused to publish the book. Klein recalled visiting Marker in his office at Seuil to discuss the project and finding himself in *Star Wars* years before its time. 'There were spaceships hanging everywhere from threads, he wore futurist pistols in his belt. And he looked like a Martian.'[12] The layout of *Life is Good & Good for You in New York* was designed by Klein himself, with a bold and perverse originality that paralleled the witty inventiveness of Marker's Petite Planète graphics. Droll captions for the photographs are contained in a mock publicity brochure illustrated with found advertising images. The album itself displays Klein's photographs in stark, offbeat, asymmetrical arrangements. Large blow-ups are set next to tiny insert images surrounded by a solid black or white border, and several double page spreads are laid out in chequerboard, contact-sheet and 'family-album' fashion. Klein's fascination with the brash urban culture of New York and the visual assault of its signs, publicity hoardings and shopfront displays also inspired him to make a short film entitled *Broadway by Light* (1957): a jazz-scored response to the neon delirium of billboards, cinema fronts and advertising logos in nocturnal New York. Marker contributed a short introductory text for the film that salutes Broadway as America's ultimate product and as the nation's consolation for the darkness of night.

In December 1953 a group of 43 French short filmmakers put their signatures to the misnamed 'Déclaration du Groupe des Trente' ('Declaration of

William Klein's *Broadway by Light* (1957).

the Group of Thirty').[13] The immediate purpose of the declaration was to protest the threat to French short filmmaking posed by the planned restoration of two-feature cinema programmes. During the war the Vichy government had abolished the two-feature programme and required cinema owners to screen accompanying shorts, with a view to encouraging the production of documentaries that would promote Vichy's own ideological vision of French national identity. In the event, these support structures fostered a culture of short filmmaking that maintained a distance from the political ambitions of Vichy, and survived and expanded after the Liberation. During the late 1940s and early 1950s shorts came to be celebrated as an aesthetic form in their own right, but they also provided a vital avenue for young directors to gain experience and realize their ideas, at a time when the French feature film industry was virtually closed to newcomers. The Declaration of the Group of Thirty may have been conceived as a defensive move, but by setting down on paper the perceived strengths of French short filmmaking, its 'style, quality and ambitious subject matter',[14] its authors effectively created the manifesto for what would turn out to be a flourishing decade for short film production in France, significantly assisted by the introduction from 1955 of a new system of grant aid for short films. This subsidy system, combined with the intervention of sympathetic producers like Anatole Dauman and Pierre Braunberger, who were willing to invest in shorts, created the context in which Chris Marker and his contemporaries were able to establish themselves as filmmakers outside the constraints of the feature industry. Dauman's company Argos Films, founded in 1949, would establish a long-standing relationship with Marker, producing or co-producing *Sunday in Peking*, *Letter from Siberia*, *La Jetée*, *Sunless* and *Level Five* (1996); while Braunberger's Les Films de la Pléiade would back *Cuba si*.[15]

French short filmmaking embraced a range of idioms including fiction, animation and publicity, but historically it had developed a particularly

close association with personal documentary. Idiosyncratic documentaries such as Jean Vigo's *A Propos de Nice* (1930), which was famously described by its director as 'un point de vue documenté' (a documented point of view), Luis Buñuel's *Las Hurdes* (1932, *Land Without Bread*) and Jean Painlevé's nature study, *L'Hippocampe* (1932, *The Sea Horse*), emerged from the Surrealist-inspired avant-garde film culture of the late 1920s and early 1930s, and were all indebted to Surrealist notions of the everyday world as a repository of bizarre or disturbing images that had the power to undermine the orderly logic of rational thought. The imaginative and poetic example of these films fed into the crop of new documentaries that appeared in France after the Liberation. These included *Aubervilliers* (1945), directed by Eli Lothar, who had been the camera operator on *Land Without Bread*, Alain Resnais' *Van Gogh*, Yannick Bellon's *Goémons* (1948), Nicole Védrès' popular compilation film *Paris 1900* (1948), and George Franju's *Le Sang des bêtes* (*Blood of the Beasts*, 1949) and *Hôtel des Invalides* (1952). Along with the veteran Painlevé, all these directors were among the founding members of the Group of Thirty.

The precedent set by the early Surrealist-inspired documentaries helped to foster a critical climate in France that strongly valued evidence of a director's attitude, sensibility and personal style in his or her approach to real-life subject matter. This is in marked contrast to the principles of social documentary associated with the producer John Grierson, whose influence has cast a long shadow over documentary practice in Britain, Canada and other nations.[16] Even though Grierson produced several films remarkable for their formal inventiveness and use of avant-garde techniques, notably *Song of Ceylon* (Basil Wright, 1934) and *Coalface* (Alberto Cavalcanti, 1935), the most familiar legacy of his theoretical writings is that 'art' should be 'the by-product of a job of work done',[17] in other words that the documentary filmmaker should subordinate his or her aesthetic vision to the demands of the subject matter and the need to make an effective social intervention. In France, documentary flourished within a continuum of short film production, and came to be regarded as at its best a mode of personal reflection on the world, more closely aligned to the authored literary essay than the social or legal document. Even the significant numbers of short documentaries made as commissions for public bodies or private companies, such as

Alain Resnais' *Le Chant du Styrène* (1957, about polystyrene manufacture) and Agnès Varda's *Ô saisons, ô châteaux* (1957, a 'tourist' film about the châteaux of the Loire), became showcases for the director's own perspective – which in the Varda example was markedly caustic – rather than being expected to follow a sponsor's brief slavishly. These creative circumstances fostered a sense that the boundaries between documentary and fiction were fluid, and Resnais, Varda and Franju among others all made successful forays or transitions into directing feature-length fiction films. When Alexandre Astruc (another signatory of the Declaration of the Group of Thirty) put forward his pioneering ideas about the 'caméra-stylo', it is possible that he had in mind the inventive and wide-ranging short documentaries made by his contemporaries, alongside the celebrated fiction films of Jean Renoir and Robert Bresson.

With Agnès Varda, Chris Marker was a later adherent of the Group of Thirty, and became close both personally and in spirit to other members of the group. Along with the collective solidarity it offered, and the subsidies that helped to finance his earliest travel films, the climate of French documentary in the 1950s effectively nurtured Marker's development of an idiosyncratic form of personal documentary making. Marker himself has never cared for the term documentary, because of what he once called the 'trail of sanctimonious boredom'[18] that it leaves behind it, and contemporary observers in France were often quick to dissociate Marker from what they regarded as the self-effacing and self-satisfied conventions of mainstream documentaries, condemned by André Labarthe, for one, as 'crude, stupid and closed in upon themselves'.[19] Yet both these positions refer more to a certain received legacy of Griersonian documentary than to the vibrant tradition of personal documentary making in France, in which direct engagement with the real world did not automatically preclude the adoption of a personal voice and a distinctive, original style.

Marker is named as a member of the Group of Thirty in the opening credits of *Sunday in Peking* – the first film he wrote, shot and directed by himself (Agnès Varda is credited as 'consultant sinologist'). *Sunday in Peking* was co-produced by Argos and Paul Paviot's Pavox Films, who donated the colour film stock. It takes a tour through the different districts of the Chinese capital from morning to afternoon, combining poetic impressions

of the contemporary city with reflections on China's past and future. The life-in-a-day format is reminiscent of the avant-garde 'city symphony' films of the 1920s, such as Walter Ruttman's *Berlin: The Symphony of a Great City* (1927) and particularly Dziga Vertov's *Man with a Movie Camera* (1929): a repeated shot of a Beijing traffic policeman echoes the recurring motif of a traffic signal that punctuates Vertov's film.

Introducing *Sunday in Peking* in *Commentaires*, Marker recounts that it was shot over a fortnight in September (and October) 1955, during a longer official group visit to China proposed by the writer Claude Roy and organized by Les Amitiés Franco-Chinoises ('Franco-Chinese Friendship League').[20] The same journey inspired a special issue of *Esprit* entitled 'La Chine, porte ouverte', featuring articles by other members of the delegation, including Paul Ricœur and Armand Gatti, who offer their impressions and analyses of contemporary Chinese society. The *Esprit* group formed part of a larger wave of sympathetic foreign visitors invited to China on official delegations, to observe at first hand the achievements of Communist rule, the most prominent of whom were Jean-Paul Sartre and Simone de Beauvoir. The editorial for 'La Chine, porte ouverte' justifies the visit in terms of the need to witness and understand China's political development, since it is increasingly becoming the model for national independence movements in South-East Asia, Latin America and Africa. A sense of hopeful optimism about the benefits to the Chinese people of the modernization undertaken under Communism, however, is tempered by disquiet at evidence of religious persecution, pointing to the workings of an oppressive authoritarian state.[21]

Marker was the first to admit that *Sunday in Peking* bore witness to a great ignorance of the elementary laws of photography,[22] and its footage does convey the sense of a beginner gradually finding his feet in the medium and getting to grips with camera movement and composition. Despite the hesitant quality of the images, the film seizes with evident fascination on the ordered displays of gymnastics, martial arts, opera and the 1 October parade that were presented to the visitors, as well as fleeting, impromptu

sightings of Beijing's streets and inhabitants that hint at a desire for exchange and understanding beyond what was officially sanctioned by the arranged tour. By itself this amateurish but sincere visual record would not make the film especially significant; its originality and interest lie rather in the relationship that is established between the image-track and the voice-over commentary. The conversational first-person narration proceeds by associations that do not simply fix meanings to the images that appear, but work at a tangent to them, unfolding familiarity and distance, lyrical observation and conventional stereotypes, as filters through and against which the viewer might grasp something of the reality of modern China.

The China of *Sunday in Peking* begins as a memory: the recollections of the unseen narrator in Paris, who pans a subjective camera across a treasure trove of souvenirs within sight of the Eiffel Tower. He recalls a primordial dream of China derived from an engraving in a childhood

book, which becomes the portal into the journey itself as a close-up of the engraving dissolves into a location shot of the same site: the avenue bordered by carved stone animals that turns out not to lead to the tombs of the Ming emperors. This 'triumphal arch on a false trail' is cited as an example of a Chinese discretion that veers into the stereotype of the inscrutable Orient; yet the refusal of the actual site to conform to the evidence of the book hints at a broader gulf between China's reality and the fantasy projections of the West.

The lively narration proceeds to relay information, impressions and interpretations of the visit to China on the basis of the sights that are encountered. The meaning of these scenes is never fixed or taken for granted, but opened up to a different, unexpected significance, which in turn triggers further imaginative associations that suddenly yield revealing insights into Chinese society. A cyclist wearing a face mask is not a forgetful

surgeon (the obvious meaning we are assumed to read into the shot), but a man protecting himself from dust. This leads to the observation that dust, germs and flies are among the enemies of the Revolution, and that they have been combated with such zeal that there may still be capitalists in China, but there are no more flies.[23] The remark neatly commends the energy put into overcoming problems, while taking ironic note of the obstacles that may have been overlooked in the rush to cleanliness. This hint of light-hearted subversion wholly escaped the selection committee for the Berlin Film Festival of 1957, who refused to screen *Sunday in Peking* unless the comment about the vanquished flies and a number of other remarks deemed to be Communist propaganda were removed.[24]

Alongside these illuminating flights of interpretation, the commentary is laced with vivid poetic metaphors – the early morning fog that makes the city look as though it has just got out of a bath, the light midway between water and silk, gymnasts lean as cats, shops covered with painted characters like giant boxes of tea. Many of these metaphors retain the flavour of orientalist clichés about Eastern exoticism and animal languor, which the commentary is elsewhere at pains to debunk. *Sunday in Peking* cunningly plays off successive myths and representations of China across the different districts of its capital. The bustle of the old Chinese quarter is China according to the movies, where one expects to see Humphrey Bogart in a white suit leaving an opium den. Anyone nostalgic for this picturesque vision is presented with a shot of an elderly woman teetering on bound feet: the

price of a tradition that makes modernization a far more attractive option. Beijing's Forbidden City, with its bronze statues and porcelain roofs, is the China of Jules Verne and Marco Polo, while the modern city under construction is 'the Peking of 2000'. Even the film's short account of China's history, set to a montage of paintings and popular illustrations, is imbued with the aura of myth and legend, and indeed the narratives of the past are shown to find their way directly into the traditional tales performed by the Beijing opera and in puppet shows.

During his tour of the Beijing of the future, the narrator reverses the rapport of France and distant China presented at the beginning of the film. He shows a class of schoolgirls a French picture book, and tells us how delighted they are at the exotic charms of its outlandish script. This impulse to make the familiar appear strange marks an attempt to grasp the distance of China from the inside, to imagine the world as the other sees it. The film also takes the opposite tack to achieve the same purpose, by comparing elements of Chinese life with familiar French equivalents: the Great Wall as a Maginot Line (and just as useless), the 1 October parade as China's Bastille Day. At the close of the film the narrator observes of an idyllic scene at the Summer Palace that 'all of this is far away like China, and at the same time as familiar as the Bois de Boulogne or the banks of the Loing'. These deft reconciliations, which will recur in Marker's later commentaries on other lands, balance the film's insistence on China's difference with an imaginary common ground, which serves the political purpose of arguing that the People's Republic is an integral part of the modern world, and that (to paraphrase the commentary) in future we in the West will have to share history with its citizens, like our daily bread.

If the evident promise of *Sunday in Peking* had been constrained by technical inexperience and the limits of the short film format, Marker's next film, *Letter from Siberia*, was a fully fledged cinematic essay that drew widespread acclaim following its release in 1958. Ranging widely and conversationally over diverse aspects of the region's geography, culture, history, industry and future prospects, *Letter from Siberia* is simultaneously

alert to the question of how to go about representing this distant country, shrouded as it is in a fog of ignorance and prejudice, and regarded by most people as nothing more than a 'frozen Devil's Island'. These dilemmas are addressed explicitly in the commentary and activated by a playful mixing of cinematic idioms, which anticipates the self-conscious juxtaposition of different styles and genres that would become a hallmark of the French New Wave. *Letter from Siberia* contrasts colour with black and white film, and combines still photographs and animation sequences – including a spoof television commercial for reindeer products – with location footage and archive film extracts. The commentary parallels this visual heterogeneity by blending factual reportage and incisive analysis with humour, poetic reverie and musical interludes. Beginning with the line 'I am writing to you from a far country' – adopted from Henri Michaux[25] – it uses the intimate and seductive address of the personal letter to draw the viewer directly into the scene, inviting them to find out more about 'the biggest wasteland in the world' through the lively curiosity and pertinent observations relayed by the writer as he sets out on his voyage of discovery.

Letter from Siberia was made in circumstances similar to those that produced *Sunday in Peking*. The thaw in the Cold War during Nikita Khrushchev's presidency of the Soviet Union, and the process of de-Stalinization officially begun at the 20th Congress of the Soviet Communist Party in 1956, expanded the available opportunities for foreigners broadly sympathetic to the regime to visit the country, in the hope that they would publicly report favourable impressions of life in the USSR. The Association France–URSS and its sibling organization in the Soviet Union covered expenses and took care of complicated practical arrangements for a delegation that consisted of Marker, Armand Gatti, the camera operator Sacha Vierny and André Pierrard, president of the Association France–URSS, in the role of executive producer for the planned film. Gatti is credited in *Letter from Siberia* as responsible for documentation, and would write a book about the region based on the visit, *Sibérie – zéro + l'infini*, illustrated with production stills from the film and photographs that Marker had taken on the journey.[26]

André Pierrard recalled that he quickly found himself in the position of diplomatic negotiator between the ambitions of Marker and Gatti, and the

bafflement and reluctance of their Soviet hosts.[27] In setting their sights on Siberia, the film crew immediately ran counter to the wishes of the Soviets for a film to be made about a more developed and accessible region, which would have given a more positive sense of the nation's achievements. During filming, Marker went out of his way to shoot the sacred larch tree covered with votive offerings that appears near the end of the film, and also the road-levellers who feature in the famous Yakutsk street sequence. In both instances, the organizers tried to dissuade Marker from recording events that they felt were not typical of modern Siberian life, but they did not actively obstruct him. In his own recollection of the trip, Marker pays tribute to their unflagging assistance while noting astringently that he had no interest in playing by the rules of what he calls the 'pre-20th Congress Soviet documentary', in which every image must be positive and – 'like Stalin's wife' – above suspicion.[28]

In his celebrated assessment of *Letter from Siberia*, André Bazin argued that Marker's film departed decisively from the familiar forms of documentary reportage to establish an entirely new form: 'the essay documented by film'.[29] Bazin was one of the first commentators to regard Marker as a pioneer of the essay-film, and the tag was soon picked up by others, including Agnès Varda, who described her friend's films as 'cinematic essays', and even on occasion Marker himself.[30] By adopting the term 'essay', Bazin registered the extent to which he saw Marker retaining a firm grasp on the capacities of the written word, even as he ventured deeper into film. Bazin felt that intelligence, expressed in the commentary, was the primary matter of *Letter from Siberia*, and he famously characterized its innovative structure as 'horizontal' montage, in which meanings and associations develop less from shot to shot than via the lateral relay of commentary to images: 'from the ear to the eye'.

Letter from Siberia unfolds as a collage offering Siberia from different angles and through various modes of cinematic representation, with the object of conveying the complexity of the country and at the same time exposing the role of the film itself in negotiating and composing different versions of Siberian reality. Marker revels in energetic litanies detailing the flora, fauna, human inhabitants, geographical features and principle industries of the region, which often take wry swipes at contemporary political sensibili-

ties. Ducks are resolutely collectivist ('there are no *kulaks* among ducks'), and the domesticated bear Ouchatik is less frightening than the police. The location footage is periodically interrupted by forays into still photography and animation sequences, the latter produced by the Arcady team of Paul Grimault and William Guéry. The history of mammoths is covered in drawn and collaged animations, whose deadpan surreal humour and wilfully archaic source materials are similar to the Monty Python graphics created by Terry Gilliam. A later sequence detailing the history of the Siberian gold rush is illustrated by bordered sepia photographs, animated to pass back and forth like a lantern slide show, which enhance the explicit mythic and nostalgic parallels drawn with the American Wild West.

The generic digressions and shifting perspectives of *Letter from Siberia* converge to frame its subject as a land of paradox, midway between 'the Middle Ages and the 21st century, between the earth and the moon, between humiliation and happiness', as the closing lines of the commentary put it. The film's energy and inventiveness come from a self-conscious dialectical mobilization of these contrasts, which purposely avoids resolving them into a tidy synthesis. At one point the commentary singles out a gift of a shot that encapsulates the opposition of past and future: a heavy lorry passing a horse-drawn cart on the road. The narrator immediately warns us to pay close attention, as we won't be seeing this image again. Marker is alert to how a real scene can lend support to a well-worn documentary cliché, and by ironic overstatement indicates his desire to avoid perpetuating a comfortable image of Siberia as a 'land of contrasts'. The most famous and commented sequence in the film shows brief shots of a Yakutsk town bus passing a Zim luxury car, road-levellers and a squinting passer-by. It is repeated four times, first in silence, then in turn with three separate commentaries – a pro-Soviet eulogy, a darkly anti-Communist critique and an objective report of the narrator's own impressions. Rather than seeking the pre-given 'truth' of Siberia, the sequence neatly demonstrates how truth is a by-product of ideological interpretation and representation. The traveller recognizes that even his own carefully balanced judgement distorts Siberia's reality by fixing it in time and space, whereas what really matters is to show 'diversity and the momentum of change'.

In place of his own objectivity, the traveller proposes an imaginary newsreel, filmed all over the country, as a better guide to the realities of Siberia. Composed of black and white library footage, the newsreel describes the winter landscape from the air, takes note of Siberia's mineral and animal wealth and the story of the nineteenth-century female diamond prospector Larissa Popougaeva, and shows the Yakut people, with their 'artists and surgeons, writers and poets'. The commentary that accompanies these images is rich in mythical and metaphoric associations: the creation of the first Yakut, or the aeroplanes that are used so commonly for transport that they have none of the romantic allure of adventure and are instead like 'women in a world without men'. Marker even confesses to having achieved a modest political coup with the montage, by using a stock shot of an

Example:

Yakutsk, capital of the autonomous Soviet socialistic republic, is a modern city, in which comfortable buses made available to the population share the streets with powerful Zims, the pride of the Soviet automobile industry. In the joyful spirit of socialist emulation, happy Soviet workers, among them this picturesque denizen of the Arctic reaches, apply themselves to making Yakutsk an even better place to live!

Or else:

Yakutsk is a dark city with an evil reputation. The population is crammed into blood coloured buses, while the members of the privileged caste brazenly display the luxury of their Zims, a costly and uncomfortable car at best. Bending to the task like slaves, the miserable Soviet workers, among them this sinister looking Asiatic, apply themselves to the primitive labour of grading with a drag beam.

Or simply:

In Yakutsk, where modern houses are gradually replacing the dark older sections, a bus less crowded than its London or New York equivalent at rush hour passes a Zim, an excellent car reserved for public utilities departments on account of its scarcity. With courage and tenacity under extremely difficult conditions, Soviet workers, among them this Yakut afflicted with an eye disorder, apply themselves to improving the appearance of their city, which could certainly use it.

American forest fire (not having film of a Siberian one to hand), which is then put out by Soviet fire-fighters.[31] This invented newsreel highlights the importance of seeing the imaginative life of Siberia's population as integral to its reality and its place in the modern world. The country ultimately emerges as a land where shamanism happily coexists with the space programme, and the legendary hero Niurgun Bootor can act as tutelary spirit to the socialist future, with his lesson to humankind that 'there is neither fate nor misfortune, but forces to overcome'.

Letter from Siberia was released in France with Mario Ruspoli's *Les Hommes de la baleine* (1956), a study of one of the last surviving whaling communities on the Azores that is built around remarkable observational footage of a traditional sperm-whale hunt using a harpoon. Ruspoli came from an Italian noble family, and his old friend Anatole Dauman joked that he was probably one of the few Ruspoli ever to earn his own living.[32]

After Dauman had taken up the project for Argos Films and the film had been assembled, Marker prepared the commentary, appearing in the credits under the fraternal Italian pseudonym Jacopo Berenzi. His narration combines elegant, concise descriptions of the history and techniques of whaling, with melancholy reflections on both the death of the whales and the demise of whale hunting. Marker's presence emerges clearly in whimsical digressions that wind up in a revealing association of ideas. Reflecting on the extensive use of sperm whale by-products in the cosmetics industry, the commentary remarks that the modern woman puts sperm whale everywhere, so much so that 'the ghost of a sperm whale clings to a pretty woman's day, to bring out her beauty, and by this means, in provoking the ruin of man, takes its revenge on him'.[33] These lines are given a macabre twist by being spoken over gruesome footage showing the processing of a whale's corpse.

The theme of human beings confronting the primal forces of the natural world returned in the commentary that Marker wrote for Raymond Vogel's and Alain Kaminker's *La Mer et les jours* (1958), which depicts the winter lull of a remote fishing community on an island off the coast of Brittany. More muted in its leaps of fancy than *Les Hommes de la baleine*, the text still echoes the preoccupations of Marker's other works, with its delicate handling of the constant presence of death in the community, and the attention paid to family photographs of fishermen lost at sea. These themes took on an explicitly personal dimension during the making of the film, when Kaminker – the brother of Simone Signoret – was drowned while shooting in the waters around the island. Marker went on to furnish the alexandrines for Vogel's *Le Siècle a soif* (1959), a commissioned film about the health benefits of fruit juice.[34]

Although Marker is credited as co-author of Walerian Borowczyk's collage animation of 1959, *Les Astronautes*, about an amateur space traveller and his pet owl Anabase, he was not actually involved in the project, apparently co-signing the film as a favour to the Polish director, who did not have a work permit for France.[35] Borowczyk and his wife Lygia would later appear with the Kleins as *La Jetée*'s 'men of the future'. Also in 1959, Marker's burgeoning reputation as a commentary writer led Paul Paviot, the producer of *Sunday in Peking*, to show him the work copy of his film about the legendary jazz guitarist Django Reinhardt, and try to persuade him to write the commentary for it. Paviot asserts that at the time Marker was systematically refusing to write commentaries for other people, and his reluctance became fury when Paviot asked him to do it for Django's sake (Reinhardt had died in 1953).[36] Yet in the end Marker agreed, returning with the project to his early passion for jazz and the cellar clubs of Saint-Germain-des-Prés. *Django Reinhardt* uses inventive re-enactments and archive materials to trace Reinhardt's life and career from his Roma origins to his place at the pinnacle of French jazz from the 1930s to the 1950s. Marker's commentary (read by Yves Montand) elevates the cult of jazz by giving it a religious cast and classical dignity. 'Until midnight, music is a job, until four o'clock it's a pleasure, and after that it's a rite.' Reinhardt's famous quintet at the Hot Club of France is credited with giving jazz its chamber music, and the man himself is portrayed as 'Walt Disney's moustache under the gaze of Philip II'.

The collaboration between Marker and Alain Resnais also flourished in the second half of the 1950s, initially with Marker's credited assistance on two of Resnais' most significant short documentaries of the period: *Night and Fog* and *Toute la mémoire du monde*, then as the commentary writer for the commissioned short *Le Mystère de l'atélier quinze* (1957). The case of *Night and Fog* exemplifies the way that Marker's modest and self-effacing estimation of his contributions to collaborative projects can conflict with the importance attached to his work by his associates. For this landmark examination of the Holocaust, Marker insisted that all he did was to act as a sounding-board for Resnais as he worked on the film.[37] Resnais offers a different version of events, stressing that Marker was indispensable to the production. It was through his regular visits to Marker's office at Seuil that

Resnais had met the novelist Jean Cayrol, a survivor of Mauthausen concentration camp who would provide the commentary for *Night and Fog* and later the screenplay for Resnais' *Muriel, ou le temps d'un retour* (1963, *Muriel*). According to Resnais, Marker undertook several rewrites of *Night and Fog* in tandem with Cayrol, and played a decisive role in shaping the commentary so that it worked successfully with Resnais' editing. Marker was extremely reluctant to receive any credit for his work on the film, and would only accept being listed as an assistant to the director.[38] For *Toute la mémoire du monde*, a remarkable portrait of France's Bibliothèque Nationale via the journey of a book into its collections and out to the reader, a credit of thanks went to 'Chris and Magic Marker'. The book that is delivered, then painstakingly catalogued, numbered and shelved in the library, is actually a fake volume about the planet Mars from the Petite Planète series. *Le Mystère de l'atélier quinze* was a commission from the social security service about workplace doctors, and Marker stepped in to write the commentary when the original writer, Remo Forlani, fell ill. It sets the quest to find the cause of a factory worker's ill health in the guise of a detective story, narrated by the doctor. At the beginning he pictures the factory yard as a film set, where one expects to see Jean Gabin dressed in workman's clothes and hopes for a glimpse of Michèle Morgan. This play of imagination to bring out the contours of reality emerges again in the doctor's lyrical nightmare fantasy of the factory as 'a jungle, an enemy planet, a theatre of cruelty', in which the machines wait like beasts of prey to pounce on the unsuspecting workers.

In tandem with *Sunday in Peking*, Marker had offered an alternative take on his visit to China in the form of a photographic supplement to the 'Chine, port ouverte' issue of *Esprit*. Entitled 'Clair de Chine' ('China's Light'), the pamphlet is presented as 'a film in the guise of a greeting card', and contains a selection of photographs accompanied by short commentary-captions. The pamphlet revisits images and episodes from *Sunday in Peking*, including the Beijing Opera and the alley by the Ming Tombs, and also contains new material that unfolds further perspectives on the film's themes. The lateral affinities between *Sunday in Peking* and 'Clair de Chine' anticipate a similar relationship between *Sunless* and *Le Dépays* (1982), the latter an album of photographs and written reflections drawn from the same sojourn in Japan as the better-known film. The film and the photo-

text publication are not designed to explain or absorb each other, but as an open-ended relay that invites fresh perspectives on their shared subject matter. Marker's advice to the reader of *Le Dépays* could equally apply to the book's relationship to *Sunless*: 'The text doesn't comment on the images any more than the images illustrate the text. They are two sequences that clearly cross and signal to each other, but which it would be pointlessly exhausting to collate.'[39]

The creation of 'Clair de Chine' was evidence of Marker's emerging philosophy that a film did not necessarily have to take the form of a projection on celluloid. This is the founding principle of *Coréennes*, the first and only publication in Seuil's 'Court métrage' ('Short Film') series. An album of photographs and written reminiscences, *Coréennes* arose from a visit to North Korea that Marker undertook in 1958. The circumstances of his visit are not clearly established, but are possibly connected to a planned film collaboration with Armand Gatti based in North Korea, which Marker eventually withdrew from in order to complete work on *Letter from Siberia*.[40] An early footnote in *Coréennes* alerts the reader to the fact that Marker's Korea is North Korea, but since the book makes abundant reference to many aspects of the nation's culture established well before the partition of 1953, the effect is that the Communist People's Republic comes to stand for Korea as a whole.[41]

In the postscript to the book, written in the form of a letter to 'Cat G',[42] Marker announces that he is not going to deal with the 'Big Problems' of North Korea, but intends to focus on ordinary people. 'At the end of this journey, there is human friendship. The rest is silence.'[43] He is fully aware that such human encounters take place through history, but professes no desire to engage in political sermonizing. *Coréennes* does not shy away entirely from the travails of Korea's distant and recent past, but more deci-

sively it reveals Marker to be thoroughly charmed by North Korea and its inhabitants – the gender of the title and the preponderance of young women and children in the photographs seem more than accidental in this regard. As a consequence, Marker's normally well-honed sense of political irony is muted, and a much softer human portrayal comes to the fore.

The existence of *Coréennes* as a book with several chapters gives the project a more tangible structure than the free-flowing commentaries of the films, although its lyrical passage from personal reverie, to cultural information, to social insight is much the same. Marker's passion for litanies is registered in the seven chapter headings, each a numbered inventory which together mirror the list of 32 spirits and constellations regulating human life that features in chapter Five. Chapter Two, 'The Two Orphans', concerns the legacy of the Korean War and the division of the country in 1953, while chapter Seven, 'The Four Corners', examines labour and leisure: the pursuits of archery, drumming and dancing among the workers and the elite. Throughout the album Korea is presented as a land of civilization, harmony and good sense. The introduction informs us that Korea invented mobile type, produced the first national encyclopedia, and sent the first Buddhist monks to Japan.[44] Korean culture is further credited with an extreme sensibility that is closely identified with women. In a revealing anecdote, the author visits the theatre for a performance of the legend of Sim Chon, and during the interval finds a female friend in floods of tears

over the plight of the characters. Having been provided with a summary of the play to allow him to follow the plot, Marker gently takes the liberty of telling her that everything will turn out all right in the end. She has seen the play 200 times and looks at him with mistrust: 'how could I be so sure of the future? And she stopped crying and began to ponder the hard hearts of foreigners, who exchange their tears for reasons.'[45]

This feminine sensibility returns in a more politically charged context, in an account of a visit to a chemical factory and a discussion with a woman worker.[46] The episode turns on the moment when, having been patiently and cheerfully answering a barrage of questions from the visiting delegation, a chance mention of her parents, who were killed during the Korean War, causes the woman's face to turn suddenly sombre. Through her tears she expresses her hatred of the United States and the renewal of purpose she has experienced as a loyal citizen of the People's Republic of Korea. The episode is framed by two photographs of the woman, taken on either side of the threshold when her expression and the mood of the gathering abruptly changed. The two images imply an instance of time and transition, and could also be interpreted as two faces of modern Korea that *Coréennes* presents for contemplation: the energy and graciousness of its inhabitants, and the violation of the war and the 1953 partition, which take on an aspect of metaphysical tragedy in the declaration that it is the border itself that is the war.[47]

Evolving photographic sequences figure elsewhere in *Coréennes* and are the feature that most clearly justifies treating the book as a film. Building on the layout techniques of the Petite Planète series, the dynamism and clarity of the photographic images dominate the album's rich and bold design. In one striking photo-spread, organized over four pages, nine successive shots of a woman's mobile and eloquent facial expressions and hand gestures are slyly offered by Marker as a contribution to 'the dossier on the Famous Oriental Inscrutability'.[48] Elsewhere a troupe of children strike poses for the visitor's camera, which are reproduced as a column of three shots that

mimic film frame enlargements. The leitmotif of the chapter entitled 'The Three Sisters' is a pairing of two full-page photographs, one showing three mountains of different heights and the other three sisters of different heights. According to legend, if one contemplates the mountains for long enough, they take on the form of three sisters. The implied transition between the two photographs conjures up the cinematic technique of a slow dissolve between two different images – a movement that Marker would literally accomplish for the *Immemory* version of the episode.

The postscript reiterates the human focus that has been evident throughout the book, with a shot of a male worker squarely returning the gaze of the photographer, and the comment 'this face which turns towards me, my real relations are with him'.[49] Seen from this perspective, *Coréennes* is an impassioned testament to Marker's abiding fascination with human encounters, and his desire to push away the constraints of political and racial stereotyping in order to present the people of North Korea as fellow beings. He would return to the basic human questions of the book in a second postscript, written for the *Immemory* version of *Coréennes* in 1997 and posted over a background of newspaper cuttings detailing the catastrophic North Korean famine. In this text Marker affirms his basic solidarity with people who struggle to improve their lot in the world, even if they fail, and clarifies that, along with his contemporary visits to China and the Soviet Union, his interest in North Korea during the 1950s was linked to hopes that Communism would develop alternative models to the tyranny of Stalinism.[50] Yet the fact remains that his studied avoidance of the big problems makes the impact of *Coréennes* very different from that of the

film projects that Marker undertook around the same time. *Sunday in Peking, Letter from Siberia* and *Description of a Struggle* are far less reticent about pointing up the political contradictions of Chinese, Soviet and Israeli society, without in any way sacrificing a compassionate respect for the humanity of their citizens. Marker's unabashed attraction to the people of North Korea is most closely matched by *Cuba si*, with its frank and unaffected enthusiasm for the island and its population. The difference is that, in Cuba's case, the big problems present Marker with fewer ideological dilemmas, and so can be broached head on.

Marker's imaginary film *L'Amérique rêve* started out as the commentary for François Reichenbach's *L'Amérique insolite*, a glossy examination of the offbeat customs and cultural habits of the United States at the turn of the 1950s. In the event, Marker's commentary was substantially adapted for the film, and he is not credited as the writer. The broad outlines of *L'Amérique rêve* and *L'Amérique insolite* are identical, and Reichenbach's film does use many of the observations and neat turns of phrase that appear in Marker's text, but it replaces Marker's erudite intertextual allusions and some of his more archly critical remarks about America with straightforward description and information. In a contemporary interview, Reichenbach hinted that the reason for the changes was a difference in attitude towards the United States between himself and Marker. He registered a certain discomfort with the original script, and accused Marker of psychoanalysing him, by making it seem that that he didn't really like America, whereas in fact he did.[51] When he published the original script in *Commentaires* in 1961, Marker stayed in the game by proposing his own imaginary credits, which list Reichenbach as the cameraman.

L'Amérique rêve puns on the cultural myth of the American Dream by casting America as a land forged entirely in fantasy, a conscientious realization of human desires on a generous scale. The imaginary status of the

film allows Marker to take joyous liberties with the illustrations that parallel the text, and he slides in lurid small ads and comic-strip characters alongside adopted photographs and illustrations, to conjure his own dream of America. The viewpoint of *L'Amérique rêve* is firmly that of the curious yet detached visitor from 'old Europe' who observes and dissects the character and foibles of this bluff young nation without a memory. The vast agricultural lands 'give wheat like you offer your hand';[52] majorettes and marching bands are a walking advertisement for America; and the living human exhibits in the Ghost Town museum already look like comic characters: all they need is Walt Disney's signature. Although Marker debunks some of their more exaggerated implications, he does take seriously even the most outlandish manifestations of American popular culture, seeing them as expressions of the same human drives and desires that forged the revered artistic traditions of Europe. As the film progresses, *L'Amérique rêve* unveils the tensions and conflicts that exist within American culture, fixing on gambling, the Mardi Gras carnival, juvenile delinquency, hot-rod racing and a restless desire for movement as scattered symptoms that puncture the illusions of the American Dream and insist that 'all isn't well, life isn't simple, *Reader's Digest* isn't always right and America is not the land of the blessed.'[53] Utopian aspirations are checked and balanced by death, destruction, inequality and unhappiness: a pattern familiar from Marker's earlier reflections on African art and the Olympic Games, and one that would recur again.

Description of a Struggle originated in an invitation from the film producer Wim van Leer to make what Marker calls in *Commentaires* 'Letter from Tel-Aviv', although the outcome was no simple repeat of the *intimiste* style of travelogue that had brought him success two years previously. Written and directed by Marker and filmed by Ghislain Cloquet, *Description of a Struggle* (which takes its title from an early story by Franz Kafka) examines the identity of the state of Israel by reading it as an accumulation of signs, marks of the multiple conflicts that have carved out its twelve years of existence as a nation. The commentary asserts that signs ask to be deciphered, and *Description of a Struggle* is an extended exegesis that maintains in intricate and lively tension the realities of Israel and its appearance through the eye (and ear) of the camera. The by-now familiar inter-

pretive exchange between the voice-over commentary and the flow of images is enhanced by the incorporation of innovative blocks of actual and invented location sound. Several sequences set still black and white photographs against the mobility of colour film footage, to draw out contrasts of past and present, stasis and dynamism. All these audio-visual elements converge as bearers of the central struggle that the film describes: the dilemma of Israel's identity as a nation. Born out of oppression and injustice, it must struggle with itself as much as its external enemies to uphold the moral principles that justified its creation. Israel has earned the privilege of being free and innocent of its past, the right to material prosperity and to what the commentary calls the vanity, blindness and egotism of nations; but the origins of its existence demand that it conduct itself otherwise.

Writing about Marker's films at the time of *Description of a Struggle*, Raymond Bellour and Jean Michaud contend that the function of true signs is to 'interrogate without lassitude', yet they recognize a moment when the sign and the process of signification are one because they simply point to the existence of something.[54] Such are the signs that begin and end *Description of a Struggle*, forming a bracket to its own process of agile interrogation. The film opens with still shots that confirm the existence of land and water, the presence of man and war – twisted military wreckage in the desert – and finally Marker's infallible sense of humour, as a camel strolls into a shot of the road sign for a bumpy surface. At the close of the film, a young girl absorbed in drawing at an easel becomes a sign of Israel itself (she looks about twelve or thirteen, the same age as her homeland). Over the girl's image the commentary reiterates the burdens of statehood that weigh on Israel, but it insists first of all that we simply look at her, at 'this little Jewish girl who will never be Anne Frank', and through her at the state that makes her existence and her innocence possible. We must look at the girl until we lose our sense of what she means, like a word repeated over and over again, and then recognize that the most incomprehensible thing is that she is there, a sign of the miracle of Israel's creation.

The use made of the girl's image implies that signs are everywhere, in the most commonplace aspects of daily life, but to understand them we need both an interpretation and a moment of defamiliarization. *Description of a*

Struggle provides both in the way it puts signs to work, defining their purpose as communication and defining communication as the business of establishing 'an order, a relationship between things that are hostile and incomprehensible.' This idea is propounded in a bravura sequence that brings together an oscilloscope in the Weizmann Institute and two owls from the Biblical Zoo in Jerusalem, as the starting point for a dynamic exploration of the relationship between scientific progress and religious tradition in modern Israel. The owls register as a sign that speaks particularly to and of Chris Marker (along with the troupe of cats fed by the Hungarian Mr Klein and the nod to Agnès Varda in the shot of the hairdressing salon that bears her name), confirming his presence in the film while in the same moment offering an insight into Israel. For if the existence of Israel is conceived as an incomprehensible miracle, then this surrealist conjunction of unlikely and unexpected elements becomes the logical key to grasping the tensions and conflicts of its history and character as a nation. The mechanics of the film participate actively in this chance invention of Israel's reality. A jump cut in a street scene causes a pregnant woman to appear and herald rapid population growth; while at the end of a travelling shot a city appears miraculously over the brow of a hill as the fulfilment of the Promised Land.

An Arab boy filmed roller-skating down the slopes of Mount Carmel with an empty delivery trolley is given a soundtrack of cheering crowds, to actualize the commentary's observation that perhaps a new Olympic sport will emerge out of this everyday struggle to make a living.

Description of a Struggle figures the concrete paradoxes and conflicts of Israel's existence with a neat economy of associations. In *Letter from Siberia*, Marker had spun away from the shores of the River Lena at daybreak to create a snapshot of the world at that given moment in time, in a passage beginning 'It's seven in the morning in Irkutsk – three o'clock in Baghdad – six in the evening in Mexico – midnight in Paris', which recalls in its turn the global community linked by the radio broadcast in *Le Cœur net*. He repeats the motif in *Description of a Struggle*, but confines his attention to the four corners of Israel, as if this one nation could satisfy his desire to reconcile the complexity and diversity of the world into a single passage of film. The pioneering ideals of the young Israeli state are embodied in the collective life of the *kibbutzim*, but they are a declining minority whom the commentary suggests function more as the good conscience of the majority of Israeli citizens, who have made a happy accommodation with capitalism. The *kibbutzim* are offered as a reverse mirror image of the Arab minority, whose status as second-class citizens is conveyed through the life of a young Arab girl caring for her family in the slums of Nazareth. Her passion for dancing links to the film's core metaphor for Israel's existence, dancing on a volcano, and gives her a symbolic stake in the nation's identity that in

social terms she is denied. High-school girls gossip about their dancing teacher the day after a serious border skirmish has resulted in several deaths. A scene showing a group of children playing in a swimming pool is posed as another inexplicable miracle for the older generation who remember the wartime ghettos. Yet the ghetto continues to exist close by as Mea Sharim, the orthodox quarter of Jerusalem. It is depicted in a suite of black and white photographs that have all the melancholy of time immobilized, suggesting an archaic adherence to fixed beliefs and the extent to which orthodox Jews inhabit a different world from (and at odds with) the modern Israeli state.

Description of a Struggle tunnels into the complex strata of Israel's history, invoking the need for an x-ray vision that can penetrate and decipher the physical and historical landscape, and which the commentary itself provides as it tells how the fertile fields we see being sprayed by a crop-duster were once malaria-ridden marshes. The same impulse operates in

the penultimate sequence of the film, where newsreel footage dating from 1947 and taken from Meyer Levin's film *Les Illegaux*, showing a ship crowded with Jewish refugees trying to reach Israel, dredges up the traumatic origins of the nation's existence in the Holocaust, and pitches them as a shadow on the faces of modern Israeli citizens, as they peacefully eat ice cream or emulate Elvis Presley.

Where *Description of a Struggle* offered a detached assessment of the state of Israel a full twelve years after its creation, for his next film Marker plunged into the midst of a country still in the early throes of revolutionary change. Its title, *Cuba si*, is a straightforward and principled affirmation of this process, hinting at the shift from the stance of sympathetic yet critical distance observable in *Description of a Struggle*, to one of wholehearted political support. Filmed in Cuba in January 1961, just two years after guerrilla forces led by Fidel Castro had succeeded in overthrowing the dictatorship of Juan Battista and establishing a Communist government, the ambition of the film was nothing less than to seize history in the making. *Cuba si* was deliberately pitched to counter the negative reporting of Cuba's new leadership in the French press, by emphasizing the benefits of Castro's programme of national reforms. For this it was banned outright by French censors, no doubt nervous about the potential impact of the film's overt support for national self-determination on the progress of the Algerian War (a conflict that was itself the object of stringent media censorship). The Minister of Information, Louis Terrenoire, sent Marker a letter informing him that *Cuba si* could not be given a visa because it was ideological propaganda for the Castro regime (hence not a documentary), and posed a direct threat to public order in France.[55] The film became a *cause célèbre* for those opposed to the patently political tenor of film censorship in France during the early 1960s, and it was shown at several privately arranged screenings. When *Cuba si* was finally released uncut in September 1963, a number of commentators acidly remarked that, not only was the perceived threat of the Cuban Revolution now safely neutralized by the passage of time, but the Algerian War was over.[56]

Marker wrote that *Cuba si* set out to convey 'the shudder, the rhythm of a revolution',[57] and like his earlier films it employs a varied repertoire of techniques and source materials to put over the sense of a nation in the

midst of momentous change. Live footage shot by Marker during his visit in 1961, combined with swift, sharp photographic montages, episodes of collage animation by the Arcady team, and archive film passages (drawn from the archives of the Cuban National Film Institute), which fill out the historical background to the revolution of 1959 and the country's present state of development. Marker also drew on newsreels sent from Cuba to compose the final sequence of *Cuba si*, covering the Bay of Pigs invasion in April 1961, which happened after he had returned to France. Cut to the powerful rhythms of Cuban music, and interspersed with snippets from popular revolutionary songs, the assemblage is streamlined by a keen sense of political urgency and demonstration. This immediacy and argument are enhanced for the first time in Marker's work by the inclusion of direct interviews, with Fidel Castro and Joris Bialin, a Cuban priest who backed the revolution against the official policy of the Church.

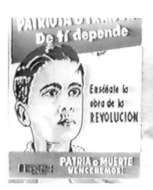

As in his previous travelogues, Marker seeks out the essential qualities of Cuba and its political

will in the inconsequential details of everyday life. Below the Americanized surface appearances of Havana he discovers 'a Cuban way of controlling traffic . . . of being curious, of being coquettish, of being patriotic . . . of peeling oranges . . . of drinking water, or nationalized Coca Cola'. The viewer's sense of the 'Cuban-ness' of these various filmed actions clearly comes from the interaction of the commentary with the images, the random scenes of daily life marshalled to demonstrate Marker's enthusiastic wonder at witnessing a people on the cusp of a new political era. There is also 'a Cuban way of looking into the camera lens'. *Cuba si* is peppered with shots of people looking, waving and smiling at the camera, privileged moments of spontaneous observation and reaction that create a sense of candid, equal rapport between the filmmaker and his subjects. At the same time Marker is not above intervening in the street life of Havana to enhance his representation of contemporary Cuban reality. At the time of Marker's visit, the country was on high alert and Castro had ordered the mobilization of the army, fearing an imminent attack from the United States. Standing at a crossroads to film a children's parade, the film crew had apparently captured (and relayed without commentary) a spontaneous outburst of conga music that suddenly brightened up the sombre crowd. Marker wrote in the

commentary that this chance had given them a key to understanding Cuba, but it was in fact an 'invented chance':[58] the scene was pre-arranged with the best conga player in the country. 'That was Havana in 1961: machine guns on the roofs and conga in the streets.'

Other passages in the film centre around Marker's characteristic leaps of lateral association, where mundane events and customs are transformed into revealing indicators of Cuban political life. The film opens with the threefold celebrations at the beginning of January: New Year's Day, the anniversary of the Revolution on 2 January, and Kings' Day, which is Cuba's Christmas celebration. The Three Wise Men appear in Cuban department stores like Father Christmas, to take orders from children for the presents they want, and the commentary announces that 'a big bearded man, of whom you can ask anything, is part of folklore in Cuba'. The analogy roots Fidel Castro's approachable style of populist government (which Marker greatly admired)[59] in the folk culture of the nation. A later comparison enhances this effect: Castro is a Robin Hood who has read Marx.

The interviews with Joris Bialan and Fidel Castro in *Cuba si* complement Marker's own impressions of the country by giving prominent Cubans the opportunity to speak directly and put forward their own case for the revo-

lution. A sense of contrast between received ideas and the power of direct speech is established in the suite of fixed images of Castro (and an associated head from a Greek vase) that precede his interview, accompanied by the remark 'everyone has his own opinion of Castro; everyone covers him with labels and explanations'. The Castro material was given to Marker by Etienne Lalou and Igor Barrère, who had shot the interview for a French television programme (which was screened without protest, even though the interview with Castro was cited as one of the reasons for refusing *Cuba si* a visa[60]). Castro discusses his political formation, his decision to take power in Cuba, and the reasons why elections are not held. The film captures the president's eloquent and persuasive style of public speech, but also a moment of hesitation – we hear Castro trip up on the word 'institutionalized', although he refuses to let it defeat him. These faltering words, recorded as they were spoken, signal the emergence of a new aesthetic within Marker's films, one that would dominate his next project, *Le Joli mai*, and thereafter become the constant dialectical companion of his own commentaries: the spontaneous encounter of the direct cinema interview.

3.
A Moment in Time

Alain Resnais recalls that at the beginning of the 1950s Chris Marker was awarded a literary prize in Brussels for *Le Cœur net*, and used the money to buy a tape recorder, on which he proceeded to record amusing interviews with everyone he met.[1] The singular voice of the commentary in Marker's earliest essay-films had given little hint of this enthusiasm for dialogue with others, although it had begun to surface in the borrowed interview excerpts of *Cuba si*. In 1962, immersing himself in groundbreaking new developments in camera and sound equipment that allowed human encounters to be filmed with greater ease and spontaneity, Marker brought the interview centre stage in the filming of *Le Joli mai*, a less-than-flattering depiction of French social attitudes at the close of the Algerian War, built up out of extended discussions with inhabitants of Paris. Two years later, *Le Mystère Koumiko* (1965, *The Koumiko Mystery*) saw Marker discovering Japan for the first time, through the mobile and inquisitive eye of his camera, and by way of a searching interview with a young Japanese woman, the Koumiko of the title, whom he met in

Le Joli mai (1962).

Tokyo during the Olympic Games of 1964. From this point on, interviews would become a regular feature of Marker's film and video repertoire. They form a logical complement to the subjective command of his voice-over commentaries, by extending their lucid and engaged focus to embrace the ways in which other people choose to express themselves.

Also in 1962 Marker completed *La Jetée*, a 29-minute film that announced further radical departures in his work by turning the documentary adventure of *Le Joli mai* inside out, distilling its subterranean fears and anxieties about the future into an elegiac masterpiece of speculative fiction that seems likely to remain his most famous film. The time-travel tale of a man obsessed and finally destroyed by an image from his past, *La Jetée* reinvented the potential of cinema at a stroke, by being made almost entirely from still images. Marker returned to this method of composition in 1966 to make *If I Had Four Camels*, a retrospective reflection on the photographs he had accumulated in a decade of globetrotting. *If I Had Four Camels* is the first in a family of works in Marker's *œuvre* that take stock of the past, drawing a period of history and a phase of creative achievement together by the act of reflexively sorting through a mass of images, to discover those that are resonant enough to constitute memories.

The simultaneous production of *Le Joli mai* and *La Jetée*, following soon after the publication in 1961 of *Commentaires*, which had brought together all Marker's film commentaries from *Les Statues meurent aussi* to *Cuba si*,

also sparked an impulse on the part of French film critics to survey what Marker had achieved to date. A number of lengthy articles and journal special issues devoted to his work appeared in 1962 and 1963, collectively proclaiming him as a major force in contemporary French filmmaking.[2] Viewed with hindsight, *Commentaires* and this crop of publications bear witness to the moment when Marker begins to move beyond the guise of the urbane world traveller who pens erudite letters from far-flung corners of the globe, in pursuit of another identity that is not yet clearly defined, but which on the strengths of his new films might be the critical conscience of contemporary France, or the cosmonaut of human memory. They also mark a juncture that would come to be decisive in Marker's estimation and exposure of his own work. In his self-curated retrospective at the Cinémathèque Française in 1998, the earliest of his films that Marker elected to show were *La Jetée* and *Le Joli mai*. He went on record to state that he regards his earlier films as rough and rudimentary drafts, and no longer wishes to inflict them on the cinema-going public.[3] While there is plenty of scope for disagreeing with Marker's judgement, it nonetheless lends the two films he made in 1962 the status of a tantalizing watershed.

On 3 May 1963, one year after it was filmed, *Le Joli mai* was released in cinemas in France. Made up largely of detailed interviews with a cross-section of ordinary Parisians, the film offers a portrait of France's capital city and its inhabitants taken during the first springtime of peace for seven

years, after the signing of the Evian accords in March 1962 had brought the Algerian War to an end.[4] *Le Joli mai* is centrally concerned with social relationships: how people become conscious (or not) of their responsibilities and connections to a world beyond the individual. In a public debate on the film, Marker stated that

> what I wanted to come out of the film is a sort of call to make contact with others, and for both the people in the film and the spectators, it's the possibility of doing something with others that at one extreme creates a society or a civilization . . . but can simply provide love, friendship, sympathy.[5]

The interviewees who appear in the film represent a variety of attitudes towards this question, from a clear awareness of their place within a social fabric, to self-absorption and indifference towards others.

Organized in two parts, the final release version of *Le Joli mai* ran for 165 minutes[6] – far longer than any of Marker's other films to date – and was pared down from more than 50 hours worth of rushes. Part 1, 'Prière sur la Tour Eiffel' ('Prayer on the Eiffel Tower'), begins with panoramic views of Paris and a lyrical homage to the city delivered in voice-over by Yves Montand. This introduction sets the stage – and uses this theatrical metaphor explicitly – for interviews with a range of individuals who are asked general questions about their lives: their hopes, opinions, manner of living and whether or not they are happy. Many of the interviews focus on immediate practical issues such as housing and money. Inhabitants of the slum tenements of Aubervilliers talk about their poor living conditions, then the film follows the delight and relief of one large family as they are finally rehoused in a spacious new apartment. Financial matters figure in discussions with employees and habitués of the stock exchange, and in a hard-bitten clothing salesman's consuming preoccupation with getting money in the till. Part 2, 'Le Retour de Fantômas' ('The Return of Fantomas'), broadens the political and social perspective of the film by focusing more explicitly on current events, notably the climate of sporadic violence and uncertainty that accompanied the ending of the Algerian War. It incorporates footage of the Salan trial, of the funeral of eight protesters

crushed to death at Charonne Métro station during a demonstration against the right-wing terrorist group Organisation de l'Armée Secrète (OAS), and an interview with a teacher who denounces the French use of torture during the Algerian War.[7] The backbone of 'The Return of Fantomas' is a series of interviews with people who, for different reasons,

have a strongly developed sense of their place in society and their relations with others. They include an African student, a former worker-priest turned trade union activist, and a young Algerian man who recounts episodes of harass-ment by the police and racial abuse at work. *Le Joli mai* closes with a return to Montand's commen-tary and long views of the city. The month is humorously summed up in a welter of statistics delivered over time-lapse footage of cars hurtling round the Arc de Triomphe. A final interview testimony comes from a woman prisoner and is delivered in voice-over, accompanied by shots of the panoptic layout of the Petite Roquette prison. The commentary concludes with a poignant reflection on the unhappiness that appears to dis-figure and imprison so many faces in the urban crowd, seeing it as the shadow of social inequality and oppression haunting the 'happy many' to whom *Le Joli mai* is dedicated. 'As long as poverty exists, you are not rich. As long as misery exists, you are not happy. As long as prisons exist, you are not free.'

The immediate impetus for *Le Joli mai* came from the technical developments in lightweight cameras and sound recording equipment that were beginning to revolutionize documentary filmmaking on both sides of the Atlantic. The development of hand-held 16mm-film cameras that could be synchronized with portable tape recorders emerged out of experi-ments conducted in the late 1950s by documentary teams in the United

States and Canada, who were seeking a way to record images and sounds directly and spontaneously, without the cumbersome set-ups and re-enactments enforced by conventional film equipment. In the United States, Robert Drew, working with Richard Leacock, D. A. Pennebaker and David and Albert Maysles at Drew Associates, successfully developed a synchronized sound system and stripped down Arriflex news cameras to film *Primary* (1960), a breakthrough film that followed John F. Kennedy and Hubert Humphrey on the campaign trail for the Democratic presidential nomination in Wisconsin. In Canada, the National Film Board's Candid Eye series, begun in 1958, consisted of short investigative documentaries for television inspired by the same desire to gain immediate access to people and situations. The momentum was gathering for what would come to be called direct cinema or *cinéma vérité*: a new approach to filming that could respond to events as they happened, and capture directly the speech and actions of people in their normal surroundings.[8]

In France, the anthropological filmmaker Jean Rouch and the sociologist Edgar Morin teamed up with the Canadian camera operator Michel Brault, who had worked on the Candid Eye series and other pioneering experiments in direct filming, to make *Chronique d'un été* (1960, *Chronicle of a Summer*). Rouch and Morin famously used the camera and the interview as catalysts to provoke a group of Parisians into revealing otherwise hidden aspects of their personalities, and to get them to meet and interact with each other across racial and social barriers that would ordinarily have kept them apart. It was Rouch who coined the term *cinéma vérité* to describe this experiment: a translation into French of the title of Dziga Vertov's newsreel *Kino Pravda*, literally meaning film truth. *Le Joli mai* refers directly to the precedent set by *Chronicle of a Summer* in its shared premise of getting a sample of Parisians to talk in depth about their lives and experiences. Rouch and Morin even make a fleeting appearance in *Le Joli mai* – along with shots of Jean-Luc Godard, Alain Resnais and Jacques Rivette – in a montage riposte to an engineering consultant who complains that most modern workers manipulate information and statistics, and few now produce anything with their hands. The two films are easily yoked together as the leading examples of French *cinéma vérité*, but there are significant differences in their form and approach. *Chronicle of a Summer* avidly brings

people together in the spirit of sociological enquiry, cajoling them into unveiling their true selves through the intermediary of the camera, and largely confining itself to a core group who were already friends and associates of Rouch and Morin. *Le Joli mai* casts its net wider, and permits its subjects to remain within their own worlds and value systems, challenging them only with an occasional pointed question or remark and instead relying on montage to draw critical comparisons and contrasts that track the wider social, political and racial fault lines of contemporary France through the lives and opinions of individuals.[9]

Le Joli mai drastically reduced the role of the singular voice-over commentary that had defined Marker's earlier essay-films in order to make space for the words and expression of other people. This shift is paralleled in the production of the film, since the engagement with a new method and new equipment led Marker to collaborate closely with a team of technicians and assistants responsible for shooting, sound recording and many of the interviews. The camera operator Pierre Lhomme is credited as co-director of *Le Joli mai*, in recognition of his central role in creating the film's mobile, responsive visual images. He used an early Coutant hand-held camera, connected to the Nagra tape recorder operated by the sound recordist

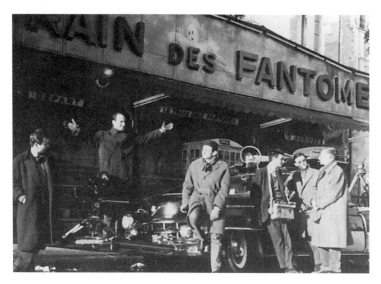

The crew of *Le Joli mai*. Pierre Lhomme second from left; Antoine Bonfanti third from right.

Antoine Bonfanti by a cable that constantly threatened to trip up the unwary. Lhomme's basic technique was to be guided by the sound (heard through headphones) when he was shooting, a method borne out in the closely observed hand gestures made by the African student and the worker-priest, which fit exactly with the rhythms and content of their speech. In one noted sequence, Lhomme abruptly shifted the position of the camera (and so the position of the interviewee within the frame) when the student answered 'no' in response to a question asking if he had any close relationships with (white) French people. Lhomme's images have many characteristics in common with Marker's own approach to filming and taking photographs: a respectful attention to human faces, sensitivity to physical movements and gestures, and the instinct to home in suddenly on trivial but potent details – like the sustained close-up of a large spider crawling on the suit of an inventor, who is holding forth about the part played by chance in creativity.[10]

If *Le Joli mai* dramatically extends the presence and involvement of other people, it remains identifiably a Chris Marker film. Faced with Rouch's label *cinéma vérité*, with its troublesome connotation of some general truth discovered through cinema, Marker is credited with promptly rephrasing it as 'ciné, ma vérité' ('cinema, my truth'). The shift in emphasis signals that Marker saw no reason to abdicate his own point of view, or the familiar signs of his presence as author, within *Le Joli mai*'s expansive engagement with the voices and opinions of others. The commentary may no longer be omnipresent, but when spoken it still contains recognizable Marker aphorisms – 'Men have invented mothballs for beauty, which they call Art', quotes liberally from Giraudoux,[11] and in company with the montage slips in references to cats and owls. Marker never appears in shot, but his grave, gritted-teeth voice can be heard conducting a number of the interviews, and occasionally he makes remarks or poses questions in a tone that reveals irritation or solidarity with the interviewee. When questioning a young couple who are oblivious to everything but their love for each other, and who epitomize the blithe indifference to political and social awareness that *Le Joli mai* exposes as a troubling characteristic of contemporary French values, Marker sounds surprised and not a little appalled at their lack of interest in current events. The montage of the film is frequently used to

comment critically or supportively on an interviewee's remarks, and throughout the film it works to build up a pattern of dialectical contrasts, in which the experiences and opinions of some interviewees are challenged or contradicted by those of others. The self-centred young couple are inter-cut with a raucous wedding reception (after telling Marker that they met at a wedding), and the opinionated discourse of two engineering consultants is punctuated with shots of bored and hostile cats, as well as the sly insert of the 'unproductive' film directors mentioned earlier. More sympathetic examples see shots of anonymous urban crowds used to corroborate the African student's account of his first impressions of France, and footage of an immigrant shanty town and Algerian workers digging up a road placed to emphasize the wider social reach of the economic and racial discrimina-tion described by the young Algerian man.

This highly partisan presentation of a 'documented point of view' in *Le Joli mai* drew criticism at the time of the film's release. The journalist Françoise Giroud complained that Marker 'pinned people down like insects', a sentiment echoed by the *Combat* reviewer Henry Chapier and others troubled by what they saw as Marker's stance of ironic intellectual detachment, and his recourse to techniques that undermined the credibility of some speakers without their knowledge or consent.[12] While it is undeni-able that Marker does remain aloof and in control in ways that can appear underhand, it is important to recognize that the principle of the documented point of view cuts two ways. As much as Marker (and Lhomme) reserve the right to use framing, editing and commentary to convey their opinions and attitudes towards the people who feature in *Le Joli mai*, the film is equally scrupulous in seeking to preserve the integrity and singularity of each participant, the circumstances they live in and the way they choose to express themselves. Marker stated that one of his ground rules was to avoid selecting the participants or manipulating the interviews (either by trick questions or strategic cutting), in order to confirm a ready-made conclu-sion about the state of France in 1962. Another was to refuse to regard par-ticipants as stock examples of social or character stereotypes. 'People exist with their complexity, their own consistency, their own personal opacity and one has absolutely no right to reduce them to what you want them to be.'[13] *Le Joli mai* does grant its participants the space to be themselves, and

to speak fully on the topics and questions proposed by the interviewer, without reducing their contributions to caricatured soundbites. Even when the film makes pointedly critical montage interventions into a discourse that it evidently regards as misguided or fatuous, it still retains the texture and substance of the interviewee's speech, so that it is possible for the spectator to measure Marker's reaction against the statements or attitudes that have prompted it.

The principles that govern the encounters of *Le Joli mai* inform most of the later portraits and interview-based projects in which Marker again centres his attention on the expression of other people. Following *Le Joli mai*, these works consistently establish a certain distance between director and subject, maintain a formal line of questioning and keep interviewer and interviewee physically detached from each other (the interviewer may occasionally be heard, but he never appears in shot). These are methods that respect social protocol rather than striving for intimacy.[14] The one exception is *The Koumiko Mystery*, where Marker adopts a far more personal tone with his subject (he calls her *tu*, rather than the formal *vous*), and works much harder at getting her to reveal herself. Marker's more habitual distance is partly a mark of respect and discretion, a way of preserving the 'personal opacity' of the individuals he is speaking with, but it is also the condition that allows each person to establish clearly their own ground in the encounter, without being directed and influenced by the potentially compromising pressures of interpersonal dialogue. Setting out his methods for *Le Joli mai*, Marker registered his distaste for interview techniques that use leading questions, and the appearance of a friendly and flattering rapport with ordinary people, to pressurize interviewees subtly into saying whatever they think the interviewer wants to hear.[15] The advantage of Marker's aloofness lies in the extent to which it permits his interlocutors to maintain and express their own social character and attitudes. In the case of *Le Joli mai*, the result is a far more nuanced and incisive portrayal of the prejudices and divisions of French society than might have been achieved had he chosen to interrogate and challenge his subjects more directly.[16]

In a recent, rare interview for the French newspaper *Libération*, Marker recounts how, during the filming of *Le Joli mai* on the crew's day off, he set about photographing 'a story I didn't completely understand'.[17] Finished in

tandem with the editing of *Le Joli mai*, this story would become *La Jetée* (1962), the best-known and most widely seen of all Marker's works, and one of cinema's finest meditations on its own nature as a medium, despite (or more likely because of) being almost entirely composed of still images. Inimitable and tremendously influential, *La Jetée* has inspired sustained philosophical and theoretical reflections on the imbrication of photographs and moving images that it enacts.[18] It is also the object of numerous creative homages: the French video artist Thierry Kuntzel's personal rewriting of its story as *La Rejetée* (1993),[19] David Bowie's music video for *Jump They Say* (1993), which re-enacts some of its most significant episodes, and most famously Terry Gilliam's feature film *Twelve Monkeys* (1996), which adopts the basic lines of its time-travel plot.

On the face of it, the new work could not have been more different from *Le Joli mai* and from Marker's previous films. Where *Le Joli mai* is an expansive, multivocal enquiry into the complexity of contemporary France using the new methods of direct cinema, *La Jetée* is a science-fiction fable that imagines the future nuclear destruction of Paris and recounts the tragic destiny of an individual hero. Marker's earlier essay-films had been personal explorations on the terrain of documentary, mingling different manners of address and proceeding by way of digression and poetic association. A mere 29 minutes in length, *La Jetée* is a model of spare, stripped-down linear narrative fiction in which nothing is superfluous and every element builds inexorably to the film's fateful conclusion. Yet *La Jetée* does not signal Marker's abandonment of the social environment and political pressures examined in *Le Joli mai*: the simultaneous creation of the two films is more than coincidental.

As early as the preparatory documents for *Le Joli mai*, Marker was already thinking of the project less in terms of the contemporary moment that it recorded than of the future that would one day look back at this moment as its past. 'This film, *Le Joli mai*, would like to offer itself as a fish tank for the future fishermen casting their nets into the past. It's for them to sort out what has left a real impression from what will turn out to have been only froth.'[20] *La Jetée* reworks this conundrum – what will the future make of us when we have become its past? – in its crucial early observation 'nothing sorts out memories from ordinary moments; it is only later

that they show themselves to us, on account of their scars'. It imagines the Paris of 1962 as fragments of distant memory recollected (or perhaps imagined) from the perspective of a post-apocalyptic future-present, in a narrative that explicitly figures traumatic and repressed aspects of contemporary history by taking them to a terrifying but plausible fictional conclusion. In this sense *La Jetée* forms the political unconscious of *Le Joli mai*, using the archetypal structures of narrative fiction to bring to the surface disturbing knowledge and pervasive anxieties that could not be fully aired and resolved in public discourse. It is notable that the film's action takes place underground, the symbolic location of the unconscious and the repressed *par excellence*. The atmosphere of fear and uncertainty that accompanied the ending of the Algerian War, combined with outraged awareness of the use of torture by the French authorities during that conflict (any mention of which was rigorously censored in the French media until hostilities ceased), mingled in *La Jetée* with the memory of the Nazi concentration camps and the hovering threat of nuclear annihilation, which was to crystallize during the Cuban missile crisis of October 1962.[21] The destruction of Paris near the beginning of the film has a charged significance in the context of the massive reconstruction of Paris's urban fabric that was undertaken between the 1950s and the 1970s, the

largest rebuilding programme since Baron Haussmann's drastic remodelling of the city in the 1870s.[22]

'This is the story of a man marked by an image from his childhood.' The story of *La Jetée* is delivered in voice-over, and its opening line immediately establishes the presence of omniscient narration: a controlling agency that tells the story from outside and has ultimate knowledge of the characters and their destiny (the voice clearly suggests that the narrator and the hero are not the same). We learn that the events connected to the childhood image took place before the outbreak of the Third World War, and that the significance of the image would become apparent to the man only years later. The narrative trap is sprung, with the intimation that its outcome is contained in this beginning. The image that the man (portrayed by Davos Hanich[23]) remembers is of the observation jetty at Orly airport and a woman's face, then a man falling and the later realization that he has seen this man die. Some time after, Paris is destroyed in a nuclear apocalypse. With the surface of the earth now uninhabitable, the survivors take refuge in the subterranean galleries below the Palais de Chaillot. Those who believe they are victors keep the others imprisoned in camps, and use them as guinea pigs for experiments in time travel, in order to seek help in the past or future. After a series of failures, the camp doctors (who whisper portentously in German) choose the hero because he is fixated on the strong image of his past, and might therefore be able to tolerate existing in another time. They use drugs to propel him into the past, where he finally encounters the woman seen on the pier (portrayed by Hélène Chatelain[24]) and gradually begins to inhabit her world. As the experiment is a success, the doctors send the hero far into the future, where he discovers 'Paris rebuilt: ten thousand unrecognizable streets', and is given a power supply to restart the earth's industry. Back in the camp, he realizes that the experimenters are finished with him and that he will now be killed. He receives a visit from the men of the future, who also travel in time and who invite him to join them, but he asks instead to be sent back to the jetty at Orly. As he runs towards the woman, he recognizes a guard who has followed him from the camp and who shoots him. The man finally realizes that there is no escape from Time, and that the image that had haunted him since childhood was that of the moment of his own death.

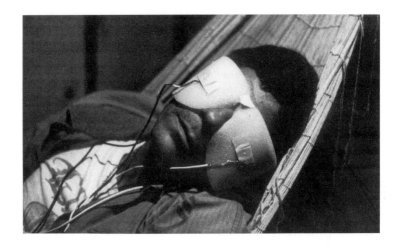

The most remarkable feature of *La Jetée* is its composition from still photographic images, which create a film by breaking with its most fundamental rule: the projection of images at a speed that reproduces the impression of natural movement. In a reminiscence for *Film Quarterly*, Marker traced the origin of his method to an optical toy called the Pathéorama, which enabled a film strip to be cranked frame by frame through an aperture and either projected or watched through the lens. He quickly set to work drawing his own filmstrip for the machine (the cartoon adventures of his cat, naturally enough), but was greeted with scorn by a school friend who announced that 'nobody can do a movie with still images'.[25] A further inspiration is the relay of narrative through still images and text found in comics, a passion that Marker shared with Alain Resnais and which is also figured in *La Jetée* by the use of science fiction and a dystopian future as generic frames, and by the fact that the hero wears a T-shirt printed with a comic-book wrestler, *The Saint*. These affinities were underlined when *La Jetée* itself re-emerged as a 'ciné-roman' graphic novel, published by Zone books in 1992 on the thirtieth anniversary of the film's release.

The stills used in *La Jetée* are often assumed to be individual frame enlargements extracted from a film shot in the conventional way, but they are in fact photographs taken with a Pentax camera. However, to call *La Jetée* a film made up of photographs (or even of production stills or frame

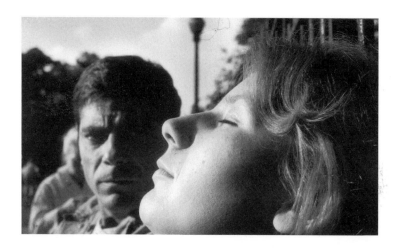

enlargements) misses what is so tantalizingly cinematic about its fixed images. Philippe Dubois, one of the few critics sensitive enough to this quality to discuss it, proposes the term 'cinematogram' for the images of *La Jetée*, recognizing the breath of life and movement that seems to animate them for the length of time they remain on screen.[26] The way the still shots are combined together is partly responsible for this effect. Like shots in a conventional film, the photographs are separated by straight cuts, fades and dissolves of varying duration, while individual sequences are broken down into the recognizable patterns of classical narrative cinema, with establishing shots, eyeline matches, shot-countershot, close-ups and so forth, all working to create a sense of narrative coherence and momentum. Yet this structure does not explain the aura of cinema that clings to the individual images of *La Jetée*. They are like memories of a film, which in our mind seem to be motionless and quantifiable, but if we search through the print never exactly correspond to one individual frame, or to the frozen drama of production stills. In *La Jetée* this aura is emphasized by contrast with other images in the film that do look more exactly like photographs. The first images that 'ooze' from the past – the peacetime countryside, the peacetime bedroom, the 'Real children. Real birds. Real cats. Real graves' – have the fixed, elegiac, self-contained quality commonly associated with photographs (even allowing for the cat looking into the camera). In his

essay 'The Rhetoric of the Image', Roland Barthes distinguished between the referentiality of the photograph as a record of 'having been there' and the prime illusion of cinema as an impression of 'being there'.[27] The suite of 'real' images affirm the existence of a pre-war past, but it is not the one the hero is looking for. When he does rejoin the woman, the shots take on once again the weight of cinematic presence, pregnant with the possibility of transforming into something else.

The momentary realization of this possibility defines the brief fragment of movement that lies at the heart of *La Jetée*.[28] It begins with a close-up of the woman's face, asleep in bed. The dissolves from one still image to another gradually quicken, and the intervals between them gradually reduce, so that the spectator begins in their mind to recreate the illusion of the woman moving in her sleep. Then, for a few seconds, normal film duration is established: the woman opens her eyes to look into the camera and

smiles. The moment is echoed on the soundtrack by a rising pitch of birdsong, which heralds this brief flight into life, out of the fixed frames and inexorable logic of the fated narrative. Later, as the film reaches its climax, the hero too attempts to take flight to reach the woman, and the cuts between his paces accelerate in jerks as though he is trying to escape the confines of the still. But his flight is abruptly curtailed by the appearance of the camp guard, who kills him. The stuffed, suspended birds that the man had contemplated in the natural history museum, during his last permitted meeting with the woman, were a fatal portent of this moment. There is no way to escape Time and return to the past as if it could be lived over again; there is no way for the hero to escape the implacable, preordained drive of the story

that is figured in the absolute control exercised by the camp authorities. The hero is never sure whether he really remembers this past, whether he has invented it, or whether the doctors have pushed him into it for their own purposes. His destiny is tragic, because he seeks – and fails – to avoid

his fate, by believing in the illusory presence of life through movement. This is, of course, the primary illusion offered by cinema itself.[29]

La Jetée distils the technical and experiential essence of cinema into a form and a story that unveil its mechanism and its power, but without in any sense depriving the spectator of their conventional pleasures in storytelling, fantasy and the projected fulfilment of desire.[30] Cinema's power to manipulate images and control our responses to them emerges in the role of the camp experimenters, and is underlined by the location of the camp under the ruins of the Palais de Chaillot, once used as storage space for Henri Langlois' Cinémathèque Française (the Cinémathèque itself would eventually be located there), and the fact that the chief doctor is portrayed

Jacques Ledoux in
La Jetée.

by Jacques Ledoux, head of the Belgian Cinémathèque and also one of the main benefactors of *La Jetée* itself. The film's fragment of movement, and the accelerating still transitions that lead up to it, eloquently demonstrate that film is made up of a succession of still images, which when projected at a particular rate will cause the viewer to perceive naturalistic movement. The hero of the film is tragically seduced by this illusion of life, and by the related illusion that the cinema brings the past back to life and allows it to be experienced as though it were the present. The allusions to Alfred Hitchcock's *Vertigo* (1958) are legion: the slice of sequoia on which the hero indicates his place outside time; the arrangement of the woman's hair, which recalls the spiral hairstyle of Madeleine/Judy in *Vertigo*; the presence of exotic flower arrangements, when the hero first spies the woman in a department store, invoking the Podesta Baldocchi florist where Scottie first spies on Madeleine; the natural history museum echoing the preserved Spanish mission and the painted wooden horse in Hitchcock's film. What they cumulatively conjure up is another story of a man who, like Scottie in *Vertigo*, seeks to turn back time by recreating the image of a lost woman, and who fails.

The woman herself represents cinema as the object of the man's desire: it is the film that seems to wake up as she does. In *Immemory*, Chris Marker reveals the origin of this primordial association of a woman's face with cinema, in his childhood memory of the face of the actress Simone Genevoix in Marc de Gastyne's *La Merveilleuse Vie de Jeanne d'Arc* (1928). The woman is also the sign of memory itself, the 'madeleine' that, like the fragment of cake for Marcel Proust, unlocks the past and restores the hero to an intact moment of a previously lived life. The remembered image of the woman focuses the ambiguities of memory's nature and the role that memory plays in creating the identity of the hero (and by implication other human subjects). *La Jetée* recognizes that memories become memories 'on account of their scars'; their intensity is directly related to the proximity of trauma and loss, and the paradoxical function of memory is both to shield the subject from this trauma, and to expose them to its presence. In Marker's film the founding memory poses the enigma of the hero's self-hood, which turns out to be his own annihilation. The man wonders if he is fixated on the woman's image (and even if he has dreamed it up), to shore

This is the image that taught a child of seven how a face filling the screen was suddenly the most precious thing in the world, something that haunted you ceaselessly, that slipped into every nook and instant of your life, until pronouncing its name and describing its traits became the most necessary and delicious occupation imaginable—in a word, the image that taught you what is love. The deciphering of these bizarre symptoms only came later, along with the discovery of cinema, so that for the child who had grown, cinema and woman became two inseparable notions, and a film without a woman is still as incomprehensible to him as an opera without music. Why this face and this gaze remained unknown for almost sixty years is yet another mystery.

up the chaotic scene of the death that followed. *La Jetée* also evokes tensions between the action of involuntary memory returning to the past in its entirety, and the experience of memory as a series of images removed from the continuous flow of time. In the hero's first encounters with the woman, the narration informs us that they inhabit a present unburdened with memories: 'Time builds itself painlessly around them.' Yet the depiction of their encounters as a series of disconnected still images frames the poignancy of this illusion. Proust himself had compared personal memories to a sequence of photographs removed from the flux of time, which present only single aspects of the remembered person.

> A great weakness no doubt for a person, to consist merely of a
> collection of moments; a great strength also: he is a product of
> memory, and our memory of a moment is not informed of every-
> thing that has happened since; this moment which it has recorded
> endures still, lives still, and with it the person whose form is out-
> lined in it.[31]

La Jetée was released at the Pagoda cinema in April 1964, in a programme with two other films: Igor Barrère's and Etienne Lalou's *Corps profond* and Joris Ivens's *A Valparaiso* (both 1963). Ivens was a celebrated left-wing documentarist whose career stretched back to the 1920s. After several films made in his native Netherlands, he had filmed Spanish life during the Civil War in *The Spanish Earth* (1937), then worked in the United States, initially for the Department of Agriculture on *Power and the Land* (1939–40), which advocated the benefits of rural electrification, and then on a number of propaganda films during the Second World War. After the war, his allegiance to Communism led him to work in the German Democratic Republic and to make films in China and Cuba. For *A Valparaiso*, a lively and compassionate portrait of the Chilean port city built on improbably steep hills, Ivens worked with students of the Santiago University film department, during a teaching visit arranged by Salvador Allende (whom Ivens had met in Cuba). The film obtained a natural structure from the sharp contrast between the low and high districts of the city, joined by a dizzying network of staircases and cable lifts, which mirrored the social divisions of rich and poor. Ivens's keen eye for how Valparaiso's poorest citizens exist in the face of social adversity, while working to solve problems like the lack of schools, medical care and water in the hilltop villages, is combined with a dynamic grasp of the peculiar urban fabric of the city that owes much to *De Brug* (1928, *The Bridge*), his early avant-garde study of the operations (as much social as mechanical) of the Rotterdam railway bridge over the Maas river. The commentary for *A Valparaiso* was written by Chris Marker, based on Ivens's notes and apparently in the space of two days, after Marker had found Ivens extremely discouraged because he was scheduled to mix the film but did not yet have a suitable text. When Ivens expressed his amazement at the speed with which the commentary had been delivered, Marker laconically remarked that he had just gone without sleep and drunk a little Cuban rum.[32] In clear strokes Marker's commentary underscores the social and elemental forces the film discovers at work in Valparaiso: the sea, the air of the hills and the blood of history (which sees the film explode from black and white into colour); and highlights bizarre details that crystallize the identity of the town, such as the houses that resemble the prows of ships.[33]

When Marker published the second volume of his collected *Commentaires* in 1967, it included a second 'imaginary film', *Soy Mexico* ('I Am Mexico'), written in 1965. It was inspired partly by rushes that François Reichenbach had brought back from Mexico, partly by Marker's recollections of his own visit to the country in 1953, as a member of a UNESCO delegation. Marker qualifies *Soy Mexico* as more a description than a commentary.[34] Proceeding by association through a vividly illustrated array of tourist spectacles, religious rituals, popular festivals and traditional ceremonies, Marker initially conjures an image of Mexico as a nation of masks and false identities, accumulated through a history in which so many other cultures – Spain, France, the United States and the Soviet Union, via Sergei Eisenstein's unfinished *Que viva Mexico!* (1930–32) – have laid claim to it and left their mark upon it. Even the strident tourist clichés of flower-strewn boats, Mexican *machismo* and Acapulco are, Marker asserts, the very images by which Mexicans themselves want to be identified. Amidst this dance of fake appearances, Marker fastens onto Indian culture as the potential source of what is truly Mexican, celebrating the belief-systems of the indigenous tribes and the spirit of Zapata's Mexican revolution.

The second half of the commentary traces a three-part journey through death – the death of animals, of God and of men – towards the rediscovery of Mexican identity. For Marker, Mexico offers a supreme example of the cultural accommodation of death that he had singled out for attention in *Les Statues meurent aussi*. It is not surprising to find that behind all the masks that so intrigue him, 'the only unmasked face is the one that we don't dare look at' – in other words, the face of death itself. *Soy Mexico* tracks an array of death-related festivities, including bullfights, the Day of the Dead and Catholic rituals commemorating Christ's Passion, which by implication are the true masks of Mexican society. Marker registers an ambivalence in these routine celebrations of death – the worry that the righteous anger that propelled the Revolution is being buried along with the effigy of Bad Temper, and the recognition that the Indian tribes are dying out – but the film ends with the possibility that a new, genuine Mexico is being born, perhaps at the very moment that the film ceases its imaginary projection.

The Tokyo Olympic Games of 1964 marked a moment of transition in modern Japanese history, when the country and its customs were projected

outwards to meet the gaze of the (Western) world. Chris Marker made his first visit to Japan with the prospect that he would make a film about the Tokyo Olympics, but in the event that honour went to the Japanese director Kon Ichikawa. Marker had decided instead to make a film about a young woman, Koumiko Muraoka, whom he met by chance in the city.[35] In *The Koumiko Mystery*, this enigmatic female protagonist acts as the lens through which Marker discovers for the first time the intense and haphazard fascination with Japan to which he would return in many later works. Japan, in Marker's estimation, is a country that obligingly refuses to make sense, forcing the visitor to accept everything in its 'disorder, simplicity and division in two', as he puts it in *Le Dépays*, and basically to make it up as he goes along.

The plan of *The Koumiko Mystery* is deceptively simple. The male narrator (voiced by Marker himself) meets Koumiko in Tokyo, films her and the city while asking her questions about herself, and then returns to Paris, leaving her a questionnaire to which she sends him tape-recorded answers. This premise enables Marker to synthesize all the widely disparate methods and idioms explored in his films so far: the light-hearted personal travelogue, the investigative interview and the melancholy and disquieting fiction. The visit to Japan forms a logical extension to Marker's previous travels in the Far East, *The Koumiko Mystery* being perhaps closest in tone and spirit to *Coréennes* in that there is relatively little emphasis on the political character and global status of the country, and far more attention paid to culture and customs filtered through an explicitly female frame. Like *Le Joli mai*, *The Koumiko Mystery* tempers the subjective reveries of its unseen male commentator with the spontaneous dialogue of the interview, here focused upon a single individual rather than the intricate social mosaic of the earlier film. If these elements locate *The Koumiko Mystery* in the realm of documentary – albeit the singular region of it that Marker had carved out for himself – the credit sequence and the atmospheric incidental music written by the well-known Japanese film composer Toru Takemitsu[36] periodically recast the whole as a romantic thriller, part Hitchcock and part Godard, in which a promising new actress is launched upon the world. Koumiko is the vanishing point into which fiction and documentary dissolve, a character whose mystery resides in being simultaneously a real

Japanese woman and a figment of Marker's fertile imagination. And if something in her manner of breezing through the streets of Tokyo evokes Godard's muse Anna Karina, this may be more than accidental. *The Koumiko Mystery* is Marker's fond and playful homage to the French New Wave, cued explicitly by his choice of the melancholy theme tune to Jacques Démy's bittersweet musical *Les Parapluies de Cherbourg* (1963, *The Umbrellas of Cherbourg*), to accompany his footage of Tokyo under the rain.

The idea that Japan persistently confounds Western efforts at understanding it is established in a pre-credit sequence that animates scenes from *La Famille Fenouillard* on a television monitor. The difficulty arises because the Japanese are seen to be both completely Westernized and thoroughly Japanese. Koumiko herself represents a similar form of cultural doubling: when the narrator asks her whether or not she is completely Japanese, she says that she is by race, but in her mind is 'too mixed up'. Her birth in Manchuria is put forward as a possible reason for this confusion, but Koumiko also studies French and is (like Marker) fond of Giraudoux. She is cast as a native informant, one who inhabits an intermediate space between Japanese culture and that of the visitor from France. The narrator first encounters Koumiko among the spectators in the Olympic Stadium, and

then proceeds on a tour through the urban landscape of Tokyo, with Koumiko appearing sporadically as on-screen guide and focus. In contrast to the ordinary Japanese whom the film captures going about their daily business, Koumiko is singled out as a character who we understand is performing everyday actions for the purpose of being filmed by the visitor, including such 'typical' Japanese habits as having her fortune told by telephone and fanning incense over herself at a temple. The sense of blatant performance is enhanced by the evident rapport established between Koumiko and the camera. She behaves like someone in a home movie, frequently engaging the gaze of the filmmaker/viewer, and striking playful poses underscored in passages where she confronts the camera directly in a bare interior, or appears as a sequence of black and white photo-portraits, wielding her cigarette holder like Audrey Hepburn or sporting an Olympic helmet. The feeling of studied display carries over into the second half of the film, when the narrator has returned to Paris and is listening to Koumiko's taped letters, and we watch her sitting alone on trains and in restaurants, absorbed in her own thoughts and as if unaware of being filmed.

The fluid roles that Koumiko plays for the camera mesh with the presentation of Japan as a 'world of appearances', as Marker would later call it in *Sunless*. With more audacity than *Sunday in Peking*, *The Koumiko Mystery* dallies with the clichés of the mysterious, feminine Orient, and the seizure of Japanese culture in particular between the contrary extremes of refined sensibility and savage violence – Buddhist rites and bondage pornography – but at the same time it refuses any truck with the picturesque and the typical. Koumiko is neither a 'modern woman', a 'model woman', nor a 'typical Japanese, if such a creature exists'. *The Koumiko Mystery* gleefully sends up the contemporary vogue for statistical surveys and market research, with its spoof enquiries into Japanese telephone use, photography and religious beliefs. These efforts to pigeonhole human values and behaviour are sent further awry in the central interview with Koumiko, in which the questions are by turns searching ('What is the Japanese spirit?') and frivolous ('Why are there beckoning cats?', meaning the lucky Japanese figurine of a cat with one raised paw). The more the voice of the narrator grills Koumiko, in a tone that mixes flirtation, a touch of paternalism and a genuine desire to understand her, the more her self-searching or playful answers elude any

attempt to categorize her or sum up her identity (and that of her homeland) in a tidy list of attributes.

Like the subjects of *Le Joli mai*, something in the depiction of Koumiko remains opaque. She is cast as an archetypal woman of mystery, but there is also the suspicion that somewhere behind her various masks she may be having the last laugh. Koumiko's ambiguity as a representation connects to the use of non-synchronized sound throughout the film. Marker was filming in Tokyo with a silent 16mm Bolex camera, so there is a practical explanation for this choice, but the result is that no definitive link exists between the woman we see on the screen and the woman whose voice we hear answering the narrator's questions. From the second half of the film we also recognize her as a projection from the past, a collection of memories on film that the narrator has carried back with him to Paris. The Koumiko we see and hear in the film is pitched exactly between her own reality and her status as Marker's ghost-guide to his own imaginary Japan, and it is ultimately impossible to extricate one from the other.

By the middle of the 1960s, Marker had amassed more than a decade's worth of photographs taken on his travels around the world. Some had been included in his films, establishing taut and instructive dialogues between the qualities of the still and the moving image. Others had appeared in books: his own album *Coréennes*, and a few works by other

writers. In 1966 Marker produced a retrospective of this photographic work, but not in the usual forms of an exhibition or book. He turned it into a film. *If I Had Four Camels* takes its title from one of the short poems in Guillaume Apollinaire's *Le Bestiaire* (1911). A title card announces the premise of the film: 'A photographer and two of his friends [the parts are read by Pierre Vaneck, Catherine le Couey and Nicholas Yumatov], look through and comment on a series of photos taken just about everywhere in the world between 1956 and 1966'. 'Just about everywhere' translates as the world according to Chris Marker. With the exception of Scandinavia, the countries that are most in evidence are those he had visited in his previous films – China, Israel, Cuba, North Korea, France, Japan and the Soviet Union, although here Moscow rather than Siberia is the focus of attention, and its reach does extend as far as a Russian Orthodox monastery in Greece.

The terrain covered in *If I Had Four Camels* is organized in two parts, 'The Castle' and 'The Garden'. Each explores different facets of human achievement and experience, and revisits the utopian ideals that Marker had admired in the work of Giraudoux, and figured through African art and the Olympic Games in his earliest films. 'The Castle' leans towards the pinnacles of human culture and civilization: cities, societies, art, religion and commerce. Pride of place is given to a sequence of photographs of Moscow. These place the Soviet Union firmly on a par with other societies in its complexity and progress, and also makes its citizens the mediators for the accomplishments of Western civilization, since considerable

attention is devoted to showing the reactions of Russian visitors to an exhibition of American modern art and consumer products that was mounted in Moscow in 1959. The survey of human achievement in 'The Castle' is located within Marker's ritual invocation of the global image of a unified world. The photog-

rapher confesses that he cannot resist films that pass from country to country at a single moment in time, and, in narrating his own journey around the world via photographs, nods implicitly at those passages in *Le Cœur net*, *Letter from Siberia* and *Cuba si* that had established the route before it.

If 'The Castle' leans towards culture, 'The Garden' focuses upon human nature, treated as a native impulse towards fulfilment and happiness. Children and animals are shown as ideal representatives of 'the law of the garden', but the desire to achieve balance and satisfaction in the human condition is also expressed through the aspirations of revolutionary politics. At a protest rally against the Bay of Pigs invasion, a shot of a pensive elderly woman allows the photographer to indulge the fantasy that she is a militant whose life has advanced step by step with the revolutionary history of the twentieth century. Another sequence contrasts attitudes to work in Iceland and North Korea, suggesting that under democratic capitalism labour is a tiresome burden, while in a Communist state it lends dignity and purpose to life. North Korea is made the model country of 'The Garden', much as Moscow had represented 'The Castle'. The grace and sensibility that Marker had celebrated in *Coréennes* is again the foundation for his idealized image of a playful, reasonable and above all good-humoured civilization.

A short way into the film, Marker posts a wry quotation from Jean Cocteau's poetry collection of 1921, *Les Mariés de la Tour Eiffel*: 'Seeing as these things are beyond us, let's pretend to be the organiser of them.' The device used is the familiar, even banal act of leafing through a collection of photographs in the company of friends, seizing on images that attract attention, and weaving anecdotes, interpretations and arguments around them. The presence of three separate voices in the commentary, although presented in this casual and familiar form, effectively distils the insights of Marker's interview-based films by building a lively and innovative three-way dialogue that incorporates conflict and argument between the different speakers, and opens Marker's erudite globetrotter persona up to searching criticism. The voices of the two friends (Nicholas and Catherine) frequently challenge and oppose the ideas of the photographer (Pierre), bringing in different opinions and perspectives that disrupt his own garrulous and on occasion rather romantic interpretations of the pictures he has taken. If the photographer represents a certain impulse to construct utopias from the images he has amassed, it often falls to the two friends to invoke the cracks in the dream worlds of castle and garden, the hard realities of social injustice and inequality that temper the illusion of a balanced and contented global community. When the photographer waxes lyrical about the Russian look over his images of Moscow, his friend Nicholas delivers an interior monologue that openly chides the photographer's Western romanticism, and counters it with his own perspective on the photographs, which is that of a Russian émigré caught in the pain of exile. Catherine, meanwhile, laces the commentary with sharp doses of political and social awareness. Faced with the sunny images of black, Asian, Arab, Jewish and white children who populate the garden, she remarks tartly that they are not treated as equals, and that their lives are made by the realities of what they have to eat and how they are brought up.

If I Had Four Camels opens with reflections on the nature of photography, this 'world of the double' that is spread like a second skin over creation, and which we routinely confuse with actual life. The idea of photographs as a sort of parallel universe, an 'image-world', is shared by Susan Sontag in her book *On Photography*. Sontag further echoes Marker's opening analogy of the camera and the gun – 'you track, you aim, you shoot,

click! – and instead of a death you create an eternity' – with her notion of the 'soft murder' of the photograph, which captures and violates, but without killing.[37] Where Marker develops a more singular approach to his topic, it is in his discussion of photography in relation to the look – of both photographer and subject. The photographer of *If I Had Four Camels* states that a photograph is not strictly speaking the image of its subject, but a record of the look that was placed upon that subject. Marker's filmed and photographed images, in this work as in others, are animated by a look of agile curiosity: the human presence behind the camera who frames the world, shoots and makes connections, and whose consciousness emerges through the commentary in a perpetual reflexive dialogue with the act of taking pictures. This look of the photographer/filmmaker is regularly figured inside the frame, through Marker's fondness for images of people who are themselves looking very intently at something. *If I Had Four Camels* is full of people gazing in active absorption, from Russian women scrutinizing American fashion magazines, and a Russian worker in a cap contemplating an abstract sculpture, to a North Korean woman (from *Coréennes*), her baby tied to her back, looking at a poster for a space satellite. The photographer is obsessed with the idea that certain peoples possess a

look, a unique way of facing and contemplating the world – although its nature is never precisely defined. Russians, Jews, Arabs and black people each have a look, but the privileged nations of the West do not – there is no American or Scandinavian look. Occasionally the meeting of looks sparks a gesture of anger or refusal – the Cuban open-air barbers who brandish their scissors at the photographer – but the final relay is when the subject turns their gaze squarely back to the photographer, and regards him as an equal, like the Korean factory worker who had appeared at the end of *Coréennes*. This 'real look' recurs right across Marker's work, a privileged moment that fires and even defines his activity as a maker of images.[38]

Towards the end of *If I Had Four Camels*, Marker holds up Scandinavia as the epitome of Western civilization in achieving the security and comfort of its citizens. A photograph of an elderly Icelandic man represents a lifestyle that the vast majority of the world's population can barely imagine, let alone obtain. Yet there is still a limit to the man's fulfilment: death. The implicit association of photographs with death, noted by Sontag and evoked at length by Roland Barthes in his reflection *Camera Lucida*,[39] is elaborated in an intricate, reflective passage of Marker's film. A slow procession of gravestones and sculptures, and the inclusion of images of a man who survived a massacre in Hungary in 1956 and now retells the moment of his own death as an eyewitness account, hark back to *Les Statues meurent aussi* and *La Jetée*. The sculptures mingle with other works of art, 'the botany of death' as Marker had called them in *Les Statues*, and through an accelerating emphasis on paintings of women, give way to photographs of women as bearers of a privileged relationship with death. In his poem of 1947 'Romancero de la montagne', Marker had written 'Each woman carries a dead man, who knocks and seeks the light';[40] and in *La Jetée* the woman is the spectral image who carries the evidence both of her own death and that of the hero. *If I Had Four Camels* even replays *La Jetée*'s celebrated fragment of movement, with the same accelerating transitions between separate photographs of a Russian woman's face, culminating in her brief and enigmatic smile. Marker's attachment to women as a sign of mortality differs from the more familiar symbolism of death and the maiden, to the extent that the fear and misogyny that traditionally cast female beauty as a cruel and vain illusion is replaced by a tender fascination with the otherness of

both femininity and dying: that equitable acceptance of death as an integral, if unknowable, part of life.

When the commentary of *If I Had Four Camels* was published, along with *Soy Mexico* and *The Koumiko Mystery*, in the second volume of Marker's *Commentaires* in 1967, most readers would actually have experienced it as a second imaginary film. *If I Had Four Camels* did not receive a theatrical release in France until 1974. The retrospective slant of the film turned out to be prophetic, because the direction and purpose of Marker's work was on the verge of a major change. The film that came out in 1967 with Marker's name linked to it was *Loin de Viêt-nam* (*Far from Vietnam*), a collective protest film against the Vietnam War that Marker organized and edited. It heralded the beginning for Marker of a decade of active involvement in militant cinema, which flourished in tandem with radical political movements of the era, and aimed to give a voice to revolutionary activists who normally went unheard in the babel of mainstream media and film production. In the small-scale collective films and counter-information newsreels that Marker produced after 1967, those human dialogues that he had opened in *Le Joli mai* found a new momentum, and newly compelling reasons to be heard.

4.

A Grin Without a Cat

The cover copy on the Academy Video edition of *Sunless* describes it as 'a triumphant return to personal filmmaking'. With this release of 1982 Chris Marker did indeed return to the quirky and digressive style of his early essay-films, following a decade of close involvement with militant political film collectives that began in 1967 with his instigation of *Far from Vietnam*, and culminated in 1977 with the French release of the two-part, four-hour *Le Fond de l'air est rouge* (*A Grin Without a Cat*),[1] a monumental montage survey of the changing fortunes of the international revolutionary Left over the previous ten years. There can be little question that *Sunless* is a triumph, and that it sees Marker drawing some sort of line under the way he had chosen to work during the late 1960s and '70s, but the phrase 'triumphant return' should not be taken to mean that Marker finally rediscovered the sensible business of making films with a recognizable *auteur* stamp, and had got over the muddle-headed idealism of trying to change cinema and the world.[2] This distorts and belittles what Marker achieved by immersing himself in collective production and the pressing political questions of that time. It also obscures the significant continuities that exist between his militant period and the work he produced both before and after it. The Marker who donned the collectivist mask of left-wing radical politics in 1967, and largely ceased to sign the films that he produced over the following decade, differs in emphasis, not in kind, from the Markers who preceded and came after him.

The wave of strikes, demonstrations, university occupations and pitched battles between riot police and protesting workers and students that swept

France during May and June 1968 have become a tidy and imperfect symbol for the wholesale questioning of established political, social and cultural authority that emerged across the world in the late 1960s. International protests against the Vietnam War, Third World liberation struggles against imperialism and neo-colonialism, the politics of Black power emerging from civil rights campaigns in the United States, the launching of the Cultural Revolution in China in 1966, the rise of opposition to the Soviet model of Communism, the intensification of labour struggles in industrialized western Europe, and the growth of the women's liberation movement, these and other radical movements seemed for a brief period in the late 1960s to utter with one voice a single demand: revolutionize the world. The politics of culture and representation were brought sharply to the fore in many of these struggles. Radicals began to question the power of state- and business-controlled mass media, and to regard established cultural forms as mechanisms that secured and maintained support for an oppressive social order. In France, many film industry personnel came together to form the Etats Généraux du Cinéma Français ('Estates General of the French Cinema'), which for three weeks in May and June 1968 locked into step with the demands of protesting students and workers, and sought to promote 'the revolution in the cinema'[3] by developing ambitious plans for the drastic reform of the French film industry and backing the efforts of radical students and workers to make their own films. Although the Estates General was an unstable constituency that could not ultimately agree on an effective programme of action, it did catalyse debates around the perceived ideological functions of the cinema, which would come to dominate French (and to a great extent Anglophone) intellectual thinking on the subject in subsequent years.[4]

This constellation of tumultuous events and dramatic changes in attitude created a new horizon of possibilities for Chris Marker's work. The shift occurred for him in 1967, with the launching of the collective Société pour la Lancement des Œuvres Nouvelles ('Society for Launching New Works'), usually known by the acronym SLON, to produce *Far from Vietnam*. The principle of working collectively outside the organizational hierarchies of the film industry would soon connect with the project of democratizing access to the tools of filmmaking (and broadcast media), so

that dissenting social groups could express and communicate their own values and ideas, rather than being spoken *for* (or ignored and misrepresented) by media professionals. In his *Libération* interview in 2003, Marker would identify a large part of his work as trying 'to give the power of speech to people who don't have it, and, when it's possible, to help them find their own means of expression'.[5] From 1967 this principle would take Marker beyond the privileged status of the *auteur*-director into the humbler and less visible functions of producer, fund raiser, editor, facilitator and general fixer, ensuring the exposure through SLON of other people's work while continuing to make his own (unsigned) films. These supporting roles are traditionally difficult to square with the creative authority accorded to the filmmaker-director, and with Marker there has sometimes been a tendency to skew the historical record of this time too far in his favour, crediting him with decisive influence in circumstances where other individuals shared responsibility for developments, or where Marker's input was actually minimal or non-existent.[6]

Marker's immersion in collective production and immediate political questions and struggles had a significant impact on the style and approach of his films. Everything most readily associated with the Marker persona in film – dazzling erudition, digressive personal input, whimsical but telling asides, bold juxtapositions and totem animals – was muted or eliminated in favour of a more austere, direct and nominally impersonal mode of documentary presentation and argument. It is as if Marker consciously fades down the 'noise' of his screen personality in order to allow the views of other people and the weight of a political argument to be heard more clearly – as well as adapting to the restricted budgets and technical limitations of militant film production. Yet the films that Marker made between 1967 and 1977 exhibit many attributes and concerns that are absolutely consistent with those of his previous works. They display the same sharp intelligence, the same ability to think lucidly and inventively in images, the same acute sense of history and the forces that create history. They gravitate towards the same regions of the world, with Marker's earlier forays into places like Cuba, Siberia and France establishing a set of loose parameters that orient his militant films primarily towards Latin America, France and the Soviet bloc.[7]

Perhaps most importantly, Marker's militant films consistently foreground that attentive curiosity first displayed in *Le Joli mai*, in how men and women make sense of their place in society and how they act within it. Many are portraits – of among others the Brazilian revolutionary Carlos Marighela, the Soviet film director Alexander Medvedkin, the singer and actor Yves Montand, the French publisher François Maspero. Marker is interested in people as social subjects and in the light of their commitment to various left-wing causes, but at the same time he depicts them with tenderness, humour and warmth. In Marker's militant films human character and potential are realized *through* political engagement, not sacrificed to it. One of the strongest impressions they leave on the viewer is a distinctive twist on the feminist slogan 'the personal is political': an attitude of friendly camaraderie that embraces individual character and political conviction as an integrated human whole.

In his introduction to the published script of *Le Fond de l'air est rouge*, Chris Marker would contend that 1967, rather than 1968, marked the turning point for the international revolutionary Left. He points to events such as the control of the Cultural Revolution in China, the schism within Latin American Communism between the orthodox parties and the guerrilla movement that led among other things to the assassination of Che Guevara, and the moves begun by state authorities to infiltrate and control subversive groups. Marker finds an arresting metaphor for his thesis, one that conveys the energy of the revolutionary movement as well as the early premonition of its defeat, in a brief, explosive scene from Howard Hawks's gangster classic of 1932, *Scarface*. A mobster (played by Boris Karloff) is shot in a bowling alley just after bowling a ball, which then scores a perfect strike as he drops dead. For Marker, the events of 1968 are the sound and fury of the ball hitting the pins, with the force of the body that bowled it already gone.[8] Yet there is a more optimistic dimension to Marker's focus on 1967 as the crucial revolutionary year of the 1960s, one less apparent in this introduction than in *Le Fond de l'air est rouge* itself. A year before the radical demands voiced in May and June 1968, French workers at the Rhodiaceta factory in Besançon and the Sud-Aviation plant in Saint-Nazaire were already ceasing simply to negotiate their place within the established order, and instead beginning to question the entire basis of capitalist society.

The importance of 1967 to Marker as the truly significant pressure point of the 1960s mirrors his own turn towards a new form of filmmaking in that year. Under the auspices of SLON (which also happens to be the Russian word for elephant), Marker instigated, edited and wrote the commentary for *Far from Vietnam*, a collective portmanteau film made to protest against American military intervention in Vietnam. Described by the critic Raymond Durgnat as 'a serious kaleidoscope, a thoughtful dazzle',[9] *Far from Vietnam* blends episodes of fiction, essay, documentary analysis and newsreel in order to argue against the war and engage with its implications

on a number of intertwined levels. Presented in twelve separate segments, the film confronts the Vietnam War as a highly mediated conflict, and examines one of the major consequences of this for French and other European citizens: the paradoxical sense of being both detached from the war and directly implicated in it. As the archival 'Flashback' episode makes clear, France is linked to Vietnam as the former colonial ruler of Indochina, and much of the film mounts an impassioned plea for the value of international solidarity; but the contributions of Alain Resnais and Jean-Luc Godard – 'Claude Ridder' and 'Camera-Eye' respectively – also explore the tangle of moral ambiguities that surrounded the conflict for French intellectuals.

Although a commercial failure in France, *Far from Vietnam* marked a watershed in the organizational norms of the French cinema. The making and reception of the film crystallized incipient tensions between the enshrined authority of named directors and the humble anonymity of technicians and industry personnel, which would emerge decisively in the debates of the Estates General of the Cinema, and inspire the later activities of SLON. As Marker was at pains to point out, *Far from Vietnam* was the result of genuine, non-hierarchical collective effort, by a group that eventually included around 150 individuals.[10] It is telling that Marker's name is listed in the credits among the contributing

technicians, with no hint of his role in proposing the project and shaping the completed work. At the top of the credits were six well-known French (or French-based) directors: William Klein, Agnès Varda, Jean-Luc Godard, Alain Resnais, Joris Ivens and Claude Lelouch – although only Godard and Resnais actually directed self-contained episodes.[11] The cachet attached to these directors was the basis on which the film was marketed, a factor that would later lead SLON to regard the project as a failure, because it had not successfully broken with the assumed creative superiority of the director, and did not influence any of the 'star' directors (apart from Godard) to change radically the way they made films.

Once *Far from Vietnam* was complete, Marker travelled to Washington to film the March on the Pentagon: the mass mobilization against the Vietnam War that took place on 21 October 1967. This footage was used in *La Sixième face du Pentagone* (1968, *The Sixth Face of the Pentagon*), which Marker co-directed with François Reichenbach, although as a SLON production its credits emphasize the equal collaboration of an entire team. *The Sixth Face of the Pentagon* is a sympathetic observational account of the progress of the march and the various groups that participated in it, shaped by its quickly acknowledged significance as a turning point for the anti-war movement in the United States, when their tactics shifted from peaceful protest to direct confrontation and resistance. The film depicts the build-up to the march and traces its progress from the relatively benign 'country picnic' atmosphere of speeches, rallies, chants and the Yippies' attempt to levitate the Pentagon – set in spiritual contrast with an anti-Communist priest, denouncing the demonstrators from his perch in a hydraulic lift – to the decisive point when the cameras run with groups of protesters who break through the government lines and reach the Pentagon itself, only to encounter violent reprisals from the military police. Voice-over commentary is used, primarily to describe and explain events for a French audience – direct speeches to camera are paraphrased – but in contrast to the impersonal address of *Far from Vietnam*, there are recognizable flashes of Marker wit. Of the folk trio Peter, Paul and Mary the commentary quips: 'what an incredible country America is, the telephone is understood and the protest singers are talented!'

While Marker was in the United States, the première of *Far from Vietnam* took place. Rather than being held in a prestigious Parisian cinema, the

event took place in front of an audience of factory workers in the industrial town of Besançon, in south-eastern France.[12] The chain of events that led to this unorthodox screening went back to the month-long strike and occupation by workers at the Rhodiaceta textile factory in Besançon in March 1967. Chris Marker had been invited to Besançon to observe the strike by René Berchoud, a member of the local popular cultural organization CCPPO (Centre Culturel Populaire de Palentes-les-Orchamps) and a great admirer of *Cuba si*. Accompanied by Pierre Lhomme and Antoine Bonfanti, Marker accepted the invitation and once in Besançon recorded a three-hour interview with the striking workers inside the factory, extracts from which were published in the weekly news magazine *Le Nouvel Observateur*.[13] This article pinpoints what was radical and unprecedented about the Rhodia strike. For the first time the workers were not merely demanding higher wages and piecemeal improvements in their working conditions, but questioning the root oppression of industrial workers within capitalist society, and placing their right to human dignity and cultural life on a par with economic needs. As part of the occupation's cultural initiative, the workers ran a library and organized film screenings and debates with invited speakers, thereby fostering links between the Rhodia workers and sympathetic film personnel that lasted far beyond the strike. Several members of the *Far from Vietnam* collective were among those who maintained contact with Besançon, and so the decision was taken to stage the première for the workers. When a second strike was called in December 1967, in support of workers from another Rhodia factory in Lyon who had been made redundant, at the suggestion of the strikers Chris Marker and Mario Marret[14] began to work with Pierre Lhomme and the sound recordist Michel Desrois on a film about the strikes, entitled *A Bientôt, j'espère* (1968, 'Hope To See You Soon').

A Bientôt, j'espère begins at Christmas 1967, as the CFDT[15] union organizer Georges Marivaud (known as Yoyo) gathers an impromptu meeting outside the factory to report the news from Lyon. Marker provides a voice-over explaining the work of the textile factories and the context of the strikes. The film then backtracks to a montage of photographs and clips detailing the strike of March 1967, including material recorded by Antoine Bonfanti and cameraman Bruno Muel. The remainder of the film consists

largely of interviews with the Rhodia workers and their wives. The men describe the constantly changing eight-hour shift cycle that disrupted their home life and left them too exhausted to do more than watch television and sleep, effectively denying them a right to cultural interests, hobbies or educational development. They discuss and mime the repetitive work of tending the machines in extreme heat and noise, with pay docked for breaks of more than a few minutes and always the hovering threat of redundancy. (*A Bientôt, j'espère* includes footage shot clandestinely by Bruno Muel inside the factory, because filming was not authorized by the Rhodia management.) Their wives, many of whom also had factory jobs, corroborate the knock-on negative effects of the work on family life. The camera focuses soberly on the interviewees' faces and gestures, filming them in their homes but in a formal interview set-up (generally seated at the dining table). It is a sympathetic but slightly awkward presence, which is signalled at one point when a visitor arrives during an interview, and warily greets the camera crew along with the other people present.

As a contrast to these testimonies of oppression and alienation, *A Bientôt, j'espère* also shows lively debates among the workers as they discuss their political development, their aspirations towards a cultural life and their need to be treated with dignity and fairness. The film closes with the recognition that although the strikes of 1967 achieved almost nothing in terms of improving conditions or preventing redundancies, their real legacy was the emergence of class consciousness and willingness to continue the fight; hence Yoyo's defiant challenge 'Hope to see you soon!', aimed at his employers at the end of the film.

A Bientôt, j'espère was produced as a commission for the current affairs television strand Camera III (which was suppressed after May 1968), and first broadcast on the ORTF[16] channel Antenne 2 in March 1968, followed by a televised debate. In April the film was screened for the Rhodia workers,

followed by a discussion that fortunately was tape-recorded and so remains an invaluable document of their reaction to the film. *A Bientôt, j'espère* was broadly welcomed, and regarded by some as an accurate portrayal of the workers' situation, but it drew criticism on several counts. A woman noted that it focused exclusively on men's work in the factories and ignored women as workers rather than wives. Some workers argued that the film gave a wholly pessimistic impression of their existence. While awkwardness in front of the camera and being unaccustomed to talking about themselves were seen as partly to blame for this, the workers' comments suggest a feeling that the film represented them as victims. As one man put it, 'our everyday problems are dealt with frankly, but our hopes, and we do have hopes, are poorly developed'.[17] Another remarked that Marker's view of the workers was essentially romantic, because it emphasized a handful of strikers seized by energies of revolt and class consciousness, but without showing the long, tedious and often thankless day-to-day struggle of creating and maintaining trade union activism.

Marker's response to these criticisms was that he and Marret would always be outsiders to the workers' lives, and that the logical step forward was for them to begin making their own films. In posing this challenge, Marker was aware that a collaboration had already begun between a group of militant Rhodia workers and a number of sympathetic film technicians, including Bruno Muel, who were teaching the workers the basics of filmmaking so that they could take control of the medium on their own terms. At Marker's suggestion the group named themselves after the Soviet director Alexander Medvedkin, who in 1932 had travelled around the Soviet Union in a specially equipped cinema train, using film as a tool to study the practical problems encountered by peasants and workers, and encourage them to find solutions. In 1969 the Medvedkin Group completed *Classe de lutte* ('Lesson in Struggle'), a fluent, energetic and wide-ranging study of grassroots trade union activism that responds directly and on a number of levels to the limitations of *A Bientôt, j'espère*.[18] When Pol Cèbe, a founding member of the Besançon Medvedkin Group, moved close to Sochaux (the location of a major Peugot factory), a second Medvedkin Group was formed there. In seven-odd years of existence the two groups made almost a dozen films, which together constitute one of the most remarkable legacies of militant cinema in France.[19]

A coda to Marker's engagement with French labour politics came in 1974, when he acted as editor on *Puisqu'on vous dit que c'est possible* ('Since We Say You Can'), a collective film documenting the landmark strike action that developed at the LIP watch factory in Besançon in 1973. An unusual degree of organizational solidarity between the CGT[20] and CFDT unions enabled the workers to seize control of the business after becoming unhappy with company mismanagement, and to run it successfully at a profit for nine months until they were forced out by armed police. The workers had invited members of the alternative media collective CREPAC (Centre de Recherche de l'Education Populaire et Action Culturelle) to film the strike as it unfolded. Faced with a mass of material that amounted to around eight hours of projection, CREPAC asked Marker to help them shape and edit the footage into the final 50-minute film. One contemporary review of *Puisqu'on vous dit que c'est possible* felt it offered a compelling record of the 'classic' moments of the strike – meetings, debates, clashes with the police – but did not really get into the heart of the strike by showing how the workers changed their habits, and actually adapted to the tasks of running the business.[21]

After *Far from Vietnam*, the initial SLON collective had drifted apart, with most of the known directors returning to the feature-film industry. What remained was a small but dedicated group, largely made up of technical personnel but including Chris Marker, who had discovered through the making of *Far from Vietnam* the possibility of organizing film production along cooperative and non-hierarchical lines, and of using film as a tool within political struggles rather than as simply a medium of entertainment. The making of *A Bientôt, j'espère* firmly established SLON as a flexible, open membership collective. It had two regular workers, and otherwise consisted of whoever chose to make films with it. The organization was initially registered in Belgium in order to bypass French censorship and financial restrictions, but in 1974 re-established itself as a French company, ISKRA (Images, Son, Kinescope, Réalisation Audiovisuelle; also the Russian word 'spark' and the title of Lenin's newspaper), in order to benefit from French film subsidies. SLON regarded itself as a tool, to help in the production of films made from a Left political perspective that would not otherwise exist. The collective offered technical assistance and training to militant groups

who wished to make their own films (the Medvedkin Groups being a case in point), and helped out with post-production facilities and financing. It then took charge of distributing the finished films, largely through the burgeoning 'parallel' circuit of trade unions, cultural centres, Left political organizations, schools and film societies, but also willingly organizing commercial cinema releases and sales to television.[22] SLON's political position was resolutely non-sectarian, and within the common parameters of anti-capitalism and anti-imperialism it produced films from a range of Left perspectives, which it felt could contribute to the understanding of contemporary political struggles around the world.[23]

One of the most significant long-term consequences of May 1968 was the discrediting of the mainstream media in France (and elsewhere) as the mouthpiece of the bourgeois state. Many of the rapidly executed street posters that appeared on the walls of Paris during the May protests forcefully attacked government control and censorship of the state-owned radio and television network ORTF, with images of a television screen covered with barbed wire, and a helmeted riot policeman speaking into an ORTF microphone with the caption 'La police vous parle' ('The police speaking').[24] Drawing inspiration from the Situationist critique of 'the society of the spectacle', militant students castigated the media as an instrument that served the political status quo and kept the population in thrall to the myths and illusory rewards of bourgeois consumer society, rather than encouraging them to fight for genuine political and personal liberation.[25] The impact of the May events upon all branches of the arts and culture in France was symptomatic of a growing belief that culture in its broadest sense (or, to express it in Marxist terminology, the many facets of the ideological superstructure that develops out of the economic base of production) must become a site of political contestation on a par with labour struggles.[26]

In these circumstances, it made concrete sense for those involved in the protest movements to begin to produce their own films and newsreels, to counter what they saw as biased and selective reporting in the established media. The Estates General of the Cinema sponsored a series of collective short documentaries recording the May events from the perspective of students and striking workers, including *Le Pouvoir est dans la rue* ('Power is in the Streets') and *Ce n'est qu'un début* ('It's Only a Beginning'). Following

an idea suggested by Chris Marker it also produced the *Cinétracts*. These were a series of anonymous, combative and often strikingly eloquent visual pamphlets, filmed on silent black and white 16mm-negative stock using easily assembled materials – still photographs, collages and texts – in order to respond quickly to unfolding events. Marker, Godard, Resnais, Jean-Pierre Gorin (who formed the Dziga Vertov Group with Godard), Philippe Garrel and Jackie Raynal were among the better-known contributors to the series, alongside young militants with no prior experience of film.[27]

The basic principle that informed this type of small-scale, dissenting filmmaking came to be called 'counter-information': the need to report on those revolutionary political events and perspectives that were ignored or misrepresented by the mainstream media. Although the work of SLON in its entirety can be seen in these terms, the organization produced two series of regular newsreels that were intended as a more explicit remedy to the felt limitations of the French media. The Besançon Medvedkin Group made eight issues of the newsreel bulletin *Nouvelle société* ('New Society'), which examined oppressive conditions in individual factories as a sardonic riposte to Prime Minister Chaban-Delmas' optimistic 'nouvelle société' project for the renewal of France. The second series, with the generic title *On vous parle* ('Speaking to You'), was billed as a 'magazine of counter-information', and provided newsreel reports about political struggles and topical issues in France and across the world. In SLON's words, the aim of the series was 'to give a voice to the men and women who are directly involved in the struggles of our times, without intermediaries and even without commentary: whether they speak in the film, or whether the film itself, which they have made, is their voice.'[28]

Chris Marker was involved in a number of the *On vous parle* films. Some he directed himself, others involved him basically editing and reshaping footage shot by other filmmakers. Although the films were generally released without individual credits, Marker's hand is immediately visible in the punchy generic opening for the series, which intercuts photographs of people with the words of the title, and includes the famous image of Marker with his Rolleiflex camera held to his face. Marker's *On vous parle* bulletins typically focus on individuals who are intimately engaged in the political movements of the time. They make abundant use of interview material, but

also employ archive footage, photographs, collages, intertitles, newspaper cuttings and brief passages of descriptive commentary to contextualize people's beliefs and actions, and in a broad sense to enable their testimonies and ideas to be expressed through the medium of film. The focused, respectful attention and evident sympathy shown to Marker's *On vous parle* subjects have their origins in his response to those interviewees in *Le Joli mai* who are engaged with their society and aware of their place in it. This attentive solidarity is evident in Marker's first contribution to the series, Number 3, *On vous parle de Brésil: Tortures* (1969). Following a brief introduction assembled from newspaper cuttings, photos and film clips with a voice-over commentary, Marker edited newsreel footage sent from Cuba of an interview with fifteen Brazilian political prisoners set free in exchange for the release of the US ambassador to Brazil, who had been kidnapped by the urban guerrilla group Action for National Liberation in September 1969. The freed prisoners describe the tortures to which they were subjected under the brutal military dictatorship that had taken power in 1964. The film focuses on each person in turn and frames their individual testimony with unwavering patience, although in fact a single narrative is repeated over and over again: savage beatings, suspension by the limbs, electric shocks, threats made against friends and family members.

The history of the revolutionary struggle against the military dictatorship in Brazil is extended by Marker in *Carlos Marighela* (1970), a tribute to the founder and leader of Action for National Liberation who was killed in a government ambush in November 1969.[29] *Carlos Marighela* begins by openly proclaiming its status as counter-information, as the blurred silhouette of one of Marighela's comrades replaces routine broadcasts on a television screen. Marker draws a lucid outline of recent Brazilian history and an elegy to a committed armed revolutionary from extremely poor and fragmentary source materials: stock news photographs, the interview with the concealed comrade, and grainy bits of film footage showing political demonstrations, which give the distinct impression of clandestine shooting in difficult and dangerous conditions.

Number 5 in the series, *On vous parle de Paris: Maspero, les mots ont un sens* (1970, 'Maspero, Words Have a Meaning'), is an affectionate portrait of the left-wing publisher and bookshop owner François Maspero, who was a

contributor to *Far from Vietnam* and would later publish the commentary to *Le Fond de l'air est rouge*. *Maspero* is one of the most satisfying and likeable of Marker's films from this period, achieving an exemplary balance of quirky human warmth with a clear and inventive form of political argument. Premised on the idea that 'for Maspero, words have a meaning' – or expressed differently, that books have an active role to play in the global revolutionary movement – the film is divided into seven sections: Quotation, Introduction, Selection, Definition, Information, Recuperation and Contradiction, each prefaced by an image of the word torn from a dictionary and placed on a black ground. The main substance of the film is an interview with Maspero in his Left Bank bookshop La Joie de Lire ('The Joy of Reading'), but he is also shown on the streets of Paris in an energetic tracking shot that ends when he turns to the camera with a look of good-natured exasperation at being followed. Maspero talks frankly to Marker about the difficulties of his position as a left-wing publisher, and the fact that his job by its nature is riddled with mistakes and contradictions: from typographic errors and occasionally issuing terrible books, to the root contradiction of being a middle-class revolutionary. Yet he maintains a principled, alert and good-humoured sense of his role as an intermediary between writers and readers, helping to raise awareness of political struggles and debates around the world, and working to betray the bourgeoisie by turning their own cultural weapons against them. Marker uses brief montage sequences to corroborate Maspero's opinions imaginatively: a close-up

of a man perusing a book in his shop cuts to library footage of a journalist in Vietnam, neatly expressing the role of the book as a medium of global information and political education. Some of Marker's own sympathies are mirrored in Maspero's attitude: the eclectic stock in his shop places Marx next to Michaux and finds room for Giraudoux, as one of the great analysts of bourgeois society. Marker's commentary acknowledges Maspero's achievement in publishing books written by revolutionaries from different parts of the world, rather than about them, a policy that echoes SLON's objective of giving a direct voice to men and women involved in political struggles, rather than speaking on their behalf.

Marker's next contribution to the series, Number 6, *On vous parle de Prague: Le Deuxième procès d'Artur London* (1971, 'The Second Trial of Artur London'[30]), examines the political controversy surrounding Constantin Costa-Gavras's film *L'Aveu* (1970, *The Confession*), an adaptation of the memoirs of the Czech Communist Artur London. London had been one of the founders of the Czech Communist Party in 1948, and deputy foreign minister in the Czech government, when he was arrested in 1951 as part of the wave of purges ordered by Stalin that decimated the ruling Communist parties in the Warsaw Pact countries after the Second World War. London was imprisoned and tortured for almost two years until he emerged to recite his forced confession at the Slanksy show trial in November 1952. Of the fourteen defendants, eleven were executed and London was one of three sentenced to life imprisonment, although he was eventually released in 1956. *The Confession*, which details London's experience of the Stalinist terror, was intended as a contribution to the liberalization policies pursued during the Prague Spring of 1968, until the Soviet military invasion of Czechoslovakia in August of that year brought the country back under the mantle of Moscow. The book was initially published in France, and Costa-Gavras, who had recently directed the acclaimed political thriller *Z* (1968), acquired the film rights.

The film of *The Confession* generated widespread controversy and a good deal of political soul-searching among those involved with it, for reasons that *Le Deuxième procès d'Artur London* sets out to examine. Marker had been employed as stills photographer on the production of *The Confession*, and had made a short, silent film about the gruelling shoot, *Jour de Tournage*

(1969, 'Filming Day'), some material from which was reused in *Le Deuxième procès d'Artur London*. The latter film is built around on-set interviews with the film's stars, Yves Montand and Simone Signoret, the screenwriter Jorge Semprun,[31] members of the crew and Artur London himself, to air the criticisms that the film had provoked and to give participants the space to respond. Although London (along with the avowedly left-wing director, scriptwriter and performers) insisted that he remained faithful to Socialism and that *The Confession* was anti-Stalinist, not anti-Communist, the film was nonetheless widely condemned by Communists for lending ammu-

nition to its enemies. Significantly, it was the decision to turn the book into a film that came under attack. Where *The Confession* as a book had been cautiously welcomed and praised, the film adaptation was seen as a betrayal that played straight into the hands of Communism's opponents, and threatened to demoralize the masses. Writing in the PCF daily newspaper *l'Humanité*, François Maurin accused Costa-Gavras of turning a Communist book into an anti-Communist film.[32] Marker's film indignantly draws out the double standard that finds criticisms delivered through a comparatively elite cultural

form acceptable, but condemns the circulation of the same ideas in a medium of popular mass entertainment. The charge is levelled in an intertitle bearing the routine party slogan *apporter l'eau au moulin de l'adversaire* ('to carry water to the opponent's mill'). The interviewees respond that it is important for all Communists to acknowledge and openly debate the failures of

124

the past, in order to build a strong foundation for the future. Both Montand and London quote Antonio Gramsci's remark that the truth is always revolutionary. This argument had a directly personal resonance for Montand, Signoret and Semprun, for whom it is not too strong to say that *The Confession* was a kind of open political penance for their own former endorsement of the Stalinist purges. The then pro-Stalinist Semprun had kept silent, while Montand and Signoret had signed the poet Paul Eluard's statement supporting the Slansky trial: decisions for which they would later express bitter regret.[33]

Le Deuxième procès d'Artur London examines the uncanny mirror effects between film and real life in London's story, playing off these complex interactions of truth and fiction to underline the political significance of Costa-Gavras's film.[34] It opens with grainy archive footage of the Slansky trial, described by the commentary as a work of cinematic fiction rehearsed and staged as meticulously as any studio production, which contrasts with the delicately observed activity on the *Confession* set. At the end the film shows how in the summer of 1970 London's past was chillingly resurrected, since his involvement with Costa-Gavras's film led to his being stripped (for a second time) of Czech citizenship, and to newspapers in Brno and Prague circulating the trumped-up charges from his trial of 1952 as proven fact. Marker synchronizes the footage of Slansky's prosecutor in 1952 with a radio broadcast from 1970 repeating the accusations, pointedly demonstrating that the abuses of the past are still at work in the contemporary Soviet bloc.

Both *Maspero: Les mots ont un sens* and *Le Deuxième procès d'Artur London* consider the question of how committed Socialists and revolutionaries can acknowledge past mistakes, undergo productive self-criticism and still maintain their basic political beliefs, in a climate where their political opponents on the Right take such criticism as proof of the total failure of Communism, and the orthodox Communist parties regard it as a betrayal. This dilemma comes sharply to the fore in *La Bataille des dix millions* (1970, *The Battle of the Ten Million*), a clear-eyed account of the failure of Fidel Castro's ambitious project for Cuba to achieve a 10-million-ton *safra* (sugar-cane harvest) in 1969–70. Working with the editor Valérie Mayoux (another *Far from Vietnam* collaborator who had maintained a close involvement

with SLON), Marker assembled Cuban newsreel footage, extracts from propaganda films about the *safra* directed by Santiago Alvarez, photographs, cartoon montages and material from his own visit to Cuba (for which Alvarez acted as camera operator) to provide a fluent analysis of the progress of the harvest and the reasons for its failure. *The Battle of the Ten Million* examines the state of international relations between Cuba, the United States and the Soviet Union as the background to the harvest. Faced with US economic sanctions, Castro decided to aim for the mammoth sugar crop in order to place the Cuban economy on a secure footing, and free it from dependence upon Soviet aid.

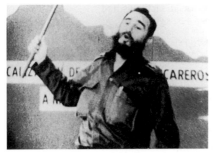

The culmination and centrepiece of the film is the astonishing speech that Castro delivered to a mass rally in Havana on 26 July 1970, in which he frankly admitted that the harvest had failed and attempted to account for why this had happened. The speech is presented in long segments to preserve the integrity of Castro's discourse, and was filmed from a fixed position where newsreel cameras were stationed. It is punctuated by shots of workers and peasants asked later what they thought of the speech, a technique that reinforces belief in a close populist bond between president and people. The July speech is mirrored at the beginning of the film by an earlier television appearance that Castro made in February 1970 to publicize the *safra* target. Where the later speech is treated as a direct and largely unmediated event, the February announcement is framed as a broadcast representation. We are shown Castro preparing to go on air and the television crew setting up in the studio, although the effect is actually to reinforce the informality and approachability of Castro's leadership style.

The commentary of *The Battle of the Ten Million* pitches the film directly as a sobering reality check for revolutionary romanticism in the West. 'This year, Cuba is no longer so fashionable', the commentary announces, proceeding to accuse those who are only interested in revolutionary martyrdom, or the immediate euphoria of victory, of being like 'ageing actresses who keep marrying ever-younger men', and of ignoring the mundane realities that face a country like Cuba: reorganizing the economy, pushing through

a reform programme and maintaining faith in the revolutionary struggle in the face of lassitude and international hostility. In making *The Battle of the Ten Million*, Marker was of course revisiting his own enthusiastic encounter with the young Cuban revolution in *Cuba si*, and without any overt gesture of self-correction, there is a clear shift in tone and purpose from the personal exploration and offbeat insights of the earlier film to the 'didacticism and desire for clarity, the refusal of lyricism',[35] that characterize the later. At the same time, there is much continuity between the two films, in terms of solidarity with the aims of the revolution, the privileged place given to Castro speaking directly, and a deep and fervent admiration for the Cuban people. In *The Battle of the Ten Million* this love of ordinary Cubans is most apparent in the scene combining film and photographs that shows the final days of the harvest in the Oriente district, which the commentary, by using the first person plural 'we', suggests that Marker observed first hand.[36] The

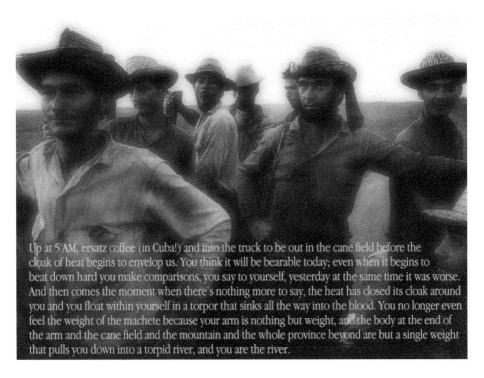

Up at 5 AM, ersatz coffee (in Cuba!) and into the truck to be out in the cane field before the cloak of heat begins to envelop us. You think it will be bearable today; even when it begins to beat down hard you make comparisons, you say to yourself, yesterday at the same time it was worse. And then comes the moment when there's nothing more to say, the heat has closed its cloak around you and you float within yourself in a torpor that sinks all the way into the blood. You no longer even feel the weight of the machete because your arm is nothing but weight, and the body at the end of the arm and the cane field and the mountain and the whole province beyond are but a single weight that pulls you down into a torpid river, and you are the river.

hard work and determination of the people augment the film's basic faith in Castro's model of hands-on populist government – earlier in the film we see Castro himself helping to cut cane. In his July speech Castro asserts that Cuba's enemies are wrong to believe that the people have any alternative to the revolution, despite the problems, setbacks and discontents. The inserts of the workers, who all voice their admiration of his speech, suggest no reason to believe otherwise.

When in 1967 Chris Marker began to tell the striking workers at the Rhodia about the film-train work of Alexander Medvedkin, he was fired by the enthusiasm of a new friendship, based on a longer-term fascination. Marker had recently met Medvedkin at the Leipzig Film Festival of 1967, through the intermediary of the Russian and Soviet film historian Jay Leyda, whose book *Kino: A History of the Russian and Soviet Film* was virtually the only history to mention the film-trains.[37] Several years earlier, Marker had been enthralled by a film sent to Jacques Ledoux at the Belgian Cinémathèque in a package of hitherto unknown Soviet works, which was Medvedkin's silent comic fable of 1934, *Stschastje* (*Happiness*, also known as *Snatchers*).[38] Sergei Eisenstein had called Medvedkin 'a Bolshevik Chaplin', and *Happiness*, the story of how a poor and discontented peasant named Khmyr found happiness by accepting his role in a collective farm, was a satirical knockabout fantasy that bore little resemblance to the glossy positivism of Soviet Socialist Realist cinema, although it still promoted the benefits of collectivization. Marker stayed in contact with Medvedkin, and in 1971, when the Soviet director visited France to make a film about pollution, he met with the group who had adopted his name, and also helped Marker and SLON with their project of rescuing *Happiness* from oblivion by organizing a release in France.

The French version of *Happiness* was accompanied in cinemas by *Le Train en marche* (1971, *The Train Rolls On*), an introduction to Medvedkin, *Happiness* and the film-trains based around an animated interview with Medvedkin filmed in a train depot in the Paris suburb of Noisy-le-Sec. The film begins with an audio-visual montage poem introducing the impact of the Russian Revolution upon cinema and the other arts. Its core motifs are the eye, the hand and the train. The cinema-eye theorized by Dziga Vertov sees everything (as we see snippets from Vertov's early *Kino-Eye* newsreels),

while 'By the trains/the blood of the Revolution circulates'. Marker found the material for this and later sequences by scouring archives in France, Belgium, the USSR and Scandinavia, although no footage from the film-train itself was discovered. The historical material is scored with a distinctive Marker accent: suites of photos with people levelling their gaze at the camera, and a sustained focus on the poignant expression of the young woman whose look is animated in *If I Had Four Camels*. The poem sets the stage for Medvedkin's description of the film-trains and their work, given as he walks past the trains in the depot. Medvedkin is a forceful and formidable talker who needs little prompting in his reminiscences. He describes the set-up of the train, which was equipped with a laboratory, editing room and cinema space, the arrangement of tanks on the train roof to provide water, and the resilience and enthusiasm of the 32person team, despite living for months on end in cramped and difficult conditions. Medvedkin then discusses specific cases where the team made films to expose and help solve the problems encountered by workers and peasants as they attempted

Medvedkin (1971)

to come to terms with the implementation of collectivization and the massive industrialization programme of the first Five Year Plan, launched in 1928. In one case, the film-train team visited an unsuccessful collective farm and showed the peasants a film that highlighted what they were doing wrong, alongside one from a model collective farm. After a heated discussion, a plan for making improvements was developed.[39] Medvedkin firmly emphasizes the impact of film as hard evidence. In another case, a film forced a factory that was producing defective goods wagons to take steps to correct the problem. The sense of the film as fact is reinforced by the direct footage of Medvedkin himself, his face held in close-up at crucial points of his narrative, which is sporadically punctuated by archive clips that serve mainly to confirm and enhance what he is saying.

The film train team (in *The Train Rolls On*). Medvedkin at far left.

The second half of the film concerns *Happiness*, and again an archive montage with commentary sums up the achievements of the film-train team: '294 days on wheels, 70 films, 91 reels, 24,565 metres of film projected, thousands of kilometres covered', before describing how the experience of the train fed directly into *Happiness*. 'So the train, while day after day dealing with immediate questions, also accumulated imaginary material. Imagination was no longer the enemy of reality, nor art of life.' Medvedkin now stands looking through the window of a train carriage, describing how the daily contact with the lives, hopes and disappointments of ordinary people that he got through the film-train inspired him to create the character of Khmyr: neither model worker nor evil *kulak*, but an average, poor, discontented peasant who finally learns to succeed and find happiness by putting his efforts into the collective farm. The film closes by emphasizing what its form had already conveyed: the continuity between Medvedkin's concern to put film at the service of the people in the 1930s, and the ambitions of the Medvedkin Group in the 1970s, 'to remind the working class that cinema is one of its weapons, and to learn how to look'.

Ecological politics are not usually mentioned as being among Chris Marker's preoccupations during the 1960s and '70s (and indeed before and since), but they are at the heart of a short film he co-directed with Mario Ruspoli in 1972: *Vive la baleine* ('Long Live the Whale'). Incorporating footage from *Les Hommes de la baleine*, the Argos-produced *Vive la baleine* is a sharply politicized re-take on Ruspoli's anthropological study, which now sets the archaic practices of the Azores whaling communities in the context of a pointed condemnation of industrialized whaling. Vivid Japanese wood-cuts, eighteenth- and nineteenth-century paintings, book illustrations, engravings, photographs and film clips are combined in a panoramic history of the evolution of whaling that takes in the Inuit, Rousseau's noble savage and the inevitable reference to Herman Melville, before arriving at cold, grisly footage showing the impersonal killing and processing techniques of the modern whaling industry. The inventive commentary weaves an

exchange between two voices, one 'exterior' (male) and one 'interior' (female – spoken by Valérie Mayoux). The former adopts the authoritative, neutral tone of the classic 'voice of God' documentary narration, while the latter speaks to (and for) the whale in an intimate, poetic, punning and allusive voice. The sombre images at the end of the film are accompanied by an impassioned poetic lament for the exploitation and destruction of a species, while a sound effect makes the whales appear to scream, before they are slaughtered and dumped on the deck of a Japanese whaler. The regular invocation of animals across Marker's work is often a secret sign pointing to the better parts of humanity, or at least to an ideal of utopian harmony between man and nature. The death of animals is part of the natural order, but here the wholesale killing and violation of another species becomes a troubling indicator of a human world out of kilter.

> For centuries, men and whales were in two opposing camps, con-
> fronting each other on a neutral territory: Nature. But Nature is
> no longer neutral: the frontier has moved. It is now between those
> who defend themselves by conserving Nature, and those who by
> destroying it, destroy themselves. Now men and whales are in the
> same camp. Each whale that dies, bequeaths us, as a prophesy, the
> image of our own death.

For once in Marker's work, the image of death is not a seductive lure, but a frightful prediction of the end of our own species.

Marker's keen interest in liberation struggles across Latin America came to focus in the early 1970s upon one country in particular: Chile. The election in September 1970 of the Socialist and Communist coalition Popular Unity, led by Salvador Allende, seemed for many on the Left to represent one of the most promising experiments in the development of Democratic Socialism for a continent where the influence of native landowning oligarchies, and the aggressive pursuit of neo-colonialist policies by the United States, had left most ordinary citizens powerless and impoverished. Marker himself travelled to Chile with a view to making a film about the impact of the new government, but when he discovered that the Chilean filmmaker Patricio Guzman and his colleagues already had the job in hand,

he decided instead to work through SLON to make their work available in France. The result was the SLON-produced French adaptation of Guzman's *El primo año* (1971–2, 'The First Year'), a sustained overview of Popular Unity's first year in office.

The brutal overthrow of Allende's government in the CIA-backed *coup d'état* that took place on 11 September 1973, and the regime of systematic terror, torture and murder instituted under the military dictatorship led by General Augusto Pinochet, dealt a severe blow to the hopes that the Left had invested in Chile as a beacon of democratic change. In the aftermath of the coup, Marker involved himself in a string of film projects that all touched in some way upon Chile's fate. In late 1973 he edited a shortened version of Miguel Littin's film *Compañero Presidente* (1971, 'Comrade President'), which showed an extended, multi-location interview between Allende and Régis Debray,[40] as Number 10 in the *On vous parle* series, *On vous parle de Chili: Ce que disait Allende* ('What Allende Said'). After a brief voice-over introduction by Debray which fills in the background of the coup, Allende discusses his political project, the problems he faces and the ruthlessness of the forces ranged against him. During the same period, Marker transposed recent events in Chile into a remarkable fictional document, *L'Ambassade* (1973, *Embassy*). In 1974 his acclaimed documentary portrait of Yves Montand, *La Solitude du chanteur de fond* (*The Loneliness of the Long Distance Singer*), fused personal friendship and the pressing political concerns of the moment, by filming the rehearsals and final performance of Montand's one-man benefit concert for Chilean refugees, held at the Paris Olympia on 12 February 1974 and his first stage appearance for six years. Marker and SLON again intervened to provide financial assistance for the now-exiled Patricio Guzman, this time to support the first instalment of his epic three-part account of the downfall of the Allende government, *La batalla de Chile* (1975, *The Battle of Chile*).[41] Marker also provided the commentary and co-ordinated production for the monumental collective film *La Spirale* (1975, *Spiral*), directed by Armand Mattelart, Jacqueline Meppiel and Valérie Mayoux, which drew on a wealth of newsreel and television footage to offer a systematic analysis of the destruction of Popular Unity.

Embassy announces itself as a Super-8 film diary discovered in an embassy. Silent, but accompanied by passages of commentary taken from

the filmmaker's notes, it records a few days during which a group of left-wing political activists took refuge in the embassy following a military coup. At first, the refugees discuss what has happened and find ways to fill the empty and uncertain time, relying on snatched telephone calls and rumours to piece together what is happening on the outside. When the television resumes broadcasts announcing the decrees of the new dictatorship, the group begin to argue bitterly among themselves about the reasons for their failure, reverting to an array of competing left-wing ideologies. The row sours the atmosphere until safe passages are arranged, and the spirit of solidarity briefly returns. The final shot of the film pans from a van in the street below the embassy to the far skyline and reveals an unexpected twist. To that point, the events described in the film seem to refer to the aftermath of the Pinochet coup in Chile, when many left-wing militants did seek refuge in foreign embassies, and when (as we learn in the film) others were rounded up and executed in the national sports stadium. Yet the final shot of the film reveals the unmistakable silhouette of the Eiffel Tower on the horizon, and the commentary confirms that the events did indeed take place in Paris. The veil of documentary authenticity is torn away, to reveal a work of fiction and a trenchant political allegory.

Embassy was Marker's first foray into using Super-8 film, which during the 1970s was promoted for amateur filmmakers and also widely used within the experimental and avant-garde cinema. Although Marker manages the camera with evident skill, pinpointing faces, social exchanges and the physical dynamics of body language, *Embassy* still retains the haphazard framing and shallow depth of field associated with Super-8, its visible grain and abrupt contrasts of light and dark. The amateur and domestic associations of the medium are played upon, as the refugees form an impromptu family group (with the ambassador and his wife as parents) and recreate a routine of cooking, eating, singing, playing games and doing household chores. Yet despite its associations with everyday immediacy, there is a distancing quality in the technical and chemical limits of Super-8: a fuzzy aura that keeps reality at one remove from the viewer. In *Embassy* this effect is reinforced by commentary filling the absence of synchronized sound. The informal, marginal nature of Super-8 is enhanced by the apologetic and awkward words of the filmmaker: these are notes, not a film; he would have liked to take his

first steps in Super-8 in better circumstances; his images cannot be processed, and so they are in suspension, like the refugees themselves. Although the people seem to ignore the camera, its presence remains 'preposterous', and after the wounding argument it is experienced as an intruder. One of the film's most striking images shows a woman caught between two dark bars and bathed in the light of a table lamp, looking at the camera with discomfort and hostility. (Her gaze is doubly violated, because she has the remains of a black eye from an encounter with the police.)

As a fictional commentary on the contemporary political world, *Embassy* invites comparison with *La Jetée*. Despite their evident differences, the films share a measured, inexorable narration, and a catastrophic transformation of Paris that leaves a small group of survivors trapped. The 'thousand unrecognizable streets' that the hero of *La Jetée* encounters in the Paris of the future resonate with the 'dead, indecipherable' urban panorama beyond the embassy windows. *La Jetée* distils fear of nuclear annihilation into a science-fiction fable; *Embassy* transposes the anxieties of the militant French Left, that the fate of their Chilean comrades could be replayed in metropolitan France, into a mock documentary that finally reveals its hand. On a deeper level, both films play with temporality to shift memories of the past into memories of the future: the favoured Marker trope of looking back at the present from the vantage point of the future. The events of *Embassy* seem to belong cleanly to the past, but once the fictional gambit is revealed, they refer to things that have not taken place – or at least not yet.

Back in 1951 Chris Marker had summed up the invigorating post-war renewal of *chanson* in one word – or rather, three: 'Montand, Montand, Montand'.[42] His article 'Petite suite sur thème des chansons' paid due tribute to other up-and-coming singers and musicians, but none excited him as much as the young working-class Italian immigrant from Marseilles, who had risen quickly through the ranks of French music hall to the resounding success of his first one-man show at the Etoile theatre in Paris in the spring of 1951. Marker admired many things about Yves Montand as a performer, but most of all his ability to marry musical refinement with a vigour and emotional frankness directed to the everyday realities of the post-war world. As Montand garnered increasing acclaim as a musician and film actor during the 1950s, he became, along with his wife Simone Signoret, a prominent 'fellow-traveller' of the PCF and an active supporter of left-wing causes. In December 1956 Montand and Signoret visited the Soviet Union, in the teeth of widespread condemnation of their trip prompted by the Soviet military intervention in Hungary just a few weeks before. Montand's tremendous popularity in the USSR (which extended throughout Communist Eastern Europe) was duly noted in *Letter from Siberia*: a Soviet song dedicated to Montand was included as both musical diversion and instructive comment on Franco-Soviet relations.

The Loneliness of the Long Distance Singer was released in Paris in December 1974 with the dormant *If I Had Four Camels*, but it was the Montand film that attracted critical accolades, as a fond and revealing homage to one of France's best-loved film actors and popular entertainers. *Loneliness* is a composite portrait of Yves Montand as man, star, dedicated performer and political being. Its playful and generous warmth registers the close personal friendship that had developed between the filmmaker and his subject through Simone Signoret, who had known Marker since the 1930s. Working with a team that included Pierre Lhomme and Antoine Bonfanti, Marker observed Montand through the week of preparation leading up to the Olympia performance. The finished film intercuts adroitly between rehearsals and final show to demonstrate the mechanics of the creative process: the impression of scintillating and effortless on-stage talent is shown to be the product of rigorous professional discipline and hard work.

Loneliness is a minor masterpiece of observational documentary. It uses intimate close-ups, zooms and pans to track meticulously the nuances of Montand's expressive, intensely physical performance style, his lively and exacting interactions with the orchestra, and even one of his legendary arguments with his long-time pianist Bob Castella, which were once described by Montand's agent as 'the best vaudeville act in Paris'.[43] The film brings out the visible centres of Montand's skill and vitality by consistently homing in on his mobile face – often his favoured left profile – quickstepping feet and graceful hand gestures. Marker had already in 1951 noted the 'steel-worker's paws which transform themselves at will into the hands of a Cambodian dancer',[44] and entire numbers in *Loneliness* are choreographed around the ballet of Montand's hands, their delicate eloquence embodying the spirit of the performer who brings life and meaning to the songs. As well as being watched, Montand makes jokey asides to the film crew,

and periodically breaks off during rehearsal to explain his performance technique and personal beliefs, either direct to camera or in an overlapping voice-over that works to reinforce the sense of organic interconnectedness between Montand's life, politics and art. The observational footage is supplemented by slowed-down iris shots of Montand's earlier stage performances and film roles (including *The War Is Over*, *Z* and *The Confession*) to flesh out the background of his life and political values, while eerie footage of the military repression in Chile (where Montand had in fact spent most of 1972, shooting Costa-Gavras's *State of Siege*) underlines the serious purpose behind the concert.

During his own visit to Chile in 1972, Marker had met the left-wing French sociologist Armand Mattelart, who since 1962 had been living and working in Latin America.[45] Mattelart was expelled from Chile in December 1973 and returned to France, where Marker suggested that he make a film based on his professional knowledge and close understanding of Chilean politics, which would examine the interplay of right-wing and

middle-class forces that, with the backing of the United States, sabotaged and finally brought down the Popular Unity government. Marker put Mattelart in contact with the editors Jacqueline Meppiel and Valérie Mayoux, and a scenario for the film was prepared in order to apply for funding. The title of the film, *Spiral*, derived from its proposed 'spiral' structure of seven successive phases of right-wing reaction leading up to the coup of 1973, many of which also delved back in history to consider, for example, the past roles of the military and the United States in Chilean affairs. The film drew on the abundant wealth of footage that had been amassed during the three years of Popular Unity government, by both Chilean and foreign filmmakers and news teams. In addition to this archive material, *Spiral* uses the device of a strategic board game, 'Politica', which had actually been designed and used in the United States to work out how to avert left-wing insurrection in Latin America, by analysing how different class, professional and social groups would behave in the event of a popular uprising. Pieces for the staging of the game in *Spiral* were designed by the satirical cartoonist Jean-Michel Folon, and scenes showing their manipulation are used to clarify the developing allegiances between the anti-government forces in Chile.

Spiral was put together through the editing process without a preexisting narration. When an initial cut was ready at the end of 1974, Marker, who had not been involved in the research and editing of the film, was invited by the team to help write the commentary. Valérie Mayoux recalls the intricate work involved in matching Marker's three-hour commentary to their 100-minute first cut (the final release version is 155 minutes long), but that the end result was that the dialectical argument proposed by the film was clarified and made more subtle. In common with Marker's other commentaries from this period, the emphasis is firmly on historical exposition and argument, but with a clear streak of mordant irony that, for example, seizes on the occupation of Santiago University by right-wing students as 'May 68 in reverse'.

Although Marker was not involved at every point of the film's production, *Spiral* nonetheless stands as an instructive precursor to *Le Fond de l'air est rouge*. It develops the same intricate marshalling of archive resources as Marker's later film, representing the arraignment of conflicting social forces at a given moment in history by playing off film extracts informed by

different political perspectives against each other. Interviewed about the film in *Positif,* Mattelart explained in detail how the team had consciously used material filmed from both left- and right-wing perspectives, to obtain a nuanced sense of the forces opposed to Popular Unity. In scenes showing the 'pots and pans' demonstrations by women against the Allende government (where they would bang on kitchen utensils), Mattelart explained that American television reports sympathetic to the protestors gave a clearer picture of the different classes of women who got involved in these demonstrations, rather than left newsreels, which relied on a clichéd vision of elderly harridans brandishing statuettes of the Virgin Mary. Like *Le Fond de l'air est rouge, Spiral* creates overlap and interplay between direct speech, voice-over commentary and music, to relay stages of the argument by exposing gaps and contradictions between different political positions, and between the gloss of public pronouncements and the reality of strategic goals. To a Chilean general who insists in an interview that the Chilean army is apolitical, and that the United States would never support a coup against the Allende government, the commentary (and significant portions of the film) retort with a firm reminder of how events turned out, and a pungent analysis of the army's past record of consistent support for the Right.

When *Le Fond de l'air est rouge* was released in November 1977, it was greeted with a flood of interest in the French press, as an ambitious attempt to take stock of the shifting tides of Left history over the preceding decade. Four hours long and organized in two parts: 'Les Mains fragiles' ('Fragile Hands') and 'Les Mains coupées' ('Severed Hands'), *Le Fond* assembles an astonishing array of archival footage, drawn from militant films and newsreels, film libraries and the French national broadcast archive INA (*l'Institut National de l'Audiovisuelle*), to retrace the issues, events and debates that provoked the upsurge of revolutionary activity in France and across the world during the late 1960s, and then saw this new Left founder in the face of right-wing repression, internal ideological disagreements and rapid political retrenchments. Marker explicitly pitched the film against what he saw as the historical amnesia surrounding the period promoted by its treatment on television, where 'one event is swept away by another, living ideals are replaced by cold facts, and it all finally descends into collective oblivion'.[46]

Le Fond opens with a majestic montage sequence of graphic matches between scenes from Eisenstein's revolutionary classic *Battleship Potemkin* (1925), and passages showing the demonstrations and pitched battles of the 1960s and '70s. Scored to a stirring march composed by Luciano Berio, the sequence condenses the entire historical sweep of the film into the dialectical unfolding of mourning, revolt and repression. Raised fists and banners are united across time; identical gestures of anger and defiance echo between history and fiction; robotic Cossacks march down the Odessa steps in synch with lines of armed CRS riot police and the US National Guard. After this breathtaking introduction, 'Les Mains fragiles' opens with the Vietnam War and its catalytic impact, tracks the rise of the student movement in Germany and France, and sidesteps to consider the Rhodia and Sud-Aviation strikes of 1967 as harbingers of 1968 in their questioning of the existing social order. It then examines the rupture between the orthodox Communist parties and the guerrilla movement in Latin America, identifying a fateful link between the imprisonment of Régis Debray in Bolivia and the assassination of Che Guevara there in October 1967, before returning to France to plot the euphoria and debacle of May 1968. 'Les Mains coupées' begins with events surrounding the Soviet military invasion of Czechoslovakia in August 1968. The conflict between old and new Left in Czechoslovakia forms a context for examining its refraction within French politics during the 1970s. Against the right-wing backlash that followed May 1968, but also Charles de Gaulle's political decline, the PCF fiercely rejected the Maoist and Trotskyist parties of the extreme Left, and instead moved towards the 'common programme': a coalition with the Socialists (led by François Mitterand) and Left radicals formed in 1972. The film then proceeds through an extended reflection on right-wing reaction and the clampdown on the revolutionary Left during the early 1970s, culminating in the violent overthrow of Popular Unity in Chile. It closes by returning to France, where 'nothing could be the same again', alluding to the transformation of the political landscape and its priorities since the 1960s via an array of clips that signal the emergence of the women's movement and the decline of the traditional Left. The final image is pessimistic yet defiant: wolves on an open prairie are being tracked and shot dead from helicopters, but 'there will always be wolves'.

The origins of *Le Fond* went back to 1973. Sorting out the ISKRA back office, Valérie Mayoux had discovered cans full of outtakes and rushes from SLON and ISKRA productions, and describing her find to Marker said: 'There's a film to be made here, a collage film that would use these fragments to tell a story.'[47] The idea of *Le Fond* as a film composed of rejected, unused materials, offcuts and outtakes would become central to Marker's conception of its historical purpose. Introducing the published script, Marker wrote that he had become curious about all the material that had been left out of militant films in order to obtain an ideologically 'correct' image, and now wondered if these abandoned fragments might not yield up the essential matter of history better than the completed films.[48] It would

be misleading to suggest that *Le Fond* is entirely composed of rejected and previously unseen material, but the film does contain some striking instances of a different history emerging from scraps of previously excised footage. In the sequence alluding to feminism at the end of the film, Marker includes a snippet from the material used to make *On vous parle de Brésil: Tortures*, where the sole woman prisoner briefly describes the sexual torture of women. This description is absent from the original bulletin, which emphasizes the common experience of all the prisoners, regardless of gender. Even where Marker reuses images familiar from existing films, they are subjected to a continual process of re-contextualization and reinterpretation through montage and commentary, so that their meaning for one

historical moment is shifted and interrogated at another. The strapline of the film could be 'You never know what you're filming', words Marker himself (in the French versions) says over grainy shots of Lieutenant Mendoza, Chile's champion show jumper at the Helsinki Olympics of 1952, who twenty years later would become General Mendoza, a member of Pinochet's *junta*. At a crucial moment near the end of *Le Fond*, Marker returns to the footage of clashes between anti-Vietnam War protesters and military police from the climax of *The Sixth Face of the Pentagon*. The commentary remarks that when the protesters broke through to the Pentagon, they were suddenly left free to advance, and speculates that they were being permitted a symbolic, empty victory, although not by the military police, who seemed taken by surprise and so attacked the protestors with considerable brutality.

> I filmed it, and I showed it as a victory for the Movement . . . but when I look at these scenes again, and put them alongside the stories the police told us about how it was they who lit the fires in the police stations in May '68, I began to wonder if some of our victories of the '60s weren't cut from the same cloth.

The process of re-contextualizing images in *Le Fond* included for Marker the idea that the work of interpretation would be opened up to the spectator. He aimed to create a dialogue between multiple political perspectives – which at certain points in the film becomes literal and hence very funny – that would avoid both a facile rapprochement of differences, and malicious point-scoring off speakers who contradict themselves.

> Each step of this imaginary dialogue aims to create a third voice out of the meeting of the first two, which is distinct from them. I don't claim to have succeeded in making a dialectical film. But for once I've tried (having abused the power of voice-over narration a fair bit in my time), to give the spectator, by means of the montage, their own commentary, that's to say their own power.[49]

This notion of two opposed voices creating a synthesis is a tidily stream-lined presentation of a film that actually incorporates a host of competing voices, those of the historical protagonists answered by the multiple voices (both male and female[50]) that periodically intervene to speak the passages of commentary.

As a groundbreaking work of visual historiography, *Le Fond* attempts nothing less than to give cinematic form to the chaotic and contradictory movement of world history during the tumultuous decade that it covers. As the critic Paul Arthur put it, 'in its rhythms and editing structures, *Grin* tries to embody the very shape and textures of historical transformation, rendering the abstraction of change as an amalgam of rapid, plurivocal, uneven, and, at times, contradictory forces aligned in provisional symmetries encompassing past, present and future perspectives.'[51] *Le Fond* is opposed to the selective versions of the past that are created by the winners of history, and to the resolution of history into a tidy linear narrative of causal progress. Instead, it attempts to trace the decline of the Left back to its sources, by juxtaposing an array of competing perspectives and events in a mosaic structure of film and television images, location sound, music and multi-vocal commentary, which benefits from the kind of hindsight that is able to see the complex interplay of different forces more clearly, but not the sort that assumes from the outset that defeat was inevitable or desirable.

Le Fond engages film and television imagery and representation more generally, as the actual substance of history, rather than its shadow. This is in keeping with the political importance attached to the media by the new Left, but it also acknowledges the crucial role that media representations had come to play in determining public response and government policy towards events such as the Vietnam War. A core premise of *Le Fond* is that the 'real' political history of the 1960s and '70s cannot be somehow abstracted from the welter of recorded images that documented it, debated it, offered it visual models of action and communication, and ultimately gave form to its memories. The sequence that opens the film's reflections on May '68 in Paris intercuts a series of blurred and jittery images with the words 'Why, sometimes, do images begin to tremble?' The reason, we learn, is that the hands of the camera operators were shaking without their realizing it. This gives the trembling images a privileged status, as the direct index of the feelings provoked by a momentous episode in history.

At the same time, *Le Fond* is keenly alert to the ambiguities that emerge when reality and representation appear to fuse together. The opening montage appears purpose-cut to tug at revolutionary heartstrings, but it also maps a visual rhetoric of political actions and gestures that undoubtedly had genuine power and meaning for those who practised them. Yet if *Battleship Potemkin* is posed as the source, these potent and sincere gestures are ultimately borrowed from a fictional jazzing-up of history. *Le Fond* maintains a keen eye for the theatre (and theatricality) of political protest: its ritual actions, gestures, chants, slogans, icons and rhetorical styles. The dilemma it confronts, from a hindsight only too aware of the defeat of the Left and the Right's attempts to make that defeat seem natural and desirable, is how to distinguish between authentic revolutionary impulses and hollow bombast, and how to deal with the possibility that both were part of a spectacle of managed dissent that was never in any danger of overturning the established order – the point raised in the return to Marker's footage of the Pentagon clashes. One of the funniest and best-loved sequences in the film, detailing Fidel Castro's habit of fiddling with microphones until he was stymied by an immovable one in Moscow, succeeds precisely because it is such a supple and effective metaphor for this very problem. Castro's gesture has an unconscious authenticity until it is blocked, at which point the

film finally (and literally) raises the curtain on the leaden and pompous spectacle of the first Cuban Communist Party Congress, and Castro (in full dress uniform rather than his usual fatigues) mouthing ritual slogans of solidarity with the Soviet Union. Extracts from the *Cuba si* interviews and one of Castro's mass rallies damningly underscore the distance that Cuba's president has travelled from the style of open populist oratory that Marker had showcased and admired in these earlier films, and from his former critical detachment from the Soviet model of Communism, to public endorsement – shown earlier in *Le Fond* – of the invasion of Czechoslovakia of 1968 as a political necessity.[52]

Le Fond provides a compelling account of specific events and developments from a tangle of competing perspectives, unfinished business and glaring contradictions – a certain conception of history carried through in the form of the film itself. There is, for example, a basic undertow of sympathy for the extreme Left Maoist and Trotskyist parties that were routinely vilified by the PCF – the funeral of the Maoist student Pierre Overney, killed by a Renault security guard in 1972 and denounced by the PCF as a *provocateur*, is presented as the last parade of the revolutionary 1960s – but the 'Letter to Some Comrades' read out in Part 2 is scathing about the ideological zealotry of Maoist intellectuals. Elsewhere, a different commenting voice remarks (rather patronizingly) that the idealistic young anti-war protesters at the Pentagon 'seemed to possess a silent but absolute knowledge of certain issues, but to be totally ignorant about others'. Much the same thing can and has been said of *Le Fond* itself. A number of contemporary critics pointed out that, while Marker offers meticulous analyses of the travails of the French Left and the split between guerrillas and Communist parties in Latin America, other significant struggles of the period are ignored completely, including those in Palestine, Cambodia and Angola, or drastically condensed into a few shots (Northern Ireland).[53] Feminists attacked the film for its failure to represent women's involvement in the revolutionary movement, arguing that the brief appearance of feminist demonstrations at the close of the film was at best tokenism, at worst a mockery of women's activism.[54] The biases of *Le Fond* broadly map onto Marker's own militant back catalogue – Vietnam, Chile, struggles between old and new Left as played out in France, Latin America and the Soviet bloc

– and this work forms its archival backbone, but to reduce the omissions of the film only to Marker's personal proclivities is to miss an important point. The loose ends, blind spots and inconsistencies pull the film *into* history as a selective, partisan and passionately contested account of events, rather than an object that can rise benignly above the muddle of a past whose repercussions were, at the time of the film's original release, still vitally important for, and hence bitterly disputed by, the French audiences who first saw it.

'A cat', the commentary of *Le Fond* remarks, 'is never on the side of power'. One proof of this is the bizarre spectacle of an annual festival held in the Belgian city of Ypres, to commemorate a medieval Christian king who defeated a sect of Flemish cat worshippers. The cat festival is immediately followed by another proof: the painful sight of disoriented, staggering and drooling pet cats – the first animals to show symptoms of 'Minamata disease', caused when the Chisso chemical corporation dumped mercury

into the water around Minamata in southern Japan. Soon the human population of the area was stricken with serious illnesses and the birth of severely handicapped children. *Le Fond* considers the vigorous protest movement against Chisso, launched by Minamata residents and political radicals, as an example of a new form of activism that developed in the 1970s, focused on local needs (and, in this case, environmental concerns) rather than grand ambitions to change the world. On a more modest scale, the reappearance of cats, even in this thoroughly politicized context, is a signal that Chris Marker was beginning to re-emerge from the anonymity of unsigned militant productions, and to reintroduce into his work the familiar tokens of his own distinct presence.

5.
Into the Zone

In 1978 the world took a small but extremely significant step into a new era of media communications, with the launch of the first Apple computer onto the market. In the same year, Chris Marker stepped into a new realm of image-making, with a sixteen-minute, two-screen video installation entitled *Quand le siècle a pris formes* ('When the Century Took Shape'). The piece contained archive film images from the First World War and the Russian Revolution that had been treated by an image synthesizer, their representational content drained away in favour of shifting coloured fields that just retained the outlines of recognizable figures and objects as a solarized flare.

By the end of the 1980s, when the market for home computers was just beginning its dramatic expansion, Chris Marker was already the established owner of an Apple II GS computer that he was using, among other things, to create primitive digital images. This computer and some of these images appear in what might seem an unlikely context: a television series investigating the legacy of ancient Greek culture in the modern world, which Marker titled *L'Héritage de la chouette* (1989, *The Owl's Legacy*). Yet, as he would demonstrate in an episode of the series devoted to mathe-

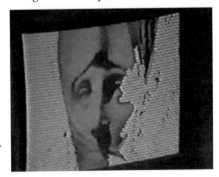

L'Heritage de la chouette (1989).

matics, there was a palpable link between the ancient Greek belief that numbers were the foundation of the universe and the digital codes that form the basis of all computing.

Between the installation and the television series, Marker began to diversify the media platforms in which he created work, under the impact of newly available technologies such as the Apple computer, the hand-held video camera and the domestic video recorder. He embraced new media enthusiastically and wholeheartedly from the outset, without any of the hand wringing or pronouncements of doom with which others attached to filmmaking frequently greeted the burgeoning electronic media and com-munications revolution. As early as 1984 Marker was conducting his rare interviews via computer, and pronouncing: 'Film and video are equally obsolete when you consider the incoming reign of digital images.'[1] Although he continued to release his work on film throughout the 1980s, every one of these projects contains images of and allusions to Marker's affirmative vision of new technology: the 'small imperfect miracle' of the video recorder that punctuates *AK* (1985), his observational portrait of the Japanese film director Akira Kurosawa; the pixel-face of the robot inter-galactic television presenter who contemplates the possible futures of the French trade union movement in *2084* (1984); and the French Minitel telecommunications terminal that carries tender memorial messages for the dead actress Simone Signoret in another portrait, *Mémoires pour Simone* (1986). Before all of these films there was *Sunless*: Marker's astonishing, exhilarating and endlessly fascinating meditation on 'the dreams of the human race'. Weaving together footage from Japan, Africa, Iceland, France and San Francisco, the global consciousness of *Sunless* contemplates the nature of memory, history and representation, through fragments of letters sent by a film cameraman to a woman who reads and comments upon them. It incorporates images manipulated by synthesizer in the same way as for *Quand le siècle a pris formes*, and casts them as products of 'the Zone', a machine with the power to create a realm outside space and time, designed for the contemplation of images in the form of memories.

Quand le siècle a pris formes (also known as *War and Revolution*) was made for the exhibition *Paris–Berlin, 1900–1930*, held at the Centre Georges Pompidou in Paris in 1978. The very fact of being placed in a museum,

rather than projected in a cinema, seemed to invite a different kind of critical reflection on the images of the past that it contained. The installation consisted of two television monitors, each showing the same sixteen-minute video loop with a short delay between them. This video presented a tight relay of archive film footage and intertitles that was inspired by the early *Kino-Eye* newsreels of Dziga Vertov. The footage was drawn from what for Marker were the defining events of the early twentieth century: the First World War, the Russian Revolution and the failed Spartacist revolution in Germany of 1919. The images of the First World War emphasize the devastation produced by new kinds of weaponry: fighter aircraft, flame-throwers and tanks. A further sequence tracks the events leading up to the Russian Revolution and Russia's withdrawal from the First World War. At some moments, the intertitles hold out promises that the images do not fulfil, such as 'Petrograd: Fraternizing Between Workers and Soldiers'. With the failure of the revolution in Germany, and the murder of Karl Liebknecht, the Soviet Union stands alone. The death of Lenin in 1924, the promise of 'no more war', and images of fashionable women in Paris intercut with Soviet women from Vertov's *Man With a Movie Camera* begin to hint at the eventual betrayal of both the Revolution and the promise of lasting peace.

The most notable feature of *Quand le siècle a pris formes* was the synthetic treatment of the archival footage. In *Le Fond de l'air est rouge* Marker had already begun to add quite prominent red, blue and sepia tints to some of the material he presented in the film, notably the extracts from *Battleship Potemkin*, to reinforce subtly its status as a cinematic representation. For the new installation, he began to experiment with a digital-image synthesizer to produce colour-saturated, irradiated representations that could be manipulated at will. Four years later, in *Sunless*, Marker would put forward a philosophy for the use of these treated images, claiming that they break down the illusory presence of the past normally created by archive film, and allow the depiction, in 'non-images', of things that either do not officially exist in history, or have ceased to exist. Viewing *Quand le siècle a pris formes* in the light of these ideas, the installation figures both the 'inhumanity' of the First World War, reducing images of people to an inchoate blur as the new weapons had reduced human bodies to rubble, and the failed, lost aspirations of the Russian Revolution. Only film has survived, and what it once

recorded must now be reimagined in the light of how history has changed.[2]

On a visit to San Francisco during the production of *Sunless*, in July 1981 Marker and two colleagues filmed a group of weathered sculptures on the Pacific shore at Emeryville Beach. This footage formed the basis of the six-minute study *Junkopia*, produced by Argos Films and awarded a César for Best Documentary Short in 1983. The spectral sculptures are assembled from discarded scrap and driftwood with dashes of colourful paint, and include a propeller aeroplane, a stork, a kangaroo, a bright fish and a rudimentary spacecraft. A fixed camera catches these figures from a variety of precise angles, framing them against the empty sky or as dispersed, edgily composed groups, with the only movement coming from wind-blown shreds of cloth or plastic. The mood of elegiac abandonment is enhanced

by a collaged score of synthesized music, location noises and snatches of a citizens' band radio broadcast (sounding like a communication link between a distant spaceship and ground control). Gradually the wider world enters the picture as we see and hear the freeway running directly behind the beach. The film begins and ends at high tide, with the sculptures submerged apart from the propeller plane mounted on its pole. The melancholy mood of *Junkopia* – cars roar past heedless as the sculptures are gradually worn away by the elements – cues one of the central preoccupations of *Sunless*: the fragile transitoriness that the commentary will invoke through the Japanese concept of 'the impermanence of things'. The little sketch connects to Marker's interest in art made from humble and abandoned materials, like the litany of twentieth-century examples, from Braque's and Picasso's collages to Alexander Calder's mobiles, which he mentions approvingly in *Giraudoux par lui-même*.[3] It also looks forward to two video studies in *Zapping Zone* that explore and record ephemeral events: *Christo '85* and the recent addition *E-Clip-Se* (1999). Like these later short works, *Junkopia* creates a memory that will remain when the sculptures have been carried away by the sea.

Marker also in 1981 provided photographs to accompany the Corsican novelist Marie Susini's bittersweet memoir of her birthplace, *La Renfermée:*

La Corse.[4] Slicing through tourist clichés of Corsica as the home of Napoleon and a benign, relaxing holiday destination, Susini depicts a land of stern beauty, implacable insularity and rigid social customs, whose memory she treasures but whose suffocating ties she readily escaped. Marker's photographs depict the rugged landscape and architecture of Corsica and its human and animal inhabitants. They broadly illustrate Susini's preoccupations with Corsica's harsh culture and troubled history, but are not engaged by her text, and so are deprived of the satisfying tension opened up in Marker's own photo-text projects by the author's allusive and penetrating engagements with his own images. That said, the human portraits do offer a tightly candid and sympathetic look at Corsicans of all ages, and two striking images of a young woman in black with her arms folded embody Susini's own vision of Corsica as a mourning woman.

If one film can be considered Chris Marker's masterpiece, the strongest candidate is *Sunless*, released in France in 1982. Certainly Marker's best-known and most widely seen film-essay (outside the atypical fiction interlude of *La Jetée*), *Sunless* enjoyed relatively wide exposure overseas, and served to bring Marker back to prominence after what looked from outside France like a prolonged period of absence. At once a grand summation of the path and preoccupations of his work to date, and a prescient hinge into the themes and ideas that would come to dominate his future output, *Sunless* manages to synthesize and transcend its component obsessions into a virtuoso meditation on time, place, memory, history and representation. The consummate world traveller and the militant filmmaker disillusioned by the defeat and collapse of the revolutionary struggles of the 1960s both emerge through *Sunless* to take stock of their past and reflect obliquely on the meaning and purpose of their activities. The bent of these reflections leads towards memory, understood as both private reverie and the shared collective beliefs that compose a sense of history, as the central preoccupation and structuring principle of the film. The ways in which memory perpetually reshapes past events and experiences are figured in *Sunless* through the periodic visual and aural distortion of both film images and sound sources, by processing them through synthesizers. The reflections that the film offers on these synthetic images (sound is not explicitly discussed) crystallize the pioneering enthusiasm for new media technologies that

Marker had first exhibited with *Quand le siècle a pris formes*, and establish a precedent for exploring questions of deep cultural memory through new media that would extend across much of his subsequent work.

The premise of *Sunless* is that an unseen woman reads and comments upon letters she receives from a globetrotting freelance cameraman, Sandor Krasna, whose name we discover only in the closing credits.[5] Krasna is particularly drawn to what he calls 'the two extreme poles of survival', Japan and Africa, the latter represented by the former Portuguese colonies of Guinea-Bissau and Cape Verde; but his dispatches also take in Iceland, San Francisco (for a tour of the locations of Alfred Hitchcock's *Vertigo*) and the Ile-de-France. As Marker puts it in his own presentation of the film, 'the cameraman wonders (as cameramen do, at least those you see in movies) about the meaning of this representation of the world of which he is the instrument, and about the role of the memory he helps create.'[6] Krasna has a Japanese friend, Hayao Yamaneko, who designs video games and as a sideline obsessively feeds film images into a synthesizer, whose de-naturalized visual world he calls the Zone, in homage to Andrey Tarkovsky's *Stalker* (1979).[7] Yamaneko believes that the graphic mutations of the Zone are in many senses more truthful than the illusory presence conjured by conventional film footage and photographs, since they can depict quite literally the shifting and transforming action of time and recollection upon the images of the past. Finally, the material provided by these various characters has been assembled by a filmmaker, not in the form of a conventional narrative, but 'in the fashion of a musical composition, with recurrent themes, counterpoints and mirror-like fugues'.[8]

Within this overall musical structure, the intricate montage of images and sounds in *Sunless*

most closely approximates what Jon Kear calls 'the structure of reflective consciousness'.[9] The film enacts a process of sorting things out and linking them together, while continually addressing itself to the nature and function of this process. Some passages of the film unfold in the form of logical argument and exposition, others via associations motivated by the cameraman's playful and incisive intellect, and others still through the haphazard drift of memory. During a long sequence focused on the dancers of the Awa Odore festival in Tokyo, for example, three brief shots of a rower, an emu and an African dancer are inserted, as random memories brought to mind by their chance resemblance to the composed expressions and hand gestures of the Japanese dancers. In *Sunless* memories are taken to be indivisible from the media that record them, as in an often-quoted passage that Krasna writes: 'I remember that month of January in Tokyo, or rather I remember the images I filmed of that month of January in Tokyo. They have substituted themselves for my memory, they *are* my memory.' Although many of the images and events treated in the film are located very precisely in time and place by the commentary, for the viewer they exist in a temporally ambiguous arrangement that makes the timeless 'eternity' of the Zone a *mise en abyme* of the entire film. The fugitive allure of *Sunless*, with its perpetual flow of dazzling, transient images that appear and disappear so quickly, is intimately linked to the sense that everything we witness has already passed through the filter of memory and is marked by 'the fragility of those moments suspended in time, those memories whose function had been to leave behind nothing but memories'. This ephemerality resonates with discussions of 'the impermanence of things', and the 'passion for lists'

ascribed to the tenth-century Japanese writer Sei Shōnagon, author of *The Pillow Book*. With his professed interest in banality, Krasna shares Shōnagon's melancholy delight in 'the contemplation of the tiniest things', and her list of 'things that quicken the heart' in particular strikes the cameraman as an apt criterion for filming. The intense poignancy derived from heart-quickening things is in direct proportion to their triviality – the motley accumulation of sights and signs gathered by Krasna on his return to Tokyo includes, in random order, a woman chalking characters on the road, a cat peering over a parapet, a shop window display of a clarinet that plays itself, a poster with an owl on it, and a street fortune-teller – and the sense that, on another occasion, the contents of the list would have been completely different.

The memory that is offered for our contemplation in *Sunless* is linked in numerous respects to the trajectory of Chris Marker's earlier work, and a thread of tidy, discreet allusions to his previous films is shot through it – not to mention a signature abundance of his favourite creatures. In the opening lines of the commentary we learn that Krasna has been unable to link a shot of three Icelandic children filmed in 1965 to other images, and see a brief flash of a fighter plane being lowered into the deck of an aircraft carrier. The plane returns us to *Far from Vietnam*, and to the shift in Marker's work to militant, collective filmmaking in 1967, which is also evoked in Krasna's various reflections on the fate of 1960s revolutionary struggles. The children themselves can be seen as an oblique reminder of Marker's comments about Scandinavian societies as the apex of modern civilization in *If I Had Four Camels*, which contributes a social dimension to

the personal resonance of 'happiness' that the cameraman associates with the shot. Krasna's return to Tokyo conjures Marker's first visit to the city to make *The Koumiko Mystery*, and rediscovers the orientation points of the earlier film, such as the Ginza owl and the spectacle of people watching television in the street, but in a subtly changed form.[10] Later in the film, two allusions are made to *La Jetée*, both heralded by a snatch of its soundtrack. This music offers the sole clue to the identity of 'the little bar in Shinjuku' (assuming one does not recognize the photos on the bar wall), which is in fact called La Jetée, and is Marker's own enterprise. The second allusion is to 'another film' in which, as in *Vertigo*, hands point at a slice of sequoia trunk to indicate a span of time.

Sunless also pushes beyond this web of Chris Marker related allusions to posit a kind of global, disembodied consciousness. Its characters may be a cast of alter egos invented by the filmmaker, but, as with the polyphonic commentaries of *If I Had Four Camels* and *Le Fond de l'air est rouge*, it is too simplistic to reduce the discourse of the film to Marker's control, and thereby overwrite the gaps and tensions that are opened up between the different personae of the film. Krasna, for example, fondly dubs Yamaneko a 'fanatic', and there is a sense in which these characters represent two conflicting models of memory: Yamaneko the truism that memory is always a selective reinvention of the past to answer the needs of the present, and Krasna a residual faith in Proust's madeleine – the inconsequential experience that can restore a moment of the past in its entirety – despite his routine affirmations such as 'we rewrite memory much as history is rewritten'. There are tensions too between the relay of Krasna's thoughts and observations by the female commentator, and those times when she offers her own reflections on the letters she is receiving, becoming more than a dutiful mouthpiece and subtly placing the viewer at a distance from the cameraman.[11] Augmenting these multivocal properties, a number of sequences in *Sunless* are borrowed from the work of other filmmakers, and apart from Haroun Tazieff's footage of an Icelandic volcano, are acknowledged only in the closing credits, meaning that the viewer can only in retrospect disentangle what she or he probably assumes are Marker's images from those shot by other people.[12] *Sunless* is thick with visual and aural allusions to other texts, which in addition to those previously mentioned include Jean Cocteau's *Le*

Sang d'un poète (1930, *The Blood of a Poet*), Modest Mussorgsky's song cycle *Sunless* (1874) and Francis Ford Coppola's *Apocalypse Now* (1979). Marker also insistently presents images that are already constituted as media representations, notably the hallucinatory sequence of moments from Japanese television, which later escape from the confines of the screen to invade the dreams of people filmed asleep in Tokyo commuter trains.

Japan is cherished in *Sunless* as 'a world of appearances'. One of the labyrinthine paths into memory proposed by the film involves simultaneously trusting to appearances (nothing is left but the ephemera of images), and recognizing that they can be deceptive; or, more specifically, that they require time in order to be properly understood. In one passage, the film proposes that what passes for collective history might be nothing more than an accumulation of private memories and wounds. Relating the progressive betrayal of the revolutionary legacy of Amilcar Cabral, who had united the independence movements of Cape Verde and Guinea-Bissau and won a guerrilla war against the Portuguese, the film lights on footage of a military award ceremony in which Amilcar's half-brother Luiz (now the president of Guinea-Bissau) is decorating Major Nino. We are told that in order to interpret this film, we must move forward a year, when Nino will have deposed Luiz in a military coup, and we will understand that what

looked like a moving affirmation of revolutionary solidarity was in fact a viper's nest of bitterness and resentment. 'And so men parade their personal lacerations in the great wound of History.' The point at which *Sunless* begins to unravel its own web of appearances is its excursion into *Vertigo*. Krasna is obsessed with *Vertigo* as the only film ever to portray 'impossible memory, insane memory', and writes that he has seen it nineteen times. Making his pilgrimage to the sites where the film was made, and recalling Hitchcock's original via a series of stills that are momentarily held and dissolved between his own footage, Krasna reworks Hitchcock's narrative into a new story, 'so carefully coded that you could miss it', which concerns the inexorable workings of time and the desire of human memory to vanquish it, by creating a new image of whatever has been lost. The spiral motif of *Vertigo*'s credit sequence, covering the space of a human eye, is really the spiral of time; the murder mystery plot is really about 'melancholy and dazzlement . . . power and freedom', and the character of Scottie (James

Stewart) is recast as 'Time's fool of love'.[13] This unveiling of appearances to reveal time at work in the representation of space may be logically extended to cover the perpetual geographical displacement enacted across *Sunless*, which then emerges as one vast metaphor for the passage of time. In the commentary of *Embassy*, Marker had written: 'What we call past is somehow similar to what we call abroad. It is not a matter of distance, it is the passing of a boundary.' The phrase is not recalled in *Sunless* itself, but it does appear in its companion volume, *Le Dépays*.

One temporal boundary explicitly addressed in *Sunless* is the passage between life and death. If the *Vertigo* sequence is one fulcrum in the film, another is the lacerating moment when the refined annual ceremony commemorating the death of animals in Tokyo Zoo is intercut with the brutal slaughter of a giraffe in the African savannah. We begin to understand the logic of Krasna's interest in Japan and Africa in relation to Marker's preoccupation with cultures that find a way to accommodate

death, rather than fearing and repressing it. The commentary relates that 'the partition that separates life from death does not appear so thick to us [the Japanese] as it does to a Westerner', and we are invited to imagine that the Japanese children who peer curiously past the table where white chrysanthemums are offered to the dead animals are trying to see across this partition. What they see, by virtue of the montage, is the shooting of the giraffe. The harsh contrast exposes the pain and loss that the ceremony endeavours to manage by giving it a form of ritual expression. From here the film begins to unfold Krasna's neat aphorism that 'memory is not the opposite of forgetting, but its lining' by extending forgetting to embrace annihilation and irrecoverable loss. The memory-image of the three Icelandic children finds its place in the film only when we discover that the town where they lived has been obliterated by a volcanic eruption – a geo-logical equivalent to the long strip of black leader that was used at first to separate them from the body of the film. History itself fabricates official versions of the past, distributing amnesia 'through mercy or calculation' to conceal the rate at which it consigns the past to oblivion, and 'has only one friend . . . horror'.

Like *Le Fond de l'air est rouge*, *Sunless* is preoccupied with the tensions between official cultural memory and those historical events and experi-ences that it routinely represses and denies. Although Krasna emerges as thoroughly disillusioned with the revolutionary movements of the 1960s (a position that has led some to regard *Sunless* as a sign of Marker's disabused retreat from political engagement), he is astute enough to temper his laments with the recognition that, for the Japanese peasants who cam-paigned against the building of Narita Airport, 'all they had won in their understanding of the world could have been won only through the strug-gle'.[14] Hayao's Zone is initially introduced as a mechanism that can make explicit the operations of time and memory upon film images, by trans-forming them from mimetic representations of the world into shifting and manipulable fields of vivid pixellated colour. Hayao defends his treatment of archive film showing the Japanese protests of the 1960s by arguing 'at least they proclaim themselves to be what they are: images, not the portable and compact form of an already inaccessible reality'. Later in the film, another use is found for the 'non-images' of the Zone: showing things that

do not officially exist in Japanese history and cultural identity. A series of Zone images depict the *burakumin*: the lowest rank of the Japanese caste system that was officially abolished in the Meiji era,[15] but which still actively operates in contemporary Japanese society. The Zone also mediates scenes showing Japanese *kamikaze* pilots preparing for a mission, and their raids against US warships stationed off the island of Okinawa. Over these images, the final letter of one pilot, Ryoji Uebara, is read to demonstrate that not all the *kamikaze* were devoted fanatics; many were torn between national loyalty and deep reservations about the sacrificial ethos of the Imperial Army that they could never fully express. The repressed history implied in this sequence echoes with the earlier observation that neither the Japanese, nor the American occupying forces, recognized the existence of the native Ryukyu civilization that was virtually wiped out in the battle to capture Okinawa – a subject to which Marker would return in *Level Five*.

On Okinawa, Krasna films a purification ceremony attended by elderly and middle-aged islanders and conducted by the Noro priestess. He writes that he is aware of witnessing 'the end of something': that when the Noro dies she will not be replaced, and the handing down of tradition will cease, because the rupture in Okinawa's history caused by the Second World War has been too violent. The feeling of loss here is especially poignant, to the extent that *Sunless* is a film lovingly devoted to rituals whose purpose is

precisely 'to repair the fabric of time where it has been broken', like the suburban Tokyo couple who have come to pray for their lost cat at the cat temple of Go To Ku Ji. The Bissau carnival, the copulating stuffed animals in the Josenkai sex museum on Hokkaido (another memory of utopia), the military ranks ceremony, the *Vertigo* pilgrimage; ceremonies for broken dolls, dead zoo animals, and the one named Dondo-yaki, devoted to the debris collected during the Japanese New Year festivities. All these, and the countless other rites and festivals that traverse *Sunless*, are drawn together and highlighted by yet another ritual activity: that of shooting film, creating a stockpile of memory-images of the world as a bulwark against the losses imposed by the passing of time. In another *mise en abyme*, Krasna recounts the plot of a film that he will never make, but which would have been called *Sunless*. It concerns a time-traveller from 4001 who has perfect memory recall, but becomes drawn in compassionate fascination to the poignancy of forgetting that exists in his planet's own past. He discovers that the emotional impact of works of art, like the Mussorgsky song cycle he

knows but has never really understood, is inseparable from the pain of loss and oblivion. At the end of Marker's *Sunless*, Krasna's own images in their turn enter the Zone. Deformed and mutable, they are acquiring the patina of time and losing their aura of presence, but they can now be cherished as memories, held so that the fleeting 'real look', directed at the cameraman by a market woman from Praia in the Cape Verde Islands, can be fixed and contemplated: a resonant figure recollected against a ground of emptiness.

In *Le Dépays* Marker invents another trajectory through his memories of Japan, this time in the form of three short texts and a series of photographs. He traverses Tokyo in pursuit of his inexhaustible mania for cats while remembering past feline companions now lost or dead. He watches the sleeping faces of train commuters, wonders which Japan is passing itself off for the other, and ponders the undercurrents of savage violence that permeate the popular Japanese legends related in films, television shows and comic strips. His written texts allude to or imagine the contents of

his photographs, while his photographs spiral off into their own parallel meditations on the themes of his texts. And all the time this Marker is actually somebody else, since he addresses himself in the second person plural. The projection of Japan allows Marker to invent a path through an imaginary country, in which the route always matters more than the destination, and where 'I am so disoriented that I am only myself in this disorientation.'[16]

The year 1984 was the centenary of the French trade union movement, and in a reprisal of his past engagements with labour politics, Marker accepted an invitation from the CFDT union to make a short commemorative film to mark the occasion. He decided to pitch the anniversary a further hundred years into the future, and in collaboration with the Groupe Confédéral Audiovisuel CFDT ('CFDT Audiovisual Group') made *2084*. The film is set in an audio-visual laboratory, equipped with film editing and projection equipment, and monitors that transmit synthesized film footage of the kind seen in *Sunless*. Three young filmmakers silently ponder three different hypotheses about what will happen to trade unionism in the intervening century, put forward by a robot intergalactic television presenter. The grey hypothesis is the path of stasis, complacency and comfortable accommodation with the powers that be. The black hypothesis is a pacified future of techno-totalitarianism in which trade unionism will have effectively ceased to exist. The blue hypothesis – the one that the robot presenter recommends – recognizes that technology can be harnessed to continue the struggle against hunger, disease, suffering, ignorance and intolerance. The future is not preordained, and the union movement can still fight for

change by becoming a bridge between anger at injustice and the dream of a better world.

In the space of *2084*'s ten-minute running time, Marker crystallizes his vision of new technology as an instrument that can abet positive social change, and delivers a rallying cry for renewed faith in the founding values of trade unionism. The laboratory depicted in the film is a time machine and an image factory where the projections of past, present and future are brought together. With *La Jetée* and *Sunless*, *2084* imagines the distant future as a critical vantage point from which to see the present more clearly, and its sights are set firmly on the business of imagining and creating that future: 'less about what's been achieved, more on what remains to be done'. The film presents a series of striking palimpsests that embody the inter-action of human beings and technology, and the belief that technology can be harnessed for the good of humanity. Film footage is projected onto the face and hand of one of the filmmakers, making her a reflective surface that projects or manipulates the images of the past and present. Later she becomes the visual source of a digital sunburst, which explodes on a screen behind her head as the terms of the blue hypothesis are read by the robot presenter. Each hypothesis is prefaced by snapshot talking heads from 1984, who, by telling the camera what they like or don't like, present the feelings and desires of ordinary men and women as the building blocks with which the union movement has to work in seizing the unprogrammed future.

> That famous technology isn't automatically destined for those who expect of it a new and particularly crafty form of power. It begins to reveal itself before our eyes as a fabulous instrument for changing the world . . . There is still struggle, but in the terms of the twenty-first century, not those of the nineteenth.[17]

The intimate association with Japan that Marker had affirmed in *Sunless* was extended three years later, when he was invited by Serge Silberman, the French co-producer of Akira Kurosawa's *Ran* (1985), to make a behind-the-scenes documentary portrait of the veteran Japanese director at work on the film. The result was *AK* (1985), a film that enjoyed considerable attention on its release as a timely adjunct to the towering critical success of *Ran*, regarded as one of Kurosawa's finest works and welcomed as a magisterial return to form after the mixed reception that greeted *Kagemusha* (1980). *AK* is built up from meticulous observational footage of the director, cast and crew working on *Ran*, with the complementary device of a television and video recorder set against a bright red background. We are informed that the *AK* crew (the commentary adopts the first person plural) use the equipment to watch television every night – its 'history without memory' an absolute contrast to the universe of the film set – and to re-watch Kurosawa's earlier films on tape. Ten title headings inscribed in Japanese characters – Battle, Patience, Fidelity, Speed, Horses, Rain, Gold and Lacquer, Fire, Fog and Chaos (this last the English meaning of *ran*) – are interspersed through *AK* to focus observations about Kurosawa's working practices, together with some of the recurring motifs found in his films. At the beginning, the television space is occupied by a hand holding a miniature tape recorder (it recurs later on), which the commentary tells us is used to play snatches of conversations with Kurosawa, recorded surreptitiously by his close associates and gratefully received by the *AK* crew.

This early admission hints at the fact that the makers of *AK* may have carte blanche to film the shoot, but they have not been granted direct access to Kurosawa himself. Firmly outside the charmed circle of regular collaborators identified in the finished film, they are confined to observing proceedings from a distance and letting slip the worry that they are being a nuisance. Since *The Seven Samurai* (1954), we learn, Kurosawa has had the habit of shooting scenes from three different camera angles. 'For him that means three times as many shooting angles to master, and for us three times as many chances of getting in the shot.' Despite this nervousness, the main actors and crew are frequently observed at close quarters during rehearsals, takes or set-dressing. The impression conveyed is of intensely focused and disciplined activity, in which a universal respect for Kurosawa

motivates everyone to pitch in and help with necessary tasks, regardless of their assigned job or professional status. A number of episodes illuminate celebrated facets of Kurosawa's character as a director: his disciplined equanimity on set, and his willingness to lavish attention on elaborate scenes that are cut without a thought from the finished film (in this case, the nocturnal sequence for which he had a field of pampas grass painted gold). It is not long before the mood of awed reverence rubs off on *AK* itself: 'We too got into the habit of calling him *sensei*: "Master".' The commentary even goes so far as to forbid *AK* from capitalizing on a particular kind of cinematic beauty that does not rightfully belong to it, as if its dazzling shot of a backlit mounted warrior was usurping Kurosawa's territory. Instead, it must stick to the humble remit of documentary observation: 'we will try to show what we see as we see it, from our own level'.

Kurosawa and his team obligingly preserve the mystique by ignoring the *AK* cameras entirely, even when relaxing between takes. It is left to the enormous cast of extras to furnish a precious moment of interaction, when one man is told jokingly that he'll probably be invisible in *Ran*, but he might actually get seen in this film. He is obligingly given a subtitle credit as 'The Unknown Warrior of Mount Fuji'. *AK* quietly extends Marker's own brand

of workaday beauty in several passages that study the extras in loving detail, homing in on busy hands and absorbed faces as they don the complicated armour, warm up with hot soup, or change back into their everyday clothes when shooting is suspended because of the fog. The extras temper the mood of high seriousness by effectively illustrating some of the more mundane aspects of filmmaking, such as the tedious stretches of time spent hanging around waiting for the weather to cooperate with the shooting script. They also provide Marker with a comic vehicle for showing the clash of ordinary reality and illusory reality on a film set, since we are treated to the spectacle of men – and one or two women – decked out in full sixteenth-century warrior garb, wearing glasses, smoking cigarettes, doing facial exercises or earnestly discussing the latest computer games. The incongruity is particularly delicious because Kurosawa was renowned for his meticulous attention to period detail – he famously insisted that the metal nails used to build the sets for *Throne of Blood* (1957) be removed and replaced with wooden pins.

AK is the second of three portrait-films in which Marker has focused, at least in part, on the outward mechanics of the creative process. His homage of 1999 to Andrey Tarkovsky, *Une Journée d'Andrei Arsenevich* (*One Day in the Life of Andrei Arsenevich*), is built around a video that Marker made of Tarkovsky shooting the climactic scene of his final film, *The Sacrifice* (1986). Like the study of Yves Montand that preceded it, *AK* is an accomplished observational work, which rises to the added challenges of showing the complex patterns of activity (and inactivity) on a feature-film set, and offering a tentative set of co-ordinates for placing the as yet unfinished *Ran* within the body of Kurosawa's other films. The difference is that *AK* lacks the spark of complicity that in the Montand and Tarkovsky portraits passes between the filmmaker and his subjects, since Marker was a close friend of both men. The tone of unwavering reverence towards Kurosawa eventually becomes cloying, but a deeper problem is that his distance from, and apparent indifference to, the presence of Marker and his crew leaves *AK* having to scramble from the outside to thread together insights into its subject's work, and paradoxically to obtain its best material from those who are also furthest removed from the epicentre of the great director.

At the Cannes Film Festival of 1986, the French television listings magazine *Télérama* sponsored the screening of a film that Marker had compiled

for the festival in homage to his childhood friend Simone Signoret, who died in September 1985. Known as *Mémoires pour Simone* ('Memories for Simone'), the film never went on general release because the rights holders of the feature films excerpted in it would not authorize commercial distribution, and it is often not listed in filmographies of Marker's work. The film is kept at the Cinémathèque Française, and was shown again in Marker's retrospective of 1998, paired with *The Loneliness of the Long Distance Singer*. *Mémoires pour Simone* was made at the suggestion of Yves Montand and Signoret's daughter Catherine Allégret, and put together in the space of two frantic months spent searching film archives and tracing rights holders.[18] It is pitched as 'the contents of a cupboard': a scatter of random memories and recollections that weave together episodes from Signoret's life with clips from around forty of her film roles and television appearances. The reflective commentary, read by the French actor François Périer, incorporates passages from Signoret's autobiography *La Nostalgie n'est plus ce qu'elle etait* (1976, *Nostalgia Isn't What It Used to Be*), and extracts from several interviews with the actress. Signoret's dozing cat César is the designated keeper of memories, a cipher for Marker's own uncredited role in assembling the film.

As a work of memory, the broadly chronological structure of *Mémoires pour Simone* frequently makes random leaps prompted by mental associations, for example across the three films in which Signoret portrayed a character named Thérèse,[19] or between her roles in two Resistance dramas, René Clément's *Le Jour et l'heure* (1963) and Jean-Pierre Melville's *L'Armée des ombres* (1969, *The Army of Shadows*). Marker is most interested in those occasions when the life and the shadow realm of the movies bleed into and influence one another, which he frequently underscores and on occasion invents by inspired graphic matching. A home movie of Catherine Allégret as a child, rinsing her feet in the garden, cuts to the adult Catherine taking a shower in Costa-Gavras's first feature *Compartiment tueurs* (1965, *The Sleeping Car Murders*), which also starred Montand and Signoret. One revealing episode concerns Signoret's forthright role in the campaign to order the retrial of Pierre Goldman.[20] In an interview extract, she remarks that the night before the trial reopened in April 1976 she was seen on television as an archetypal 'good woman' in Jean Chapot's film of 1973, *Les*

Granges brulées. Over extracts from the film, Signoret wonders if the digni-fied reception she got at the trial would have been the same had the station chosen instead to broadcast Georges-Henri Clouzot's *Les Diaboliques* (1954), in which she portrays a brassy mistress scheming to murder her lover's wife. *Mémoires pour Simone* also sees Marker reprising his fascination with the female face as the embodiment of cinema, but on this occasion he chooses to underscore the gulf between collective fantasy and human reality. In an astonishingly tender sequence that echoes the famous movement of *La Jetée*, he lap-dissolves photographs of an elderly, immensely dignified Signoret while on the soundtrack she discusses coming to terms with the ageing process and the loss of her youthful good looks.

Mémoires pour Simone is rigorously attentive to the place of technology as support and mediator of memory, while swiftly and humorously noting Signoret's hatred of computers and her notorious ineptitude with anything mechanical. The first extract, from Patrice Chéreau's *La Chair de l'orchidée* (1975), shows Signoret's character setting up a home movie projector to lose herself in fictional memories. The motif of shelved video boxes and 8mm-film containers becomes a recurrent reminder in the film that memories of Simone are largely memories of her screen appearances, and this is enhanced by a systematic framing system that shows 35mm extracts full screen, 16mm extracts surrounded by a black border and television images at an angle. *Mémoires pour Simone* also affirms Marker's belief in the affec-tive capacities of technology – its power, as Hayao Yamaneko puts it in *Sunless*, 'to treat memory, feeling and imagination' – by showing the mov-ing personal tributes to Signoret that were posted on the French Minitel system after her death.

Television has on more than one occasion been positioned as the adver-sary in Chris Marker's presentation of his own work in film. He explicitly contrasted the interviewing strategies he adopted for *Le Joli mai* with the fake camaraderie of televisual encounters between media professionals and ordinary people. *Le Fond de l'air est rouge* was an attempt to construct a crit-ical space for the contemplation of recent history, against television's per-nicious evacuation of memory through its constant flux of empty images. Although this combative stance might appear to despair of television's potential for anything other than inanity, Marker's relationship with tele-

vision is in fact based on a keen critical interest and engagement that have never precluded the possibility of intervening in the medium from the inside.[21] In the late 1980s the newly formed cultural television channel La Sept (forerunner of the Franco-German Arte), with the support of the Onassis Foundation, commissioned Marker to make a television series on the legacy of ancient Greek civilization in the modern world.[22] Composed of thirteen 26-minute episodes, *The Owl's Legacy* is among Marker's most ambitious projects, but because it has not had the wide exposure of a commercial cinema release, the series has garnered comparatively little critical attention.[23] *The Owl's Legacy* stages an extended encounter between Marker's commitment to interviews and the oblique yet unmistakable intervention of his own private sensibility and preoccupations. The notion of the 'owl's legacy' primarily represents the stated quest after the contemporary heritage of ancient Greece (the owl being associated with Athena, the Greek goddess of wisdom), but Marker himself can be discerned in the guise of his favourite bird, as the different episodes of the series set out and expound, via a range of opinions and perspectives, the abiding concerns and reference points of his own work.

Each of the thirteen episodes of *The Owl's Legacy* explores a concept that has its origins in ancient Greek culture and language. Part 1, 'Symposium, or Accepted Ideas',[24] sets out received notions of the importance and legacy of ancient Greek civilization for the present, and introduces the idea of the symposium (a convivial debate taking place over food and wine), through the device of four banquets, one each taking place in Paris, Tbilisi, Athens and Berkeley, California. These banquets will recur sporadically throughout the series, as the guests – artists, philosophers and Classical scholars – are shown expressing their ideas on the various topics covered. Part 2, 'Olympics, or Imaginary Greece', focuses more specifically on the ideals and myths of ancient Greece and how a number of the interviewees first came into contact with them. The invention of the Classical Greek ideal by eighteenth- and nineteenth-century German philosophers is contrasted with the realities of modern Greece, and the dark side of the ideal is invoked by the recognition that it was used as a justification for Nazism. Part 3, 'Democracy, or the City of Dreams', compares and contrasts the democracy of ancient Athens with that practised in the contemporary political world.

Parts 4 and 5 engage specifically with modern Greek experience. Part 4, 'Nostalgia, or the Impossible Return', considers the truism that Greeks are nostalgic for a lost homeland by looking at successive waves of forced migration and diaspora. Part 5, 'Amnesia, or History on the March', examines the tribulations of modern Greek history, from the war of independence of 1820, through the fate of the country during and after the two World Wars, to the dictatorship of the colonels. The interconnected realms of mathematics, language and music are explored in Part 6, 'Mathematics, or the Empire Counts Back', Part 7, 'Logomachy, or the Dialect of the Tribe', and Part 8, 'Music, or Inner Space'. Part 9, 'Cosmonogy, or the Ways of the World', sees art and the realm of imaginary creation as analogous to the order imposed by the Greek gods upon primordial chaos. Part 10, 'Mythology, or Lies like Truth', considers the persistence of Greek myths as an archetypal structure still found in modern narratives and cultural representations, and examines their similarity to Japanese mythology. Ancient Greek attitudes to sexuality and the place of women are the concern of Part 11, 'Misogyny, or the Snares of Desire'. Part 12, 'Tragedy, or the Illusion of Death', explores the preoccupations of Greek tragedy and again draws parallels with Japan through the Kabuki and Nō theatres, and a Japanese performance of *Medea*, staged in Athens. The closing episode, 'Philosophy, or the Triumph of the Owl', begins with an engaging enquiry into the attractions of Athena's bird, before going on to interrogate the purposes of Greek philosophy. Ending at Tbilisi as the banquets wind up, we are reminded that, for Plato, the function of philosophy was to prepare for a dignified death.

Interviews are the backbone of *The Owl's Legacy*, and they allow Marker to compose the investigations undertaken by the series as a mosaic of different experiences and interpretations that are permitted on occasion to contradict each other, much like the structured polyphony of *Le Joli mai* and *Le Fond de l'air est rouge*. The 46 interviewees listed in the credits are enthusiasts and scholars of ancient Greece, cultural figures and individuals of Greek origin (frequently expatriates), including the film directors Theo Angelopoulos and Elia Kazan. Apart from the guests at the four banquets, the individual participants are shown by themselves addressing an unseen interviewer, and most are accompanied by the figure or image of their own individual owl. The philosopher Cornelius Castoriadis appears with a

rotund painted owl figurine that resembles a Russian matryoshka doll or the Japanese mascot Daruma, while the towering illustration of a white owl looms behind the left shoulder of Elia Kazan. There is a variation in the presentation of the philosopher George Steiner, who in the first episode expounds the centrality of the Other to ancient Greek notions of selfhood, and so, in addition to the large stained-glass tawny owl behind him, always appears facing an angled screen, which transmits the image of a silent woman listening sympathetically and nodding in agreement with what he says. The solitary interviewees are habitually framed by a fixed camera in a mid-shot, and at the banquets too the camera will generally concentrate on whoever is speaking, but here there are occasional cutaways to the other listeners around the table. The camera's unwavering attention accords each speaker the space to develop her or his own discourse and perspectives, which are then woven into an ongoing conversation across the length of the series. One major thread running through the interviews and supporting many crucial themes addressed by *The Owl's Legacy* is reflective personal experience. The Greek expatriate Angélique Ionatos voices her irritation at

In order to be a rea

being the object of mythical projections and assumptions, and so draws attention to the gulf between fantasy ideals of ancient Greece and the realities of contemporary Greek experience. In recounting their first contacts at school or university with ancient Greek literature, mythology or pedagogic methods, many of the participants affirm the extent to which Greek models have shaped the educational and cultural norms of the modern world.

In dialogue and counterpoint with these interviews are the veiled but unmistakable traces of Marker's presence: his witty rejoinders, agreements and demonstrations. These are delegated to the voice-over commentary that introduces and punctuates each episode, and to a rich, heterogeneous variety of imagery and sound effects. On the single occasion that we hear the voice of the interviewer – bringing Elia Kazan back to the point – it is a synthesized, mechanical one (although elsewhere both Kazan and Castoriadis address Marker by name). The use of both contemporary and archive film footage to carry Marker's arguments is well established – among the works sampled for this purpose in *The Owl's Legacy* are Riefenstahl's *Olympiad*, Resnais' *Hiroshima mon amour* and Kazan's *America, America* (1963). They are

augmented by rough-hewn computer-generated images created on Marker's Apple II GS machine, and (a novel departure for Marker) by acted tableaux. The computer images, meticulously framed on monitors or displayed at an angle to emphasize their technological origins, are used to especially pertinent effect in Episode 6, not merely to illustrate the mathematical basis of computing, but to embody the ancient Greek belief in the unity of science and the humanities. We see a digital image of a serene Greek statue build up in layers, from the numerical programming code to the representational image. In the same episode (one of the wittiest and most delightful in the series), the French actress Arielle Dombasle[25] stars as a soft-focus muse who explains the mathematical principles discovered by Pythagoras. Catherine Belkhodja features in a number of similar vignettes: the first appearance in Marker's work of the actress who would incarnate Laura in *Level Five*. She turns up as a silent, harp-playing hostess at the Paris banquet, and among the audience for a staged projection of *Hiroshima mon amour* that accompanies the description of Plato's cave, and invokes its ritual association with the cinema.

The broad cultural history examined in *The Owl's Legacy* is angled, as might be expected, through the filter of Marker's sensibility and established preoccupations. Making the series brought Marker back to one strand of his intellectual origins, since one of the more reliable fragments of information about his early life is that he obtained a degree in philosophy from the Sorbonne. Many of the facets of ancient Greek thought and culture explored in the series – the concept of selfhood as a constant interior dialogue with the Other, the Socratic principles of rigorous intellectual enquiry by questioning and debate, the centrality of myth and the meaning of artistic creation – are the foundations of Marker's own approach to cinema and other audio-visual media as a perpetual dialogue with oneself and others, which seeks to generate reflective knowledge about the world. Episodes focused on nostalgia, on history twinned with amnesia, and on the Olympic ideal, extend themes widely present in earlier works, such as *Le Fond de l'air est rouge*, *Sunless* and *Olympia 52*. Marker's growing preoccupation with how images and illusions escape the realm of shadows and influence the course of history finds expansive material in the spectre of ancient Greece as a set of ideals developed and perpetuated by later genera-

tions – not to mention the tantalizing befuddlement of illusion and reality in Plato's cave.

When Marker explores the influences of ancient Greek civilization beyond the confines of Europe and North America, he returns to the primary co-ordinates of *Sunless*. Balthasar Lopez describes how he taught humanities on the Greek model to Amilcar Cabral's generation, in a Portuguese mission school in Cape Verde. Japan is visited in two episodes, numbers 10 and 12, on the basis of perceived affinities between ancient Greek mythology and tragic theatre, and their Japanese counterparts. Interestingly, the examination of mythology favours the hypothesis of a Japanese scholar, Atsuhiko Yoshida, who claims that the Greek myths came to Japan via Korea, transmitted by Scythian tribes from the Black Sea coast who journeyed to eastern Asia, rather than the belief that universal constants in human experience explain structural similarities between the foundation myths of different cultures. Marker's deferred presence reasserts itself in the programme on tragedy, as a group of Japanese gather in the La Jetée bar for their own impromptu symposium, to discuss their first encounters with ancient Greece. In the same episode, Marker pointedly disputes Alexis Minotis's assertion that only the Greeks have the capacity for tragedy, and the Japanese have simply copied its devices, by cutting straight to footage of Yukio Ninagawa's production of *Medea*, which was performed to triumphal acclaim in Athens and praised by the Greek minister and former actress Melina Mercouri as evidence of the deep rapport between Greek tragedy and Japanese culture.

Two aspects of ancient Greek culture have a particular resonance with Marker's ongoing concerns. One, already mentioned in passing, is the idea that, for the ancient Greeks, all the different intellectual disciplines that sought to understand both the physical world and the realm of human experience were seen as an integrated continuum. Modern divisions between the sciences and the humanities, *logos* and *mythos*, theatre and life, as well as the either/or choices imposed by monotheistic religions, are antithetical to the Greek belief that all such modes of enquiry are profoundly interconnected, and to the Greek acceptance of ambiguity or uncertainty as a legitimate philosophical position (represented by the three roads offered to Oedipus). The assertive defence of these beliefs by a number of the

speakers in *The Owl's Legacy* forms an oblique manifesto for Marker's own demonstrations that politics, wit and poetry can and should mix, and that the realms of myth and imagination are as much a bedrock of human reality as objective happenings in the physical and historical world.

The other significant facet of Greek culture forms the closing reflection of the series. It is the recognition that, for Plato, philosophy was essentially a training for death: a habit of integrating the fact of death into the fabric of life, and disciplining the self so that death can be met and accepted with equanimity. Over the remains of the Tbilisi banquet (the only one to take place in a country where to engage in certain kinds of philosophy had meant until very recently the direct threat of death), Leonid Tchelidze proposes a final toast to 'death with dignity'. Ancient Greece thus materializes as another, perhaps the founding, instance of a culture that knows how to create masks, ceremonies and conversations that engage with death and permit it to be recognized. Before toasting death, Tchelidze had raised a glass to dialogue: that constant thread that holds *The Owl's Legacy* and Marker's other interview-based works together. Dialogues for Marker can take many forms, but in this instance the link is made to communing with death itself, finding the impulse to face it and look at it finally as an equal.

6.
Memories of the Future

Even the best-kept secrets are shared sooner or later. The period since the turn of the 1990s has seen public recognition of Chris Marker's achievements steadily increase, so that the enigmatic figure who was once barely more than a 'cinephile's whisper'[1] is now a touchstone for artists, commentators and audiences in many fields of contemporary audio-visual culture. Following the first major retrospective of his films held in Portugal in 1986, over the past decade there have been Marker surveys at the Cinémathèque of Ontario in 1993 and the Pesaro Film Festival in 1996, as well as numerous smaller-scale screening events. The surge of interest that greeted Marker's first film-essays and prompted a run of journal publications about his work in the early 1960s has been recently matched by a series of Marker special issues and dossiers in French and German film periodicals, culminating in comprehensive studies such as Birgit Kämper's and Thomas Tode's edited collection *Chris Marker: Filmessayist* (1997), Guy Gauthier's *Chris Marker: écrivain multimédia* (2001), and 'Recherches sur Chris Marker', a dedicated issue of the journal *Théorème* (2002). At the time of writing, the first English-language Marker dossier has just appeared, courtesy of *Film Comment*; and specialist websites provide on-line resources and reflections around his work.[2]

Marker, meanwhile, has steadfastly refused to retire into the role of elder statesman and figurehead. He agreed to curate his own retrospective in 1998 for the Cinémathèque Française, on condition that he could indulge the pleasure of including some of the lesser-known films that have inspired him alongside a selection of his own work, and thus use the occasion to

realize a fantasy film programme, rather than an exhaustive trawl through his past accomplishments. Utterly disinterested in resting publicly on his laurels, Marker has nonetheless profited from his increased renown, to the extent that he has been able to accept prominent gallery commissions in France and the United States to create the installations *Zapping Zone* and *Silent Movie* (1995), and also the CD-ROM *Immemory*.

In *Sunless*, Marker had written of a plan for machines to come to the assistance of the human race. Beginning with *Zapping Zone*, a succession of innovative major works completed during the 1990s saw Marker elaborate the creative potential of new media technologies for mapping and interrogating the processes of human memory, and exploring the interfaces between private recollection and collective remembrance. The death of Alexander Medvedkin in 1989, closely followed by the final collapse of the Soviet Union in 1991, prompted Marker in *Le Tombeau d'Alexandre* (1993, *The Last Bolshevik*) to pull the thread of his friend's life and unravel the history of twentieth-century Russia and the Soviet Union, via a screen assemblage of treated and insistently questioned images. *Silent Movie* conjured a resonant cinematic imaginary from Marker's reminiscences of the pre-sound era, abetted by the serendipity of the computer interface that pilots the work. *Level Five* returned Marker to the forgotten and traumatic history of the Battle of Okinawa, reconfigured as an unfinished computer-game design bequeathed to a woman, Laura, by the dead lover whose memory she strives to preserve. Most recently *Immemory* proposes a grand *summa* of Marker's capacious memory as a series of interlocking hypermedia zones.

For Marker, the new electronic media technologies and image-processing systems used to make these works are tools that he has been anticipating for much of his creative life, and which now lead him to regard film as something he just had to make do with in the interim. In 1994, commenting on the development of the AVID non-linear editing system, he wrote: 'I thought immediately of the computer: finally, they've done what I was aiming at with the rudimentary tools I had, since I tried to shape things my way. (This with the reflection that *they* could have speeded it up a bit – let's say ten years earlier . . .)'[3] If, forty years before this, Marker had speculated on cinema as the art of the twenty-first century, by the close of the twentieth he would be claiming: 'No, film won't have a second century. That's all.'[4]

Statements such as this have firmly established Marker's profile as a new media pioneer; but it remains significant that much of the interest of his recent works actually derives from their continued reliance on the cultural memories and traces of the older media he has worked with: literature, film and photography. In *Level Five* Marker plays off the recognizable conventions of both fiction cinema and documentary investigation, across the computer and the Internet as the virtual screens and databases that are our new condition of access to historical memory. *Immemory* offers a hypermedia inventory of Marker's memory and imagination by transmuting the scattered mementos of a lifetime – childhood books, family photographs, picture postcards, illustrations, posters and the like, in addition to the hefty back catalogue of his own work – into a multi-directional, interactive virtual collage that integrates words, images and sounds into a new representational continuum. Marker has also increasingly stayed away from the cutting edge of new technological development, preferring to work with the more rudimentary digital and electronic tools that he can master himself, and to cast his excursions into digital image design as what he calls 'naïve informatics': the primitive dabbling of a 'Sunday programmer' more akin to Douanier Rousseau than to Industrial Light and Magic.[5] If Marker's position chimes with a widespread valorization of new media as providing much cheaper and more accessible resources to would-be filmmakers than the sclerotic institutions of mainstream cinema and television, it is significant that he has underlined its potential for the type of highly personal film-essay with which he has always been associated.

> The process of making films in communion with oneself, the way a painter works or a writer, need not be now solely experimental. My comrade Astruc's notion of the camera as a pen was only a metaphor. In his day the humblest cinematographic product required a lab, a cutting-room and plenty of money . . . Nowadays, a young filmmaker needs only an idea and a small amount of equipment to prove himself.[6]

Marker's ongoing interests are not confined to exclusively private reflections in the realm of new media. In two recent television works he has

returned to portraiture, with an acclaimed study of Andrey Tarkovsky, *One Day in the Life of Andrei Arsenevich*, and an exploration of the inter-war photographs of Denise Bellon, *Le Souvenir d'un avenir* (2002, *Remembrance of Things to Come*), made in collaboration with her filmmaker daughter Yannick Bellon. Marker has also continued to engage directly with contemporary political events and debates. In *The Last Bolshevik* and in *Berliner Ballade* (1990), a report produced for a French television current affairs strand, Marker reflects on the political ideals that collapsed at a stroke with the fall of the Berlin Wall and the end of Communist rule over the Soviet Union and Eastern Europe, and attempts to hold open a space for those who still believe in the founding principles of Socialism. Coinciding with this abrupt shift in the political landscape of Europe, the welter of savage inter-ethnic conflicts triggered by ultra-nationalist movements in the former Yugoslavia during the early 1990s (and again more recently in Kosovo) has focused Marker's attention through a series of candid engagements with people caught up in the long drawn-out war. *Les 20 heures dans les camps* (1993, *Prime Time in the Camps*) focuses on a group of Bosnian refugees who are producing their own television broadcasts. *Casque bleu* (1996, 'Blue Helmet'), is an extended interview with a French soldier who served with the UN peacekeeping force in the former Yugoslavia, and now voices his disillusion with UN policy towards the region. Two as yet unreleased works, *Un Maire au Kosovo* (2000, 'A Mayor in Kosovo') and *Avril inquiet* (2001, currently unfinished, 'Worried April'), are built around interviews with Kosovans involved in the most recent stage of the conflict. This cluster of short, pointed, interview-driven videos is the direct descendant of Marker's unsigned political films of the 1960s and '70s, and retains the same ambition: to give a voice to people who are spoken about, but never heard, in mainstream news reporting.

The installation *Zapping Zone* publicly consolidated Marker's commitment to electronic multimedia. The project was commissioned for the exhibition *Passages de l'image*, curated for the Centre Georges Pompidou in 1990 by Raymond Bellour, Christine van Assche and Catherine David, which set out to examine passages and interfaces between film, video and photography in contemporary audio-visual art.[7] As a physical entity, *Zapping Zone* manifests itself as a ramshackle assemblage of televisions and computer

monitors clustered on low platforms in a darkened gallery space, echoed by photographs and computer-generated collages attached to the walls. The fourteen video monitors, thirteen laser disc players with speakers and seven computer terminals are the hardware that supports a packed virtual tour of Chris Marker's imaginary, proposed to the visitor in the form of zones, whose raw material is stored on thirteen video discs, and in seven computer programmes and a suite of 80 colour slides.[8]

Zapping Zone initially provokes an enchanted bewilderment, as a multitude of self-contained image-bands and sounds confront and compete for the visitor's attention. Raymond Bellour described the work as 'a mini-market, a knowingly disorganized Woolworth's store, where visitors may not find what they need, but might at least see displayed what they desire'.[9] Fleeting glimpses of the trademark signs and obsessions that signal Chris Marker – a sleeping tabby cat, a familiar photograph, a snatch of *Le Fond de l'air est rouge* or the Tokyo commuter trains seen in *Sans soleil* – offer a tentative point of orientation, but one that is more than likely to be displaced quickly by the host of other competing stimuli. Marker himself commented

that the installation plays 'on the near-impossible task of focusing on a precise target in the middle of the cyber-noise'.[10]

Zapping Zone brings together elements from Marker's previously known film and photography projects – a zone devoted to extracts from some of his earlier films, and a virtual slide show of selected photographs – with a new set of computer-generated works, and a series of short video pieces that he had assembled over the previous five years. Some of these new inclusions enjoy a free-standing existence separate from the installation, among them *Matta '85*, a portrait of the Chilean artist Roberto Matta leading Marker on a wise and funny private guided tour of his solo exhibition at the Pompidou Centre; the three-part *Bestiaire*, dedicated to Marker's beloved animals; and the two video travelogues *Tokyo Days* and *Berlin '90*, which in their turn are both annexes to other independent works, *Sans soleil* and *Berliner ballade*.

Every one of the audio-visual elements contained in *Zapping Zone* is in a state of flux, often carrying with it the ghosts of a previous existence, always with the potential to be turned into something else. The 'clip' Zone, for instance, features Marker's sole venture into directing a pop video, for Electronic's hit *Getting Away With It* (1990). The band had rejected Marker's effort (the story goes that Marker had had part of the video filmed in the Château de Sauvage wildlife park, and the band's singer Bernard Sumner hated animals)[11], and so it passed into *Zapping Zone*, in transit to yet another life as the segment 'Laura among the animals' in *Level Five*. The different zones inevitably criss-cross each other in the viewer's imagination,

provoking flashes of association and lateral insight. Cinema films mutate into fragments edited back-to-back on a television screen; casual, impressionistic video sketches re-emerge as independent works (available to project in cinema spaces). Images from a multitude of origins – films, photos, television broadcasts, paintings, engravings, illustrations – are absorbed and reworked into electronic montages and primitive digital palimpsests. To add to this pervasive trans-

mutation, the installation itself remains a work-in-progress. Marker has modified it on several occasions over the years by adding new elements and reworking, expanding or replacing others, while the content and physical arrangement of *Zapping Zone* have varied depending on where it is shown.

One *Zapping Zone* component, *Théorie des ensembles* (*Theory of Sets*), offers a light-hearted meta-commentary on the whole, in the guise of a tale told in a computer program via the alternation of colourful digital collage images and intertitle screens. Noah is faced with the problem of how to classify the animals in the Ark, a vessel Marker depicts in the form of John Tenniel's beaming Cheshire Cat. Two owls come to the rescue by explaining the rudiments of set theory (they do everything together, *ensemble*, hence the theory of 'ensembles'). Snoopy, *Sunless*'s emu and a rabbit from the medieval tapestry *The Lady and the Unicorn* (Paris, Musée de Cluny) pop up to illustrate their examples. Noah learns that animals can be classified in a number of different sets, and hence that sets can overlap.

Marker subtitled *Zapping Zone* 'Proposals for an Imaginary Television'. The habit of idly switching television channels forms an obvious

analogy for how a viewer might negotiate the installation, but the design of *Zapping Zone* also functions as a sort of cautionary tale about channel hopping, where instead of replacing one another, all the different channels keep accumulating and clamouring simultaneously for attention. *Zapping Zone* can on one level be viewed as Marker's fantasy television schedule, and there is a delightful precedent for this in a wish-list of programmes he drew up in 1986 under the banner of 'Canal [Channel] Chris'.[12] Within this desire to reshape broadcasting according to his own whims and enthusiasms, Marker uses *Zapping Zone* to propose a critical interrogation of television as it currently exists, and invites the viewer to share in imagining the possibilities of what television might be instead. Nowhere is this vein of criticism more pointed than in the eight-minute video piece *Détour. Ceaușescu*, which re-edits taped television footage into a sardonic commentary on French television coverage of the trial and execution in December 1989 of the Romanian dictator Nicolae Ceaușescu and his wife. The TF1 newsreader makes much of the moral imperative to broadcast the videotape of the swift trial and summary execution of the Ceaușescus in its entirety, without commercial breaks. Marker chips in with arch indignation via an intertitle, 'What, no adverts?', and proceeds to intersperse the grim reportage with snippets of breezy television commercials, through darkly apposite montage proposing new uses for kitchen paper and laundry detergent in dealing with the bloody aftermath of the execution. French television's hypocrisy in attempting to deny its own complicity with advertising is undermined to devastating effect.

Like *If I Had Four Camels* and *Sunless, Zapping Zone* is a summative project, which sees Marker going back over a stretch of previous work by the act of reflectively sorting through it and replaying it in a new medium (thus in the earlier works photos become a film, and film enters the virtual realm of the Zone). The difference with *Zapping Zone* is that the installation format permits Marker's memories to escape the linearity and fixed temporal rate of film projection and voice-over commentary, to be dispersed across a host of simultaneous virtual spaces, and rendered potentially infinite. Hayao's Zone finally explodes the cinematic constraints of *Sunless*, to reconstitute the traces of Krasna/Marker's memory as a series of perpetually shifting possibilities and encounters. Although the effect may seem even

more perplexing than trying to keep up with the breakneck pace of *Sunless* and keep track of its labyrinthine propositions and allusions, the user of *Zapping Zone* is now liberated to explore at his or her own pace, to choose one focus of attention over another, to experience the contents of the installation in whatever order he or she likes. This principle of engaging the user through an interactive dialogue, whose pace and direction they can control, reaches its apotheosis in *Immemory*, the grand *summa* that gathers up the physically dispersed elements of *Zapping Zone* and transmutes them into the elegant hypermedia architecture of the CD-ROM.

The *Berlin '90* video sketch in *Zapping Zone* was the fruit of a visit that Marker had made to the city just four months after the Berlin Wall was brought down, to film a report for the Envoyé Special television strand. This was broadcast in March 1990 on Antenne 2 as *Berliner ballade*. With voice-over by Catherine Belkhodja, *Berliner ballade* picks up in the Tiergarten Zoo where *Sunless* had left off: 'This time you write to me from Berlin.' Shot immediately after the first legislative elections for the former German Democratic Republic, the report combines mobile, tightly framed video footage that catches the city's abruptly transformed signs and surfaces, and interviews with East German political campaigners and cultural figures. All express a sense of dispossession at the swift transition to capitalist values, and the denigration of everything they had struggled for and believed in. In the first part of the report, Marker's mobile camera ranges through Berlin under the aegis of Jean Giraudoux, seeking the signs his hero had recorded in the city in 1930. Its furtive, penetrating gaze captures a network of marginal and clandestine activities that map the rupture in East Germany's history, and its abrupt conversion to Western values, as the weight of the past collapses into ruin, consumer opportunities and museum fodder. Black market currency transactions and the trade in relics of the Soviet era are joined by the opportunists who manufacture and sell fake fragments of the graffiti-coated Wall, directly in front of the flat white crosses commemorating people who were killed trying to cross it. Vividly decorated panels from the original Wall languish discreetly in a park, 'awaiting what museum?'

In the second part of *Berliner ballade*, Marker films the novelty of the elections, the waiting crowds at the different party headquarters, and the

angled and distorted images of television reports. As the victory of the CDU is announced, the political despair of the Green women's candidate Ina Merkel augments that of other interviewees, including the painter and film-maker Jurgen Böttcher and the Socialist campaigner Jutta Braband, who register their disillusion with East Germany's headlong rush into capital-ism, and the near impossibility of continuing to promote left-wing values. The writer Stefan Hermlin stoically registers that he has never been among the victors, and does not wish to be.[13] These are voices raised against the tide of history, fragile reminders of the radical hopes that had withstood and helped put an end to the entrenched abuses of Soviet-style Communism, but were now being swept into oblivion along with it.

The failed utopia of Soviet Communism casts a defining shadow over *The Last Bolshevik*, Marker's posthumous second portrait of his friend Alexander Medvedkin. Made as a two-part television programme first shown on La Sept/Arte in France, as two episodes entitled 'Le Royaume des ombres' ('The Kingdom of Shadows') and 'Les Ombres du royaume' ('The Shadows of the Kingdom'), *The Last Bolshevik* has become one of Marker's most familiar works in Britain, thanks to the co-production involvement of Michael Kustow for Channel 4, and a video release on the Academy label. The fortuitous span of Medvedkin's life – he was born in 1900 and died in 1989, 'on the crest of *perestroika*' – and the fact, remarked early in the pro-

gramme, that he was a man profoundly marked by the course of historical events in Russia and the Soviet Union make him in Marker's estimation a key to unlocking one of the defining histories of the twentieth century. As a film director, Medvedkin has what for Marker are the ideal cre-dentials to be a lightning-rod for Russian and Soviet history. Marker had paid homage to the cinema as the eyes and mind of the Revolution in *Le Train en marche*, emphasizing the significance attached to film in the new Soviet Union as the medium best equipped to forge a new society and a new history. Taking stock of the twists and turns of this legacy at the moment when the political system that sustained it has ended, *The Last Bolshevik* is guided throughout by a remark of George

Steiner's that serves as its epigraph: 'It is not the literal past that rules us, it is images of the past.'

The structure of *The Last Bolshevik* derives from six posthumous letters addressed to its subject, which trace the chronology of Medvedkin's life and times through Marker's familiar epistolary habits of association and anecdotal digression. 'Dear Alexander Ivanovich, now I can write to you. Before, too many things had to be hushed up, now, there are too many things to say, but I will try and say them anyway, even if you are no longer there to hear.' The terms of address are intimate and forthright, but already there is an indication that this correspondence depends upon the absence of its subject. The ritual of mourning for a friend and for lost political ideals that Marker carries out by composing these letters to Medvedkin promises to break silences imposed by their friendship and the continued existence of the Soviet Union. The void left by Medvedkin is filled by extensive interviews, with his daughter Chongara and his colleagues, admirers and contemporaries, who build a composite, and on occasion conflicted, portrait of him through their opinions and recollections. A crucial witness is the camera operator Yakov Tolchan, in whose voice, Marker writes, he sometimes hears Medvedkin speak. With his collection of photographs (a further layer of images) and his conviction that it is a moral duty to preserve the relics of the past, Tolchan is a cipher for Marker within the film – Marker even lends Tolchan his Sony Handycam to film his own reflection in a mirror (incidentally catching Marker's profile in a few frames as he does so), seeing that Tolchan was one of the first operators to use a hand-held camera. It is left to Tolchan to live out the traumatic contemporary events that death has spared Medvedkin; and, by expressing his own feelings of devastation at the execution of the theatre director Vsevolod Meyerhold during the Stalinist purges, to voice experiences about which Medvedkin was reticent, and which in any event he is no longer alive to articulate.

'My work', the commentary says, 'is to question images'. *The Last Bolshevik* is a screen for interrogating representations of the past, probing the compacted layers of truth and fiction that they contain and conceal, like the matryoshka dolls that pop up as ready-made metaphors of Soviet history. Marker uses a panoply of special effects that literalize and draw attention to the scrutiny of images, including bordered inserts, freeze-frames,

slow superimpositions, synthetic mutations and graphic devices laid on top of the image – like the red square or spot frequently placed over a face or detail. Together they posit the moment and process of film editing, when already-constituted images are brought together and manip-ulated to create meaning, as an occasion for delving into issues of historical significance and interpretation. (We are told that Medvedkin wept when he first stuck two pieces of film together and found that they made sense.) The small frame-within-a-frame images interspersed throughout *The Last Bolshevik* mimic film as seen by an editor on a Steenbeck, or an Avid non-linear editing programme, and they are subject to transformations that, together with the accompanying commentary, scrutinize the evidence of the image directly. A news film made by Roman Karmen, showing the triumphant meeting of the Soviet armies at Stalingrad in 1943, is superimposed with the perspective lines of a viewfinder, and we are told that you can tell the footage was staged, because the soldiers embrace bang in the middle of the frame.

The business of stage-managing the appearance of reality would become a central preoccupation of Soviet culture under Stalin, and it is one of the core variants of the image-reality conundrum explored in *The Last Bolshevik*. The exhaustively rehearsed show trials of the 1930s, with their elaborate *mise-en-scène* and stock characters, lent the stable contours of narrative fiction to reality, and created a generic template that was repeated not only in the Warsaw Pact satellite states after the Second World War, but in the format of the Nazi political trials overseen by the Soviet prosecutor Vyshinsky's German counterpart, Roland Freisler. *The Last Bolshevik* recognizes how much framing (in every sense of the word) has gone into these representations, but it also attempts to understand how a sincere director like Medvedkin, whose personal honesty and candour are confirmed by many interviewees, and who had tried to grapple with the unvarnished real-

ities of Soviet society in his film-train work, could come to endorse the practice by directing *Blossoming Youth*: a glossy and affirmative film record of the May Day parade of 1939 in Moscow. The filmmaker Marina Goldovskaya, who made one of the first documentaries about the *gulags* – and was thus better placed than many to understand the brutal reality that such unfailingly positive images ignored – recalls the happiness and sense of belonging that she experienced at these parades as a child. Comparing Medvedkin to the peasants of Kouban, who preferred the uplifting colour vision of their lives in a Socialist Realist musical to harsh everyday reality, she communicates the power of the cultural pressure to believe in at least the image of utopia, even when (or because) reality lags so woefully far behind.

The Last Bolshevik probes other fictions that have assumed the place of reality, such as Eisenstein's *Battleship Potemkin*, or the actor Gelovani who portrayed Stalin in popular films. The letters speculate that he probably *was* Stalin for most ordinary Soviet citizens; meanwhile Tolchan acknowledges that he risked his life by filming for Dziga Vertov a candid shot of the real Stalin walking inside the Kremlin. A photograph showing the storming of the Winter Palace in 1917, used on the cover of a French edition of Trotsky's *History of the Russian Revolution* and credited as an authentic document, turns out to come from a film showing a commemorative re-enactment of the attack on the Winter Palace staged in 1920. It is even possible, as Marker does, to stop the film at the exact point where the photo was lifted. In other circumstances, artifice can preserve a vanished reality, like the replica Civil War agit-train exhibited in the Museum of the Moving Image in London – the last place where

you can be called *tovarich* (comrade) – or the scale model of Medvedkin's film-train, shown and described by the young archivist and Medvedkin enthusiast Nikolai Iswolow.

Marker's interrogation often scours images already deemed to be realistic for traces of an even deeper and more revealing reality that subsists in some trivial or obscure detail. Near the beginning of the film we are invited to peruse a familiar archive film from 1913, showing a procession of dignitaries

during the tricentennial of the Romanov dynasty. Our attention is drawn to a man making a curious gesture at the crowd: he is framed in close-up and picked out in a bright square. We learn that he is telling the people to remove their hats before royalty. Marker rewinds history to recall the just cause of the Russian Revolution, despite the cavalcade of tyranny that eventually followed it, and the revival in contemporary Russia of reverent pilgrimages to the tomb of Tsar Alexander III, symbolic resting place of the Romanovs. 'And since the fashionable sport these days is to rewind time to find culprits for so many crimes and sufferings inflicted on Russia within one century, I would like everyone to remember, before Stalin, before Lenin, this fat man who ordered the poor to bow to the rich.' A parallel movement occurs in a passage from Medvedkin's film of 1938, *New Moscow*, when a malfunctioning film projector runs backwards, causing the ambitious architectural projects for the reconstruction of Moscow to be replaced by old buildings.

This motivation to turn back time and re-read the images of the past can depend, as it had done in *Sunless*, on acquiring a new historical perspective on events. Returning to *Happiness*, Marker speculates on an obscured or unconscious reality lodged within the bravura social realism he had celebrated in *Le Train en marche*: the expression of naked terror before authority, which he now sees on the stilled face of the peasant Khmyr. In *The Last Bolshevik* Marker finally tackles head on the disparities between Medvedkin's optimistic portrayals of collectivization and the grim catalogue of catastrophic abuses outlined by Victor Dyomin, who concludes that Medvedkin was 'sincere but wrong' in his puzzlement at the peasants' reluctance to support collectivization, because he did not fully realize – perhaps could not believe – that the policy was enforced under extreme duress. Similarly, at the end of *The Last Bolshevik* Marker nails the paradox of Medvedkin's life through his final film, *Anxious Chronicle* (1972), a documentary that combined a prescient awareness of ecological disaster with a blind faith in Brezhnev and the party. Marker wonders tartly what a cameraman at Chernobyl would have made of it, inserting raw video footage of the notorious nuclear disaster as a bold counter-argument.

The Ukranian Jewish writer Isaac Babel had provided a more damning account of collectivization in his story 'The Village', much as he had

recorded a more ambivalent experience of fighting in the Red Cavalry (where he encountered crude anti-Semitism) than Medvedkin's euphoric recollections. Babel's widow Antonia Pirojkova describes the author's arrest and summary execution during the purges, the fate that Medvedkin managed to escape, even though many of the films he made in the 1930s were banned, and *Happiness* was denounced as 'Bukharinite'. Several times in *The Last Bolshevik* Marker sets two figures opposite each other on angled screens, to indicate lives that in many respects are poles apart, but by virtue of being bound up in the same history have instructive resonances and parallels. As he writes of one such duo, Vyshinsky and Freisler: 'in the Kingdom of Shadows you get strange mirror effects.' Medvedkin and Babel form another pair, 'the enthusiast and the curious one, both necessary to receive the tragedy in stereo'. Babel is one of several figures who form a dialectical complement to Medvedkin, opening *The Last Bolshevik* to the recognition of other fates and choices than those taken by Marker's friend. According to Goldovskaya, both Medvedkin and Dziga Vertov were hampered in their talent and honesty by a certain political naivety; but where the latter ended his life in bitterness and isolation, Medvedkin succeeded in accommodating his work to the

regime, and was able to pursue his career with conventional Socialist Realist dramas and anti-Maoist films in the 1950s and '60s, eventually winning the Lenin Prize in 1970.[14]

For Victor Dyomin, Medvedkin's tragedy was that he was 'a pure Communist in a world of would-be Communists'. In *The Last Bolshevik* Medvedkin is made to embody that grain of genuine utopianism that, the commentary says, the Soviet Union continued to symbolize long after it had betrayed it in reality, but which would finally die with it. We see the iconoclasm of Eisenstein's *October* (1928) replayed as statues of Stalin and Dzerzhinsky are torn down and mocked, amid video film showing the bitterness and chaos that followed the abortive coup of 1991 and the final collapse of the regime. In the midst of this mass disillusion, Marker seizes on Medvedkin as a thread that not only connects to the Soviet past, but

might just preserve the spirit of the Revolution as a beacon of hope, through the little clan of enthusiasts (all in turn framed in a red circle at the end of the film) who have set about preserving Medvedkin's legacy for future generations: the kids who love dinosaurs, figured by the closing freeze frame of a little girl with a dinosaur toy.

In his oneiric passage through Japanese television in *Sunless*, Marker had manipulated an image to illustrate a *haiku* composed by the seventeenth-century Japanese poet Bashō: 'The willow sees/ The heron's image/Upside down'. In 1984 Marker would compose his own suite of '*haikus* for the eye' (as *Sunless* calls Japanese television commercials): the video triptych *Chaika*, *Petite ceinture* and *Owl Gets in Your Eyes*, known as *Three Video Haikus*. The traditional *haiku* poem uses a strict and extremely compact formal structure (three lines of five, seven and five syllables respectively) as the vehicle for a spontaneous poetic insight, often derived from a coincidence of elements in the natural world, that must retain its freshness and immediacy in written form. Marker's *haikus* showcase his trademark obsessions and allusive wit in brief video expositions. In the five-shot *Tchaika* Marker shows treated, semi-abstracted images of the River Seine flowing thickly past a bridge and trees. In the final shot the white silhouette of a bird is frozen as the river moves on. *Petite ceinture* is a homage to the early Lumière Brothers' *actualités*, as Marker films a section of the old 'petite ceinture' ring railway around Paris from a fixed camera angle. There were no trains because of works on the line. For *Owl Gets in Your Eyes*, Catherine Belkhodja performs as a screen goddess smoking a cigarette in a long holder. Over the image of her serene face with smoke drifting in front of it, a flying owl fades in and out.

Belkhodja's screen siren role in *Owl Gets in Your Eyes* directly anticipates her presence in Marker's second major gallery installation, *Silent Movie* (1995). *Silent Movie* was commissioned by Bill Horrigan of the Wexner Center for the Arts, Columbus, Ohio, to celebrate the centenary of cinema in 1995.[15] It consists of five vertically stacked television monitors contained in a Constructivist steel tower, which Marker modelled on the Vesnin

brothers' design for the Pravda building. The top two monitors are devoted to 'The Journey' and 'The Face'; the bottom two to 'The Gesture' and 'The Waltz'. Each transmits a 20-minute videodisc loop of brief clips from a wealth of pre-1940 films (of mainly French and American provenance, and not all silent), combined with imaginary silent film moments starring Catherine Belkhodja, which Marker videotaped for the installation. Horrigan describes Belkhodja as 'the entire installation's unacknowledged narrator – or, rather, as its dreamer'.[16] She is a bridge between past and present, one who for Marker resurrects the vanished aura of the pre-sound era, but belongs to our own time.

The theme for each monitor is periodically posted in English, French, German, Japanese and Spanish. The fifth, middle monitor is devoted to images of eyes and 'abstracted archival imagery',[17] together with 94 discrete intertitles written by Marker himself in the style of silent film texts. A computer interface is used to generate random transmission sequences across the five monitors, so the images and intertitles are constantly appearing in new arrangements. Musical accompaniment is provided by a loop of

eighteen solo piano pieces from a variety of sources, including Alexander Scriabin, Federico Mompou, Duke Ellington and Billy Strayhorn. *Silent Movie* extends onto the walls of the gallery space, with eighteen video stills of the Belkhodja moments, and ten computer-generated posters for hypothetical feature films that Marker has dreamed up: screen classics that should have existed but didn't. These include silent versions of *Hiroshima mon amour*, starring Greta Garbo and Sessue Hayakawa, and *Breathless*, directed by Raoul Walsh and featuring Wallace Beery and Bebe Daniels; Ernst Lubitsch's adaptation of *Remembrance of Things Past* ('The first movie where the captions take more space than the image'), starring Gloria Swanson as the Duchess of Guermantes and John Barrymore as Swann; and Oliver Stone Sr's *It's a Mad, Mad, Mad Dog* (for which the strap line runs 'Rin Tin Tin – He Came to Help our Russian Allies – The Bolsheviks Turned Him into a Monster').[18]

Silent Movie conjures the fragmented memory of pre-sound cinema at the point where personal recollection on the historical plane fuses with the pervasive allure of collective nostalgia. In an elegant essay written for the exhibition catalogue, Marker narrates his own reminiscences of the films he saw in childhood as a psychic rite of passage, in which clearly defined memories of William Wellman's *Wings* (1927, the first film he remembers clearly) and the face of Simone Genevoix in Marc Gastyne's *La Vie merveilleuse de Jeanne d'Arc* (1928) are preceded, 'like in any self-respecting cosmogony',[19] by a disordered tumble of vague and shadowy half-forms. It is this primordial realm of inchoate images, Marker writes, that has inspired *Silent Movie*: 'The idea of a state of perception anterior to understanding, anterior to conscience, anterior by millenniums to film critics and analysis. A kind of *Ur-Kino*, the cinema of origins, closer to Aphrodite than to Garbo.'[20] He expands this notion to explain the curious abstractions of the first thirty-odd years of film history: the absence of synchronized sound that was compensated by music, intertitles and sometimes commentary – silent movies, he quickly points out, were never experienced in silence – and the absence of colour, despite the fact that sound and colour systems were developed early on. Marker conjures the silent, black-and-white era as a phase of productively arrested development, in which the defiance of nature became an opportunity 'to assert man's inner resources':

in other words to privilege creativity and imagination over imitation.

Implicit in Marker's presentation is a homage to the formal innovations most commonly associated with French and Soviet cinema in the pre-sound era, notably the development of montage as a way of generating meaning through the manipulation of the visual image. Marker himself is of course one of the major contemporary exponents of this tradition – the curator Bill Horrigan described *Silent Movie* as being edited 'in the key of Dziga Vertov'. The reconstitution of self-contained films as an infinite array of moments and fragments invokes the concept of *photogénie* developed by Jean Epstein in the 1920s: the unexpected and alluring visual qualities of the filmed or photographed image, which go unnoticed in nature, and in a film have the power to undercut the momentum of narrative.[21] Marker hints at such a power to account for his misremembering Gary Cooper as the hero of *Wings*: 'I suppose this is what makes a star: one gesture, one smile, and it's him you remember, not the vague young man who was then in charge to get the girl.' Epstein's contemporaries, the Surrealists, famously invented habits of cinema-going that also fixated on the fragment over the coherence of the story, entering and leaving cinemas at random and refusing the expe-

rience of absorption in the narrative – much as gallery visitors might pass in and out of the *Silent Movie* installation, spending a few random moments with it before moving on.

The point of *Silent Movie*, though, is that for the visitor who spends enough time contemplating it, the random alignments of images and inter-titles with passages of music *do* seem to make sense, generating snatches of graphic or emotional association, and even plausible narrative scenarios, that perpetually flicker in and out of the viewer's consciousness: the Kuleshov effect cued synchronically from the music of chance. A good many of the intertitles seem to offer a sporadic reflection on the nature and experience of the installation itself:

> Watch the stars . . . Believe it or not, I read your thoughts . . . Never forget . . . Are we the hollow men? . . . Seems your soul is restless . . . Must there be an answer for everything? . . . Haven't I been here before?

Silent Movie rolls on regardless of whether visitors are present or paying attention, but the computer interface is perpetually generating moments of potential serendipity, when images, intertitles and music lock together in a flash of sense for the viewer, before becoming scrambled again into a chaos of potential meanings.

In four short videos made since the early 1990s Chris Marker has docu-mented the experiences of a range of individuals caught up in the prolonged and destructive nationalist wars that broke out with the dismantling of Yugoslavia into smaller independent states after 1991. The impetus behind these works is that of the SLON films: to give a voice to people otherwise unseen and unheard in the dominant media. The point is made explicitly in the most recent of these videos, *Un Maire au Kosovo*, when the commentary remarks that Kosovans are usually depicted only as desperate refugees fleeing by the roadside. Marker and his video camera assume the role of attentive and unobtrusive listeners in these works, which all centre on extended interviews with their protagonists. The faces of speakers are held in long, unwavering close-ups that privilege their right to express their own ideas and experiences without interruption. Supplementary visual infor-

mation functions to corroborate what they are saying, or to show and explain aspects of their life.

Questions of media representation and agency are central to the first of these videos, *Prime Time in the Camps*. A group of young Bosnians in the Roška refugee camp, a disused army barracks in Ljubljana, have created their own regular television broadcasts using equipment donated by a Belgian organization, Causes Communes. The team assemble their evening news bulletin by pirating CNN, Sky News, Radio Sarajevo and other European satellite channels, then including contrasting reports in their programme, so that both they and their audience can compare how different news services are covering events in the former Yugoslavia. Members of the team describe their work, and reflect on how much it has taught them about how television works. The interviews combine with footage showing the different stages of preparing the news report: taping the satellite broadcasts, assembling the edit and recording voice-over comments, then finally transmitting the evening bulletin to a silent and attentive audience gathered in the camp's communal screening room.

The Roška television project was instigated by the French documentary maker Théo Robichet, who had worked with Marker on *Far from Vietnam*. In *Prime Time in the Camps*, Robichet outlines the importance of the television workshop in breaking down the isolation of the Bosnian refugees, by creating practical networks for information and communication among the dispersed refugee community, and also lifting individuals out of the private solitude in which they are enclosed, cut off from their past and facing an uncertain future.[22] Members of the television team confirm these feelings as they talk about their own personal experiences as refugees. Their testimonies subtly undercut the customary neutrality of broadcasters, emphasizing that the television team share common experiences of suffering and displacement with the other inhabitants of the camp.

A second project being developed by the television team is to record the memory of the camp by interviewing their fellow refugees, inviting them to talk about the circumstances that brought them to Roška, and recording their present experiences, daily routines and possessions. The impulse expressed by one member of the memory project, 'to keep hold of a moment for a time yet to come', precisely echoes Marker's own preoccupa-

tion with preserving memories in filmed and videotaped form. *Prime Time in the Camps* reflexively observes the activities of the memory team as they set up and record interviews, and Marker's camera relays their instinctive focus on refugees' personal possessions:

Le 20 heures dans le camps (1993).

a gesture explained by one member of the team in terms of the tremendous significance that such objects possess for people who have been forcibly exiled from their homes. To close the film, the refugee broadcasters offer their own messages to viewers. They hope that their work will be seen by other journalists and media workers, but most importantly they enjoin their audience to live together in peace.

Casque bleu, which was broadcast on Arte in October 1995, is a sustained 27-minute testimony by François Crémieux, a young Frenchman who during his military service volunteered to join the United Nations peacekeeping force in the Bihać enclave, a designated safe haven for Bosnians created in May 1993. Following a brief introduction to the role of UN forces in the former Yugoslavia, using library footage and a voice-over commentary, the programme is entirely devoted to a fixed close-up of Crémieux's face as he recounts his experiences. The only interventions come from white-on-black intertitles that fill the place of interview questions by periodically signalling a new theme in his discourse, for example Obedience, War, Death, Lies; and photographs (presumably taken by Crémieux himself), that are turned up to the camera like the pages of a book, in order to amplify and illustrate what he says.

Crémieux volunteered for service with the UN forces in the former Yugoslavia (France was actually the largest provider of UN troops in the region), and left for Bihać in May 1993, where he would spend six months. Initially motivated by a belief in the UN mission and the moral imperative to intervene in the conflict, Crémieux recounts how he quickly became disillusioned with the weaknesses of UN policy, and with the ingrained culture of

the military, which fatally undermined the ethos of peacekeeping and protecting the Bosnian inhabitants of the enclave. Crémieux describes the casual racism that underlay the briefings the troops were given about the situation – when they were told not to trust the local population because living under Communism had turned them all into liars – and the attitudes of the French soldiers towards the Muslim Bosnians, carried over from their antipathy towards the Arab Muslim community in France. He points out that most volunteers were motivated by money (salaries for UN soldiers were considerably higher than those of regular conscripts) or career advancement rather than humanitarian goals. Perhaps most disquietingly, he argues that an armed occupying force that is prevented from using its weapons is automatically placed on the side of the aggressor, which in this case was the Serbs (a position reinforced by the fact that many French officers held fast to France's historical alliance with Serbia). Summing up his experiences, Crémieux was personally satisfied with the handful of humanitarian activities he had taken part in – escorting food convoys and supervising exchanges of prisoners – but felt that as a whole the mission was a complete failure, proved when the UN withdrew from the enclave and the Serb army quickly overran it.

Casque bleu is a compelling testimonial, largely because Crémieux has already taken it upon himself voluntarily to bear witness (which a soldier in the regular army could not do). The technique of holding his face in fixed close-up, and withholding all intervention from the interviewer, which together combine to focus the viewer's attention tightly on what he is saying, would arguably not work with someone more reticent and hesitant about speaking. Although Crémieux appears to speak forcefully and continually, it is possible to observe small jump cuts where parts of the tape have been edited out. When he remarks at the end that few people are willing to listen to him as Marker has done, we learn that the full interview was just short of an hour long. Crémieux is able to recognize and discuss the extent to which he became implicated in the military culture that he so dislikes. He admits that the culture of absolute obedience led him to obey all the orders he was given, even though he had fantasized about refusing to do anything he found morally repugnant, and confesses his excitement at undertaking missions to collect corpses from the front line – the nearest

thing to actual warfare that he took part in. On the evidence of the programme, there is nothing of which Crémieux is unaware or about which he is unwilling to speak, and Marker frames no silences or hesitations in his discourse that might figure otherwise.

Marker collaborated with François Crémieux again when they returned after 2000 to the former Yugoslavia to film *Un Maire au Kosovo*, together with the incomplete *Avril inquiet*, a collection of interview-portraits of Kosovans. *Un Maire au Kosovo* is an extended interview with Bajram Rexhepi, a surgeon who fought with the Kosovan Liberation Army and was later appointed mayor of the city of Mitrovica, as someone respected by all political parties and not seen as an extremist. (With high irony, a notice at the end of the film observes that when Rexhepi was defeated in the elections of October 2000, the press proclaimed that the moderates had finally won out over the extremists.) In his office and driving around in his car, Rexhepi answers questions from Marker and Crémieux about how he came to join the Kosovan Liberation Army, and how he treated the wounded in very difficult conditions. He goes on to discuss the impact of the war and his feelings about the future of the Balkans. The interview is intercut with scenes from a ceremony for the Kosovan Liberation Army with songs, dancing and poetry.

As far back as 1989, Anatole Dauman's memoirs mention an upcoming feature-film project for which Chris Marker was developing a science-fiction, computer-based scenario to examine the history of the Battle of Okinawa, the final battle of the Second World War, launched in April 1945 when US forces invaded the island in the closing stages of the Pacific campaign.[23] This project would finally surface in 1996 as *Level Five*, a film that engages the virtual universe of computer games, databases and the Internet as the conduit for interweaving a searching documentary account of the battle with a fictional drama of lost love. A woman known as Laura (played by Catherine Belkhodja) is trying to complete the design of a computer game about the Battle of Okinawa left unfinished by her lover, who has died in mysterious circumstances. She speaks constantly to the dead man, communing with him through the computer they shared and her efforts to fathom the game programme. Laura's research into Okinawa's history – much of it conducted on-line through Optional World Link (OWL), a

science-fiction alter ego of the World Wide Web – forces her to confront the devastating consequences of the battle for the island's civilian population. Renowned in history for their gentleness and pacifism, one third of the native islanders (approximately 150,000 individuals) perished during and after the battle, the great majority pressured by the 'never surrender' ethos of the Imperial Army into killing themselves and the members of their own family, rather than fall alive into the hands of the victorious Americans. Laura is overwhelmed by the ghosts of Okinawa's past as well as her own (she speaks of suffering from 'a migraine of time'), and at the end of the film disappears in her turn, leaving behind a video diary. Parts of Laura's story, and Okinawa's, are narrated by her editor friend Chris (Marker in an uncharacteristically transparent guise, speaking in his own voice and under his most familiar pseudonym), and we may surmise that it is he who has discovered the video diary and assembled the film we have just watched.[24]

Sandor Krasna had alluded to the rupture of Okinawa's history in *Sunless*, but in *Level Five* Chris accuses himself of having become so Japanese that he blindly shared in the general amnesia about the battle. The destruction of Okinawan civilization, and the searing trauma of the mass suicides, went unacknowledged in many Japanese and American accounts of the Pacific War, in large part because neither nation recognized, or valued, the cultural autonomy of the Ryukyu Islands. Japan had annexed the islands in 1875; the American Occupation force simply regarded them as part of Japan. Okinawa's pivotal role in the war had also been obscured behind its fateful consequences for the Japanese cities of Hiroshima and Nagasaki. The refusal of the Japanese command to surrender after they lost control of the island, after three months of savage fighting and massive military casualties on both sides, directly determined the US decision to deploy the atomic bomb against Japan, rather than risk further devastating losses in a land invasion of the main islands. Okinawa's history speaks to Marker's long-standing concern for aspects of the past that have been written out of existence by those in power, and his interest in exposing decisive events that languish forgotten and obscured behind the official versions of history.

Raymond Bellour has heralded *Level Five* as a new kind of film, the first cinema release to examine the links between cultural memory and the production of images and sounds by computer.[25] The literal presence of the

computer and the virtual realm of cyberspace function, like the implied process of editing in *The Last Bolshevik*, as the screen for assembling and questioning the visual evidence of the historical past. Many of the raw materials and visual special effects assembled for the Okinawa strand of *Level Five* are much like those found in *The Last Bolshevik* – solarized and coloured footage, framed images, borrowed extracts from other films, interviews, contemporary sequences depicting the battle museums and memorial sites on Okinawa and the people who visit them. Laura relates two parables about representations insinuating themselves in place of actual events, which echo *The Last Bolshevik*'s story of the Winter Palace photograph. Gustav, the all-purpose burning man of the wartime news-reels, gets up and walks away in a few frames that were never shown. A US Marine named Ira Hayes never forgave himself for his part in creating what would become an iconic image of American troops raising the Stars and Stripes on Iwo Jima, because it was a re-enactment. The crucial innovation made by *Level Five* in treating this material is that the computer is firmly established as the mediating link. Full-screen sequences frequently reappear

on a monitor next to Laura in her workspace. File menus classify sources under headings such as 'Media Coverage' and 'Witnesses'; and two of the latter, the film director Nagisa Oshima and the karate master Kenji Tokitsu, first appear as flat silhouettes emerging from graphic designs on the computer screen. Composite digital images, which are often extremely intricate and visually dazzling, pervade *Level Five* alongside more conventional documentary source material, to depict the cyber-worlds of the computer game and the OWL network.

Level Five's computer is not simply a neutral tool that enables Laura to investigate Okinawa's past (as a conventional understanding of what computers do might lead us to expect). It is the moral arbiter of her encounter with history. The game program will not allow Laura to create a more favourable outcome for Okinawa, but compels her to replay the battle and its consequences in all their horror, to search to the end for the crucial witness, Kinjo Shigeaki, who recounts the circumstances in which, with his brother, he killed his mother and younger siblings rather than permit them to be captured by the Americans. There is an opacity in Laura's relationship with her computer, which works to disrupt the easy access to information that we are conditioned to expect, and restores to the gradual unfolding of Okinawa's history a sense of appropriate gravity and risk. Fed up with the computer crashing when she tries to reinvent the battle, Laura feeds it a series of joke command words, for the pleasure of seeing it admit 'I don't know how to cauliflower', or 'I don't know how to shoe'. In the final image

of the film, after she has disappeared, it signals 'I don't know how to Laura'. She also confesses her fear at discovering something dreadful lurking unseen in the computer files and databases – which, more than the revelations about Okinawa, turns out to be her own face in the on-line Gallery of Masks. The computer is a screen in both senses: it transmits information, but it also has a protective or concealing function that provokes terrible consequences for Laura when it dissolves. It marks Okinawa as a site of trauma, which still has the capacity to overwhelm the present, and resists being consigned to a benign and readily consumed historical narrative.

The originality of Marker's treatment of new media in *Level Five* is matched, in terms of his own films at least, by the presence of Laura: the 'cyberpunk Lorelei' who is the first fictional character ever to appear and speak directly in one of his films. Marker's meeting with the actress Catherine Belkhodja had proved decisive in his plans for the film, crystallizing the character of Laura as an intended point of identification for the audience, a bridge between a recognizable loss (the death of a lover) and the almost unimaginable sufferings of Okinawa.[26] With her name taken from Otto Preminger's *film noir* of 1945 and the overt allusion of her story to *Hiroshima mon amour*, Laura is an avatar of fiction cinema itself, and in respect of her link to Resnais' actress, to its most radical engagements with questions of history and memory. Marker has jokingly referred to *Level Five* as a 'semi-documentary', on the basis of the remark by Harry S. Cohn, the Columbia Studios boss, that a documentary can't have a woman in it. This underlines Laura's allegiances to the classical cinema, even though she breaches one of its most basic conventions, by looking directly into the camera and addressing the viewer, when within the story she stares at her computer screen and converses with her dead lover. Laura's status as a projection is scrupulously observed: at one point her image 'downloads' into the workroom, and she goes in and out of focus when she adjusts the video

camera with a remote control. Her link to Preminger's heroine, who appears first as a painting and then seems to appear as a ghost in the dream of a police detective, hints at the spectral status she enters with her disappearance at the close of the film: the elusive 'Level Five'. Like the chain of women and works of art who appear near the close of *If I Had Four Camels*, Laura entertains a special relationship with death: she herself is a screen that can communicate on the audience's

behalf with the ghosts of Okinawa, even though the cost of such an encounter ultimately proves too great.

Level Five returns Marker by an oblique route to the experiences of the Second World War in Europe, when Chris remarks that, proportionally, the only population to have suffered as much as the Okinawans were the deportees. It also closes the circle of his involvement with cinema. Marker has said that *Level Five* will be his last theatrical feature film (it was shot on video and digital video and transferred to 35mm), and that in future he intends to work only with the computer.[27] Marker offers a final homage to the lost world of the classical fiction film by entering at least halfway onto its terrain, folding it and the conventions of documentary historiography into the databanks of the computer, before finally entering them for good himself.

The figures of Marcel Proust and Alfred Hitchcock preside over the entry into the Memory zone of Marker's CD-ROM *Immemory*. Developed in collaboration with the Centre Georges Pompidou, as the first in a planned series of artists' CD-ROMs concerned with questions of memory, *Immemory* was premiered there during 1997 with the title *Immemory One* (to allow for subsequent modifications), and then released commercially in 1998 (an English version appeared in 2003). In an essay written to accompany *Immemory*, Raymond Bellour writes: 'Whatever he may or may not do after his CD-ROM, it is clear that the latter already stands as a final work and a masterpiece, in conformity with its craftsmanly character and with its programmatic value.'[28] What Marker proposes in *Immemory* is the geography of his own memory, to be traced via the accumulated signs and mementos of a lifetime. His hypothesis is that 'every memory with some reach is more

WHAT IS A MADELEINE ?

structured than it seems', that 'photos taken apparently by chance, post-cards chosen on the whim of the moment, begin once they mount up to sketch an itinerary, to map the imaginary country which spreads out inside of us.'[29] Each one of these elements is for Marker a madeleine, that token shared by both Hitchcock and Proust, a frail and inconsequential object that by itself can support, as Proust wrote, 'the immense edifice of memory'.

The portal into *Immemory* is a welcome screen with the icons for seven separate Zones: Cinema, Travel, Museum, Memory, Poetry, War and Photo-graphy, plus a zone devoted to X-Plugs – dense digital collages that have also appeared as an on-line slide show. From there on in, the pathways through *Immemory* fork and diverge on to infinity – until you click on the red arrow at the top of the screen that takes you back to the opening page. Certain zones overlap with each other (Memory with both Travel and Cinema); one click of the mouse can propel you from one zone into another if you choose a certain route. Photography, Poetry and Cinema offer a sub-sidiary menu; Museum offers a choice of how to navigate it. Every so often, the cartoon image of Guillame-en-Egypte, the 'silent-movie cat' and oblig-ing tour guide through *Immemory*, will pop up to pass comment, reveal

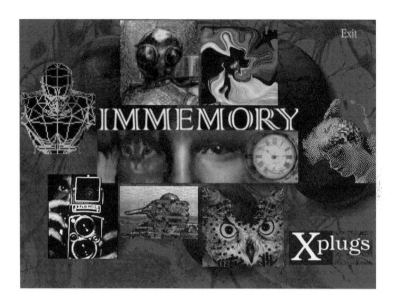

another layer of the image or invite you to take a detour somewhere else. It is also possible to tour *Immemory* via the Index, which serves as a handy reminder of all the elements you haven't managed to see yet.

The user instructions to *Immemory* advise 'Don't zap, take your time'. The unfolding screens have a built-in element of discretion: it is often necessary to linger a while and wait for things to happen, or to move the mouse slowly over the screen in order to discover the small eye icon that, when clicked, will unfold another change – as in the Poetry zone, where clicking on concealed eyes in a suite of images will cause part of the picture to slide up and reveal a scrolling poem. At certain points, moving the mouse also triggers the appearance of layers of text, which will hastily roll back out of sight if you skate around too quickly. The experience of navigating *Immemory* is precisely like rummaging through a virtual attic of stored treasures, time in suspension as you become absorbed in poring over the random, forgotten mementos of the past that rise to the surface as you delve through with your hands.

The materials that Marker assembles in *Immemory* are signs and traces that propel the user back across his entire career as a writer, image-maker and compulsive hoarder, and through a strand of autobiographical revela-

tions that are firmly stated to be true, but which the seasoned tourist of planet Marker is nonetheless likely to suspect of being dressed up a little (in the spirit of all good family legends). The intimacy of the family album is a leitmotif of *Immemory*, and we discover in it a picture of Marker's mother Rosalie, an album in the Photo zone of 'assorted fairies' ('feés diverses' in French, a pun on *faits diverses*) containing photos of women he has loved (if only as images), and in particular many tales of his Uncle Anton and Aunt Edith Krasna, cosmopolitan travellers of Hungarian and Russian extraction who are the elective parents of his passion for travel and photography. In the Travel zone, Marker revisits an illustration from Jules Verne and one of his own photos to replay *Sunday in Peking*'s transport back to the alley that supposedly led to the tombs of the Ming emperors. Between these images (which appear in stages with separate clicks of the mouse), he puts a photo of the Ming alley taken by Uncle Anton in the 1930s. Meanwhile, in the Cuba segment of the Photo zone, we discover that Marker spent two years in Cuba as a young boy, in the company of his uncle and aunt.

At the end of *Sunless*, Sandor Krasna's film images entered the zone and were transformed into memories. The zones of *Immemory* are the logical

culmination of this virtual space that extends outside the parameters of place and time, via their intermediate dispersal across the multiple screens of *Zapping Zone* and *Silent Movie*. Marker reabsorbs past works into *Immemory*: the photo-text albums *Coréennes* and *Le Dépays* are re-presented as subsections of the Photo zone, with only slight modifications of layout, and the spatial layout of the book is replaced by unscrolling layers of image and text. Marker also uses the text of his *Vertigo* essay 'A free replay' in the *Vertigo* segment, which is shared by Cinema and Memory. Yet, like the amassed footage used to compose *Le Fond de l'air est rouge*, Marker does not present this material as a flat, routine, unmediated archive. *Immemory* is more properly what Thomas Tode calls a 'recycling plant', in which images familiar from Marker's earlier works are put into different contexts, by being combined with new texts and associated with other images.[30] Many past works are conjured in *Immemory* in the blink of an image: the photograph of a wrecked military vehicle in the Negev Desert that opened *Description of a Struggle*; and the faded sepia photo of a group of young men who push their faces through the cut-out holes in a fairground group painting. Marker had placed this image in *Regards neufs sur la chanson*; in

Alexandra S

Immemory he names the participants, who included two Chinese visitors, Joseph Rovan and the gifted young writer François Vernet (who would die in Dachau), and offers the caption 'That's what you call a generation.' Other suites of images, particularly those of Cuba and Russia (again in the Photo zone), supply fresh and expanded perspectives on the films devoted to those countries.

The capabilities of the CD-ROM provide the ideal vehicle for Marker's virtual projection of his memory, since they enable him to draw together text and images in new, mobile, infinitely open-ended hypermedia constellations that transcend the existing models of both book and film. One of Marker's crucial conceptual sources for *Immemory* is the philosophical model of memory proposed by the seventeenth-century English savant Robert Hooke, whose studies anticipated Newton's theory of gravity. Hooke postulated the existence of a point in the human brain, the seat of the soul, where 'all sense impressions are transmitted and gathered for contemplation'.[31] The CD-ROM, and the electronic technology that designs and powers it, becomes the equivalent to Hooke's seat of memory, processing impressions of the past that seem to arise on the screen from nowhere, and then disappear again without leaving any trace (except in the navigator's own memory). The sound and cinematic elements of *Immemory* (the latter in the form of small QuickTime projections) are limited for reasons of memory space, and the same practical consideration led Marker to favour written texts over spoken commentary; but the result is that writing can be made an integral component of the image in a way that speech never can. The CD-ROM in fact has the capacity to stretch beyond the book and the film to incorporate all types of image in digitized form: paintings, engravings, ticket stubs, postcards, the impression of physical objects (like the handprint found in the Museum zone), newspaper cuttings, letters, posters torn from walls. *Immemory* recapitulates and expands the promiscuity of images first apparent in Marker's Petite Planète layouts, displaying the same fluent, inventive and playful handling of graphic space, but with the added dimensions of movement, transition and superimposition. The way that Marker works over and transmutes his source material (which he did by himself, designing *Immemory* alone using Roger Wagner's Hyperstudio software) offers an instructive parallel with the ideas of the new media

theorist and historian Lev Manovich, who sees in the creative techniques of digital media a return to the handmade processes of painting, drawing and animation, rather than the mechanically generated images of photography and cinema.[32] In some parts of *Immemory* the analogy is quite literal: Marker and Guillame have much fun in the Museum section tweaking a few pixels to wipe the smile off the Mona Lisa's face, and make a languid Renoir bather appear to breathe. We can also click through imaginary galleries in which Marker has turned photographs of his friends (including Simone Signoret) into paintings, and morphed together famous paintings with images of warfare.

Marker's final wish for *Immemory*, the same one he had expressed with regard to *Silent Movie*, was that the visitor might be furnished with enough familiar cues – the family album, the holiday snapshot, the totem animal – to superimpose gradually upon Marker's chosen images the treasured contents of his or her own memory, so that, as he had written in *Sunless*, everyone might write poetry, and compose their own list of things that quicken the heart. Although this modest gesture of deferral to the visitor is well meant and taken, it is a moot point whether the user of *Immemory* ever

really replaces the style and artistry of Marker's words and images with their own personal reveries, and whether the attraction of *Immemory* is not precisely that Marker has fashioned a global memory out of the signs of his own life, through which complete strangers may experience all the emotion and shocks of intimate recognition that they would normally obtain only from their own private worlds.

All Marker could do after *Immemory* was confound expectations. In 1999 he published a short story in the journal *Trafic*. 'Phénomène (n.m.)', deploys Marker's interests in mathematics, Platonic philosophy and Lewis Carroll to create a new twist on his favoured theme of human utopias. Professor Loewen is the perplexed and finally philosophical witness to a world in which all competitors are suddenly equal. A France–Hungary football match ends in disarray when, after a 6–6 score in extra time, a coin tossed to decide the outcome fails to fall back down. A sprint final sees all the athletes hit the tape at exactly the same moment, a university computer awards a class of students identical marks, a televised lottery wheel spins endlessly. As Loewen contemplates this brave new world of mathematical equilibrium, he can only look forward to the next election results.[33]

One February day in 1986, ten months before his death, Andrey Tarkovsky had confided to his diary: 'Chris. is a gifted, interesting man. I don't know how friendly he is with [Anatole] Dauman, but something exists which is rarer, more subtle and more exceptional than talent: the gift of discerning and acknowledging the talent of another; not everyone has that gift, far from it.'[34] Tarkovsky was musing on the character of the film producer he and Marker had in common – Argos produced Tarkovsky's final work, *The Sacrifice* – but his mention of Marker in the same sentence as the idea of a rare gift, the ability to recognize somebody else's talent, would turn out to be prophetic. Thirteen years later, in 1999, Marker would complete *One Day in the Life of Andrei Arsenevich*, a portrait of the Russian director for the long-running French television strand 'Cinéastes de notre temps' ('Filmmakers of our Time'), which stitches Tarkovsky's life and films together in a lyrical tapestry, a tribute to their friendship and to one of the most remarkable bodies of work in the history of cinema.

Apart from Tarkovsky's own work, the raw material of *One Day in the Life of Andrei Arsenevich* was two film and video records that Marker had

made of Tarkovsky during 1986, previously presented as *Tarkovski '86* in *Zapping Zone*. He had accompanied Tarkovsky and his crew to Sweden to make a video document of the final stages of the *Sacrifice* shoot, in particular the climactic sequence shot in which the central character sets fire to his own house. The atmosphere is far more intimate and informal than Marker had found with Kurosawa on the set of *Ran*. Tarkovsky is observed at close range, mapping the shot through the camera and joking with the actors as he puts them through their paces, all in the teeth of extreme pressure to get the complicated shot right, after a first attempt had ended in failure. *One Day in the Life of Andrei Arsenevich* uses iris masking and circular inserts from the finished film, to analyse more precisely how the shot is structured to integrate the performers and the elements of the landscape within the mobile frame.

Marker had also filmed Tarkovsky's reunion with his mother-in-law and son Andrioushka, who had finally been granted visas to join Tarkovsky and his wife Larissa in Paris. In *One Day in the Life of Andrei Arsenevich* Marker adds Tarkovsky's commentary on the scene from his diary, about how he held back his emotions and repeated banal phrases. What he does not quite capture is how Tarkovsky blends his feelings towards his family with his sensibility as a film director. The diary entry expresses profound gratitude to Marker for having recorded the moment, but Tarkovsky also admires his film from a formal viewpoint, and muses about using it for a biographical film he was planning to make with Franco Terilli.[35]

This seamless integration of art and autobiographical life becomes the motor of *One Day in the Life of Andrei Arsenevich*, as it had been a central element in many of Tarkovsky's films. The rich stylistic and thematic coherence of Tarkovsky's work is a gift to Marker, allowing him to dip at will and use his trademark associations and graphic matches to weave his own vision of the director's work. As the film opens, the bun of the waiting mother in *Mirror* (1974) matches Larissa's bun as she waits anxiously at the airport for her mother and son. Watching Tarkovsky filming *The Sacrifice*,

Marker imagines him to be like the bell-caster in *Andrei Rublev* (1966), who works by faith alone. The elements of earth, air, fire and water are relayed from film to film in their complex associations, as is the appearance of paintings and mirrors as indicators of Tarkovsky's ruling ambition: to raise cinema to the status of art. The echoing apartment in *Mirror* becomes a house inhabited by all Tarkovsky's films, and finally the entirety of his work is shown to have been contained between two images of boys under trees: the opening shot of *Ivan's Childhood* (1962), and the final shot of *The Sacrifice*.

Marker's latest film (2002), co-directed with Yannick Bellon, is his third work composed of still photographs. *Remembrance of Things to Come* is a memorial to the work of Bellon's mother Denise (1902–1999), a widely travelled professional photographer during the 1930s and a member, along with Robert Capa, of the Alliance Photo agency (1934–40). Its title comes from a poem by Claude Roy, who was the husband of Yannick's sister Loleh. *Remembrance of Things to Come* is bracketed by images of the two Surrealist exhibitions held in Paris in 1938 and 1947 – Bellon was associated with the Surrealist group and we see a dedication to her from André Breton on the flyleaf of her copy of *Les Vases communicants*. Across the epochal shift between these shows, Bellon's work is surveyed via thematic clusters and chronologically, from the optimism of the early 1930s to the Second World War and its aftermath. Marker deploys the full range of techniques mastered in *La Jetée* and *If I Had Four Camels* to infuse the photographs with dynamism and reflective intelligence: close-ups, dissolves, pans and crisp montages. The themes singled out from Bellon's work include artists, the urban spaces of Paris, cinema, the French empire in Africa and finally war. As usual Marker navigates effortlessly by associational logic. The opening Surrealist exhibition provokes images of artists – Picasso, Salvador Dalí and Marcel Duchamp among them – then shots of the Facteur Cheval's Palais Idéal, adored by the Surrealists and by Marker himself. A graphic resemblance links one of the sculpted heads in the Palais, shaped according to one man's dream of an earthly paradise, to the deformed face of a former soldier wounded in the First World War: a hell on earth. In a second suite of images drawn from Bellon's work for women's magazines, an illustrated advertisement for hot chocolate turns out to be based on Bellon's photograph of her two daughters, Yannick and Loleh. A digression into the family

album follows, further images of the two girls and the recognition by the commentary that in adult life they would follow two paths, one on either side of the camera, Yannick as a director and Loleh as a film actress.

The central premise of *Remembrance of Things to Come* is contained in its title: 'each of the photos shows a past, but deciphers a future'. Bellon's functional, accomplished photojournalism is mined by the commentary for unconscious traces of the future, in particular the imminent recurrence of war in an era of transient and fragile peace. The Rif War between Spain and Morocco foreshadows the Algerian War; amateur parachutists become harbingers of wartime landings from the air; the body of a woman stretched asleep by a lake anticipates corpses laid out by the road. The grotesqueries and weird juxtapositions of the Surrealist exhibition of 1938 seem to portend the horrors and bizarre spectacles of the war – a dog wearing a gas mask – while the wartime drive to recycle scrap iron is promoted with a phrase that sounds like a Surrealist slogan: 'victorious steel'. In other instances, Marker pushes beyond the raw evidence of the photograph to seek (or invent) the future of Bellon's images. A photo of the Sorbonne courtyard sounds to a fragment of the soundtrack of May 1968 from *Le Fond de l'air est rouge*. An innocuous image of Bir-Hakeim Bridge over the Seine becomes sinister when we are shown that Bir-Hakeim is listed next to Birkenau in an encyclopedia, as does a copy of the photo magazine *Paris Match* with a Roma woman on the cover, when it is opened up to reveal extracts from Hitler's *Mein Kampf*.

Bellon's photos ultimately permit Marker to resurrect one of the most persistent themes of his work: a history that does not officially exist. A handful of her images are the only evidence of a failed Spanish Republican uprising against General Franco in 1944, otherwise cast into oblivion. *Remembrance of Things to Come* stands as a barrier to prevent all the other, better known, histories that it documents from going the same way. What happens to the deep cultural memory of the twentieth century as we pass into the twenty-first? At least these scattered moments remain, and a memory that can stretch far enough to recall what they meant in their own time, and to decipher what they will become in the future.

Conclusion: The Eye That Writes

Imagine an apartment somewhere in Paris. The windows are covered to black out the daylight, and inside seven or eight television screens are perpetually switched on. One receives satellite broadcasts from Korea, another from China, while a third is hooked up to French cable. Above the sounds of the television, ambient jungle noises are playing. The room is immaculately tidy, crammed with books, tapes and the mementos of a lifetime of travel and friendship. The occupant of the apartment, Chris Marker, spends much of his time taping the television broadcasts, writing the audio-visual archives of the future. He sits and sleeps with his legs folded up in an armchair, like an elderly monkey who has no use for a bed. Visitors find him friendly and polite, a fast talker and a fast thinker (although there is no point trying to continue the conversation if a programme about parrots happens to start on the Animal Channel). But at the end of the day, he is happiest to be by himself, creating his own worlds by recording and reflecting upon the images of this one, and holding them up as mirrors and masks for the deepest cultural memories and desires of the histories we live.

References

Introduction: Free Radical

1 See Chris Marker, 'Marker mémoire (Cinémathèque Française, 7 janvier–1er fevrier 1998)', *Images documentaries*, 31 (1998), p. 75.
2 See the discussion of Godard and Marker in Raymond Bellour, 'The Book, Back and Forth', in *Qu'est-ce qu'une madeleine?: A propos du CD-ROM* Immemory *de Chris Marker* (Paris, 1997).
3 Chantal Akerman has exhibited parts of her films *d'Est* (1993) and *Jeanne Dielman, 23 Quai du Commerce, 1080 Bruxelles* (1975) as gallery installations. In collaboration with the Artangel organization, Atom Egoyan created the installation *Steenbeckett* at the disused Museum of Mankind in London in 2002, incorporating his film of Samuel Beckett's play *Krapp's Last Tape*. Isaac Julien's recent cinematic installation works include *The Long Road to Mazatlan* (1999), *Vagabondia* (2000) and *Paradise Omeros* (2002). Harun Farocki has produced *Interface* (1995) and the three instalments of *EYE / MACHINE* (2001, 2002 and 2003).
4 The most complete and accurate filmography of Marker's work (excluding works released after 1997) is that contained in Birgit Kämper and Thomas Tode, eds, *Chris Marker: Filmessayist*, CICIM, 45/46/47 (Munich, 1997).
5 André Bazin, 'Lettre de Sibérie', in *Le Cinéma français de la Libération à la Nouvelle Vague, 1945–1958* (Paris, 1983), pp. 179–81. This review was first published in *France-Observateur*, 30 October 1958 (English translation in *Film Comment*, XXXIX/4, July–August 2003, pp. 44–5).
6 Chris Marker, 'William Klein: Painter / Photographer / Film-maker', *Graphis*, 33 (May–June 1978), p. 486.
7 Chris Marker, *The Forthright Spirit* (London, 1951), p. 184 (English translation of *Le Cœur net*, Paris, 1949).
8 Interview with Chris Marker by Dolores Walfisch, *Vertigo*, 7 (Autumn 1997), p. 38 (first published in *Berkeley Lantern*, November 1996).

1: The Invention of Chris Marker

1 Benigno Cacérès, *Les Deux Rivages: Itinéraire d'un animateur d'éducation populaire* (Paris, 1982), p. 27. All translations from French sources are my own.

2 Quoted in Jean-Louis Leutrat, 'Le cœur révélateur', *Trafic*, 19 (Summer 1996), p. 67.

3 'Newsreel', *Esprit*, 133 (May 1947), pp. 836–8; 'Newsreel', *Esprit*, 146 (July 1948), pp. 93–4.

4 'Petite suite sur thème des chansons', *Esprit*, 179 (May 1951), p. 769.

5 Alexandre Astruc, 'The Birth of a New Avant-Garde: *Le Caméra-Stylo*', in *The New Wave*, ed. Peter Graham (London, 1968), pp. 17–23; first published in *Ecran Français*, 144 (1948).

6 'Corneille au cinéma', *Esprit*, 153 (February 1949), pp. 282–5.

7 For a detailed account of the cultural and intellectual impact of existentialism in the late 1940s, see *Paris Post War: Art and Existentialism, 1945–55*, exh. cat., Tate Gallery, London (1993). For an eye-witness report, see Boris Vian, *Manuel de Saint-Germain-des-Prés* (Paris, 1974).

8 The activities of Uriage and Mounier's involvement with them during the Occupation have become the subject of considerable historical controversy, which has inevitably coloured how the work of *Esprit* and related organizations after the war are viewed. A sympathetic account is given in Michel Winock, *Histoire politique de la revue* Esprit, *1932–1950* (Paris, 1975). A more critical perspective is offered by John Hellman, who emphasizes the anti-democratic bent of the Uriage group and their ideological affinities with the Vichy regime. See his *Emmanuel Mounier and the New Catholic Left, 1930–1950* (Toronto, 1981) and *The Knight-Monks of Vichy France: Uriage, 1940–1945*, 2nd edn (Liverpool, 1997). The most extreme exponent of this position is the French philosopher Bernard-Henri Lévy, who regards the values of Uriage as a facet of home-grown French fascism. See his *L'idéologie française* (Paris, 1981).

9 'Editorial', *Esprit*, 105 (December 1944), p. 2.

10 Quoted in Dudley Andrew, *André Bazin* (New York, 1978), p. 101.

11 This quotation and the account of the *Esprit* Round Table is drawn from Andrew, *André Bazin*, p. 102.

12 'En attendant la société sans classes?', *Esprit*, 130 (February 1947), p. 312.

13 'La mort de Scarface, ou les infortunes de la vertu', *Esprit*, 131 (March 1947), pp. 488–91.

14 'L'apolitique du mois', *Esprit*, 133 (May 1947), pp. 808–12; 'Le sommeil de l'injuste', *Esprit*, 133 (May 1947), pp. 844–7; 'L'affaire Tito vue de Yougoslavie', *Esprit*, 147 (August 1948), pp. 207–9.

15 'Actualités imaginaires', *Esprit*, 132 (April 1947), pp. 643–4; 'Le Tito entre les dents', *Esprit*, 147 (August 1948), pp. 210–12.

16 'Orphée', *Esprit*, 173 (November 1950), p. 697.

17 Studies of the relations between intellectuals and political ideology in France during the Cold War period include Tony Judt, *Past Imperfect: French Intellectuals, 1944–1956* (Berkeley, CA, and Los Angeles, 1992); David Caute, *Communism and the French Intellectuals, 1914–1960* (London, 1964); and Janine Verdès-Leroux, *Au Service du parti: le parti communiste, les intellectuels et la culture, 1944–1956* (Paris, 1983).

18 'A propos du paradis terrestre', *Esprit*, 129 (January 1947), p. 158.

19 'Sauvages blancs seulement confondre', *Esprit*, 146 (July 1948), pp. 1–9.

20 'Sauvages blancs', op. cit., p. 5.

21 According to Alain Resnais, Marker made a number of accomplished 8mm films in the late 1940s, including one entitled *La Fin du monde vu par l'Ange Gabriel* (1946). When Marker himself was asked about this early work in an interview of 1962, he dismissed it as amateur dabbling. Marker's career in film is thus taken to begin in 1950 with *Les Statues meurent aussi*. See interviews with Alain Resnais in *Image et Son*, 161–2 (April–May 1963), pp. 52–3, and in Birgit Kämper and Thomas Tode, eds, *Chris Marker: Filmessayist*, CICIM 45/46/47 (Munich, 1997), pp. 205–17; and interview with Marker from *Miroir du Cinéma*, 2 (May 1962), reproduced in *Anatole Dauman: Souvenir-Ecran*, ed. Jacques Gerber (Paris, 1989), pp. 157–9.

22 'Le Cheval blanc d'Henry Cinq', *Esprit*, 141 (January 1948), pp. 120–27; 'Orphee', op. cit.; 'La Passion de Jeanne d'Arc', *Esprit*, 190 (May 1952), pp. 840–43; 'On The Waterfront', *Esprit*, 224 (March 1955), pp. 440–43; 'L'imparfait du subjectif', *Esprit*, 148 (September 1948), pp. 387–91.

23 Jacques Chevallier, ed., *Regards neufs sur le cinéma*, Collection 'Peuple et Culture' no. 8 (Paris, 1953); André Bazin, Jacques Doniol-Valcroze, Gavin Lambert, Chris Marker, Jean Queval and Jean-Louis Tallenay, *Cinéma 53 à travers le monde* (Paris, 1954).

24 'Siegfried et les Argousins, ou le cinéma allemand dans les chaînes', *Cahiers du Cinéma*, 4 (July–August 1951), pp. 4–11; 'Adieu au cinéma allemand?', *Positif*, 12 (November–December 1954), pp. 66–71.

25 See 'L'esthétique du dessin animé', *Esprit*, 182 (September 1951), pp. 368–9; 'Gérald McBoing-Boing', *Esprit*, 185 (December 1951), pp. 826–7; '"Prince Bayaya" de Jiri Trnka, une forme d'ornement', *Cahiers du Cinéma*, 8 (January 1952), pp. 66–8, and in *Images Documentaires*, 15 (1993), pp. 11–13; and 'Cinéma d'animation: UPA', in Bazin *et al.*, *Cinéma 53 à travers le monde*, pp. 136–43.

26 See 'Lettre de Hollywood', *Cahiers du Cinéma*, 25 (July 1953), pp. 26–34; 'Le cinérama', *Cahiers du Cinéma*, 27 (October 1953), pp. 34–7, republished as 'And Now This Is Cinerama', in Bazin *et al.*, *Cinéma 53 à travers le monde*, pp. 18–23; and 'Cinéma, art du XXIe siècle?', in Chevallier, ed., *Regards neufs sur le cinéma*, pp. 499–502.

27 'Le Cheval blanc d'Henry Cinq', op. cit., p. 121.

28 'Le cinérama', op. cit., pp. 35–6.

29 Quoted in Andrew, *André Bazin*, p. 23.

30 'La Passion de Jeanne d'Arc', op. cit., p. 841.

31 'Orphée', op. cit., p. 696.

32 Cacérès, *Les Deux Rivages*, p. 13.

33 This account of the Travail et Culture ambience is drawn from Andrew, *André Bazin*, pp. 89–91.

34 Resnais interview in Kämper and Tode, *Chris Marker*, 206.

35 Joseph Rovan, *Mémoires d'un Français qui se souvient d'avoir été Allemand* (Paris, 1999), pp. 256–7.

36 'Les trois petits cochons', *Esprit*, 131 (March 1947), p. 470.

37 Chris Marker, *L'Homme et sa liberté*, Collection 'Veilées' no. 4 (Paris, 1949), p. 7.

38 Benigno Cacérès and Christian Marker, *Regards sur le Mouvement Ouvrier* (Textes assemblées et présentés), Collection 'Peuple et Culture' no. 5, (Paris, 1952).

39 'Croix de bois et chemin de fer', *Esprit*, 175 (January 1951), pp. 88–90.

40 Rovan, *Mémoires d'un Français*, p. 279.

41 'Till the end of time', *Esprit*, 129 (January 1947), pp. 145–51.

42 'Chant de l'endormition', *Le Mercure de France*, 1067 (July 1947), pp. 428–34; 'Romancero de la montagne', *Esprit*, 135 (July 1947), pp. 90–98; 'La dame à la licorne', *Le Mercure de France*, 1024 (December 1948), pp. 646–8; 'Les Separés', *Esprit*, 162 (December 1949), pp. 921–3.

43 'Romancero de la montagne', op. cit., p. 98.

44 Chris Marker, *The Forthright Spirit* (London, 1951), p. 103 [English translation of *Le Cœur net* by Robert Kee and Terence Kilmartin].

45 Marker, *Forthright Spirit*, p. 54.

46 Marker, *Forthright Spirit*, p. 51.

47 See Bibliography for a full list of Marker's translations.

48 See, for example, Francis Gendron, 'Chris Marker, ou l'évidence', *Miroir du cinema*, 2 (May 1962), pp. 10–11.

49 Chris Marker, *Giraudoux par lui-même*, Collection 'Les Ecrivains de toujours' no. 8, (Paris, 1952), p. 50. The book has been reprinted on several occasions, with Marker updating the essay and adding photographs.

50 Marker, *Giraudoux par lui-même*, p. 23.

51 Marker, *Giraudoux par lui-même*, p. 26.

52 Marker, *Giraudoux par lui-même*, p. 42.

53 Marker, *Giraudoux par lui-même*, p. 43.

54 For a fuller account of Dumazedier's ideas, see Brian Rigby, *Popular Culture in Modern France* (London and New York, 1991), pp. 46–52.

55 This account of the making of *Olympia 52* is drawn from Cacérès, *Les Deux Rivages*, pp. 35–7 .

56 Simone Dubreuilh, interview with Chris Marker, *Les Lettres Françaises*, 28 March–3 April 1957, p. 6.

57 Georges Guy, 'Olympia 52', *Image et Son*, 161–2 (April–May 1963), p. 30.

58 'L'aube noir', broadcast 10 February 1949 on France-Inter, produced by Chris Marker and Sylvain Dhomme. The text of the broadcast was published in *DOC 49* (1949).

59 From the commentary of *Les Statues meurent aussi*. All further uncredited quotations come from the commentaries of films under discussion.

60 This account is taken from Resnais' recollections in Nicole le Garrec and Réné Vautier, 'Les Statues meurent aussi et les ciseaux d'Anastasie', *Téléciné*, 175 (January 1972), pp. 32–6; and Kämper and Tode, *Chris Marker*, pp. 207–9. The letter from the CNC Censorship Commission is reproduced as an appendix to Chris Marker, *Commentaires* (Paris, 1961), n.p.

61 'Du Jazz considéré comme une prophétie', *Esprit*, 146 (July 1948), pp. 133–8.

62 Marker, *Commentaires*, p. 9.

63 Luce Sand, 'Les censures meurent aussi', *Jeune Cinéma*, 34 (November 1968), pp. 1–3.

2: Travels in a Small Planet

1 'Pôles', *Esprit*, 134 (June 1947), p. 1092 .

2 Francis-Régis Bastide, Juliette Caputo and Chris Marker, *La Strada: un film de Federico Fellini* (Paris, 1955).

3 Richard Roud, 'The Left Bank', *Sight and Sound*, XXXII/1 (Winter 1962–3), pp. 24–7.

4 Georges Sadoul, 'Au rendez-vous des amis: deux heures autour d'un micro avec Agnès Varda, Henri Colpi, Armand Gatti et Alain Resnais', *Les Lettres Françaises*, 903 (30 November 1961), reprinted in Georges Sadoul, *Chroniques du Cinéma Français, 1939–1967*, Ecrits 1 (Paris, 1979), pp. 226–46; Raymond Bellour, 'Un cinéma réel', *Artsept*, 1 (January–March 1963), pp. 5–27. Bellour extends the circle to include Jean Cayrol and Paul Durand.

5 Guy Gauthier has closely examined the role of these nineteenth-century sources in forging Marker's imagination of the world. See his essay 'Images d'enfance', in *Théorème*, 6, 'Recherches sur Chris Marker' (Paris, 2002), pp. 46–59, and also chapter 1 of Guy Gauthier, *Chris Marker: écrivain multimédia* (Paris, 2001).

6 Chris Marker, *Coréennes*, Collection 'Courts-Métrage', 1 (Paris, 1959), p. 15. *The Diary of A. O. Barnabooth*, first published in France in 1913, narrates a modern-day South American Grand Tourist's journey in search of self-realization through the capital cities of Europe. Plume is the eponymous anti-hero of Henri Michaux's Surrealist novella, included in the volume *Plume, lointain intérieur* (Paris, 1963). He navigates uncomplainingly through a series of increasingly bizarre and self-destructive episodes provoked by his failure to understand local customs.

7 Marker, *Coréennes*, p. 15. In *Immemory* the author admits to travelling Plume-fashion.

8 Victor Ségalen, quoted in Gauthier, *Chris Marker*, p. 23.

9 Chris Marker, 'Petite Planète', *27 Rue Jacob*, 10 (Summer 1954), p. 1.

10 The editorship was taken up by Marker's assistant Juliette Caputo, and the series continued publication until 1964, when it was reinvented as 'Collections microcosme'.

11 William Klein, *Life Is Good & Good For You in New York: Trance Witness Revels*, Album Petite Planète, 1 (Paris, 1956).

12 William Klein, 'Un livre d'auteur', *Cahiers du Cinéma*, 497 (December 1995), p. 73.

13 The following historical account of French short filmmaking is taken from 'Le court métrage français', special issue of *Image et Son*, 150–51 (April–May 1962); René Prédal, 'Des origines au grand tournant des années 60', in *Cinémaction*, 41, 'Le Documentaire français' (Paris, 1987), pp. 70–77; dossier 'Le Group des trente, un âge d'or du court métrage?', *Bref*, 20 (February–March–April 1994), pp. 22–42; and Guy Gauthier, *Le Documentaire: un autre cinéma* (Paris, 1995), pp. 66–9. A further useful source is François Porcile, *Défense du court métrage français* (Paris, 1965).

14 Quoted in Gauthier, *Le Documentaire*, p. 67.

15 See Pierre Braunberger, *Cinémamémoire* (Paris, 1987); Jacques Gerber, ed., *Anatole Dauman: Souvenir-Ecran* (Paris, 1989).

16 See Ian Aitken, *Film and Reform: John Grierson and the Documentary Film Movement* (London, 1990).

17 John Grierson, 'First Principles of Documentary', in *Grierson on Documentary*, ed. Forsyth Hardy (London and Boston, MA, 1979), p. 41. The essay is also included in Kevin McDonald and Mark Cousins, eds, *Imagining Reality: The Faber Book of Documentary* (London, 1996).

18 'Terminal Vertigo', interview with Chris Marker by computer, *Monthly Film Bulletin*, LI/606 (July 1984), p. 197.

19 André Labarthe, 'Le Rolleiflex de Christophe Colomb', *Cahiers du Cinéma*, 122 (August

1961), p. 59.

20 Chris Marker, *Commentaires* (Paris, 1961), p. 29. Claude Roy was a prominent French writer who travelled extensively in China and the Far East during the 1950s. His books on China include *La Chine dans un miroir* (Lausanne, 1953); *Clefs pour la Chine* (Paris, 1954); and *L'Opéra de Pékin* (Paris, 1955) .

21 Editorial for 'La Chine, porte ouverte', *Esprit*, 234 (January 1956), pp. 1–4.

22 Marker, *Commentaires*, p. 29.

23 Although this sounds fanciful, the Chinese government had actually instigated vigorous hygiene campaigns to eradicate germs and pests from many regions of the country.

24 The letter from the selection committee is reproduced among the 'Appendice et Pièces justificatives' in Marker, *Commentaires*, p. 187.

25 'Je vous écris d'un pays lointain' is the title of a story included in Michaux's *Plume, lointain intérieur*, pp. 73–80 .

26 Armand Gatti, *Sibérie – zéro + l'infini* (Paris, 1958). Gatti's book shares with *Letter from Siberia* a heterogeneous approach to its investigation of the region, in one section incorporating Chinese poems, literary extracts and factual reports in a textual montage of Siberian history.

27 This account is taken from André Pierrard, 'A propos de Lettre de Sibérie', *Image et Son*, 161–2 (April–May 1963), p. 37.

28 Marker, *Commentaires*, p. 43.

29 Andre Bazin, 'Lettre de Sibérie', in *Le Cinéma français de la Libération à la Nouvelle Vague, 1945–1958* (Paris, 1983), p. 180. This review was first published in *France-Observateur*, 30 October 1958 (English translation in *Film Comment*, xxxix/4, July–August 2003, pp. 44–5).

30 'Agnès Varda', in *Image et Son*, 161–2 (April–May 1963), p. 56; Jean-Louis Pays, interview with Chris Marker in *Miroir du Cinéma*, 2 (May 1962), pp. 4–7, and in Gerber, ed., *Anatole Dauman*, pp. 157–9. For further discussion of the notion of essay film, see Phillip Lopate, 'In Search of the Centaur: The Essay-Film', in *Beyond Document: Essays on Nonfiction Film*, ed. Charles Warren (Hanover, NH, and London, 1996), pp. 243–70.

31 Marker, *Commentaires*, note p. 65.

32 Gerber, ed., *Anatole Dauman*, p. 71.

33 'Les hommes de la baleine', *L'Avant-Scène Cinéma*, 24 (15 March 1963), p. 49.

34 The information about *Le Siècle a soif* comes from Porcile, *Défense du court métrage français*, p. 211, and is contained in the on-line filmography of Marker's collaborations, compiled by Sam DiIorio for *Film Comment* in 2003. See http://www.filmlinc.com/fcm/online/markerfilms.htm. Marker is also credited by Porcile (p. 280) as author of the commentary for Jean-Jacques Languepin's and A. Suire's film of 1958, *Des Hommes dans le ciel*.

35 Birgit Kämper and Thomas Tode, eds, *Chris Marker: Filmessayist*, CICIM 45/46/47 (Munich, 1997), entry for *Les Astronautes*, p. 376.

36 'Paul Paviot', *Image et Son*, 161–2 (April–May 1963), pp. 58–9.

37 Jean-Louis Pays, interview with Marker, in Gerber, ed., *Anatole Dauman*, p. 157.

38 Alain Resnais interview in Kämper and Tode, *Chris Marker*, pp. 211–12.

39 Chris Marker, 'Avertissement au lecteur', in *Le Dépays* (Paris, 1982), n. p.

40 See interview with Armand Gatti in *Miroir du Cinéma*, 2 (May 1952).

41 Chris Marker, *Coréennes* (Paris, 1959), note on p. 5.

42 Marker, *Coréennes*, p. 138. In 'The Left Bank', Richard Roud identifies 'Cat G' as Armand Gatti (*gatti* meaning cats in Italian). In a new presentation of *Coréennes* as a sub-zone of 'Photography' in *Immemory*, Marker either unveils or thickens the mystery by naming a certain Gédéon, feline resident of the Ile Saint-Louis in Paris, as the recipient of his letter.

43 Marker, *Coréennes*, p. 138.

44 Marker, *Coréennes*, p. 4.

45 Marker, *Coréennes*, p. 16.

46 Marker, *Coréennes*, pp. 24–5.

47 Marker, *Coréennes*, p. 28.

48 Marker, *Coréennes*, p. 20.

49 Marker, *Coréennes*, p. 138.

50 'Postscript 1997', in Marker, *Coréennes*, part of the Photo zone of *Immemory*.

51 François Reichenbach, interview in *Artsept*, 2 (April–June 1963), pp. 93–4.

52 Marker, *Commentaires*, p. 96.

53 Marker, *Commentaires*, p. 116.

54 Raymond Bellour and Jean Michaud, 'Apologie de Chris Marker/Signes', *Cinéma 61*, 57 (June 1961), p. 40.

55 The letter is reproduced in the 'Appendices' of Marker, *Commentaires*, n. p.

56 See Samuel Lachize, 'Symphonie pour un peuple libre ("Cuba si" de Chris Marker)', *L'Humanité*, 14 September 1963, p. 2; Albert Cervoni, '"Cuba si", enfin', *France Nouvelle*, 934 (11–17 September 1963), pp. 24–5; and Pierre Billard, 'La censure, encore et toujours', *Cinéma 62*, 66 (May 1962), pp. 86–92, a dossier on French film censorship that details the case of *Cuba si* when it was still banned.

57 Marker, *Commentaires*, p. 155.

58 Marker had used the phrase 'inventer le hasard' ('to invent chance') in his study of Giraudoux, and it became a byword for his own approach to reality as something created by the interaction of an inquisitive consciousness with the random circumstances it discovers – or on this occasion provokes – in the world.

59 See 'Le socialisme dans la rue', interview with Chris Marker by Francis Gendron, *Miroir du Cinéma*, 2 (May 1962), p. 12.

60 Billard, 'La Censure', p. 88.

3: A Moment in Time

1 Alain Resnais interview in Birgit Kämper and Thomas Tode, eds, *Chris Marker: Filmessayist*, CICIM 45/46/47 (Munich, 1997), p. 207.

2 Chris Marker and Armand Gatti, special issue of *Miroir du Cinéma*, 2 (May 1962); Roger Tailleur, 'Markeriana: description peu critique de l'œuvre de Chris Marker', *Artsept*, 1 (January–March 1963), pp. 47–62; Chris Marker, special issue of *Image et Son*, 161–2 (April–May 1963). Roger Tailleur's two articles 'Parisiennes', *Artsept*, 2 (April–June 1963), pp. 83–7 [on *Le Joli mai*]; and 'Entre quatre opéras', *Artsept*, 3 (October–December 1963), pp. 76–80 [on *La Jetée*], are also significant, as are the publications on the Left Bank group listed in Chapter 2, notes 3 and 4.

3 See Chris Marker, 'Marker mémoire (Cinémathèque Française, 7 janvier–1er fevrier 1998)', *Images documentaries*, 31 (1998), p. 78.

4 Arguably the first springtime of peace since 1948, since an extended colonial war in Indo-China (1948–54) had immediately preceded the outbreak of the Algerian War.

5 Chris Marker, 'L'objectivité passionnée', *Jeune Cinéma*, 15 (May 1966), p. 14.

6 Marker later shortened the film to just under two hours, removing much of the material directly relating to the Algerian War from Part 2. The copies currently distributed in the United States and the UK are the shortened versions. Sam DiIorio's 'The Truth About Paris', *Film Comment*, XXXIX/3 (May–June 2003), pp. 46–7, helpfully summarizes the content of the missing scenes.

7 The OAS was an extreme right-wing military group that conducted a terrorist campaign in Algeria and metropolitan France with the aim of preventing Algerian independence. It intensified its attacks in the closing stages of the war, and in the interim between the signing of the Evian accords and the first Algerian elections in July 1962 (the period during which *Le Joli mai* was filmed). General Salan, a leading member of the OAS, had organized a failed military *putsch* against de Gaulle's government in April 1961. He was arrested and tried one year later.

8 For overviews of the development of direct cinema, see chapter 5 of Erik Barnouw, *Documentary: A History of the Non-Fiction Film*, 2nd edn (Oxford, 1993); and chapter 5 of Guy Gauthier, *Le Documentaire: un autre cinéma* (Paris, 1995).

9 Genevieve van Cauwenberge, 'Le point de vue documentaire dans *Le Joli mai*', *Théorème*, 6, 'Recherches sur Chris Marker' (Paris, 2002), pp. 83–99, offers a detailed consideration of the differences between *Le Joli mai* and *Chronicle of a Summer*.

10 See 'Entretien avec Pierre Lhomme', *Image et Son*, 173 (May 1964), pp. 38–43; and 'Témoignages–Pierre Lhomme', in Chris Marker dossier, *Positif*, 433 (March 1997), pp. 90–91.

11 'Priere sur la Tour Eiffel' is the title of an extract from Giraudoux's diary, included in *Juliette au pays des hommes* (1923), which is read to close the prologue of *Le Joli mai*.

12 See van Cauwenberge, 'Le point de vue documentaire dans *Le Joli mai*', p. 92, for an overview of this negative criticism (the quotation from Giroud is taken from this source); also Henry Chapier, 'Le "cinéma-vérité" dans l'impasse', *Combat*, 6 March 1963; and Michel Aubriant *et al.*, 'Table ronde autour "Le Joli mai"', *Combat*, 16 May 1963, p. 9.

13 Marker, 'L'objectivité passionée', p. 12.

14 See van Cauwenberge, 'Le point de vue documentaire dans *Le Joli mai*', p. 97.

15 Marker, 'L'objectivité passionnée', pp. 12–13.

16 In a coda to *Le Joli mai*, Marker edited a film made by Catherine Varlin entitled *Jouer à Paris* (1962). Varlin had written the libretto for the title song of *Le Joli mai*, and her film, which explores the 'game' of Parisian social and artistic life, draws on essentially the same type of material as *Le Joli mai*. In 1964 Marker also edited François Reichenbach's *La Douceur du village*, a study of small-town life in rural France, and Pierre Kast's *La Brûlure de mille soleils*, an animated science-fiction fable in which a melancholy poet (accompanied by his cat Marcel) travels in time and falls in love with a woman from another planet. This information comes from the on-line filmography of Marker's collaborations, compiled by Sam DiIorio for *Film Comment* in 2003. See http://www.filmlinc.com/fcm/online/markerfilms.htm.

17 'Marker Direct', Chris Marker interviewed by Samuel Douhaire and Annick Rivoire, English translation in *Film Comment*, xxxix/3 (May–June 2003), p. 40 (original interview in *Libération*, 5 March 2003).

18 Examples include Peter Wollen, 'Fire and Ice', *Photographies*, 4 (March 1984), pp. 118–20; Raymond Bellour, 'L'interruption, l'instant' and 'Six films (en passant)', both in his *L'Entre-images: photo–cinéma–vidéo* (Paris, 1990); Jean-Louis Schefer, 'A propos de "La Jetée"', in *Passages de l'image*, exh. cat., Centre Georges Pompidou, Paris (1990), pp. 89–93; Philippe Dubois '*La Jetée* de Chris Marker, ou le cinématogramme de la conscience', in *Théorème*, 6, 'Recherches sur Chris Marker' (Paris, 2002), pp. 9–45.

19 Thierry Kuntzel, 'Notes sur la Jetée', in *Thierry Kuntzel*, exh. cat., Musée du Jeu de Paume, Paris (1993), pp. 32–7.

20 Chris Marker, preparatory notes for *Le Joli mai*, quoted in Guy Gauthier, *Chris Marker, écrivain multimédia* (Paris, 2001), p. 94. Marker's description incidentally evokes a short story by Henri Michaux, also entitled 'La Jetée', in which the feverish narrator imagines himself at the end of a pier, next to an old man who fishes all manner of improbable treasures out of the sea, then throws them back without appearing to have found what he is looking for.

21 For further reflections on *La Jetée* as a response to upheavals in contemporary French society – but without reference to *Le Joli mai* – see Lee Hilliker, 'The History of the Future in Paris: Chris Marker and Jean-Luc Godard in the 1960s', *Film Criticism*, xxiv/3 (Spring 2000), pp. 1–22 .

22 This development saw traditional working-class and immigrant *quartiers* inside Paris undergo a process of demolition, rebuilding and gentrification to house the growing ranks of middle-class professionals, while their former inhabitants were removed from the core of the city to the new high-rise *banlieues*. See Kristin Ross, *Fast Cars, Clean Bodies: Decolonization and the Reordering of French Culture* (Cambridge, ma, and London, 1995), especially pp. 149–56.

23 Davos Hanich is a sculptor. Although *La Jetée* is his only film role, he would later provide one of the commenting voices for *Le Fond de l'air est rouge*.

24 Hélène Chatelain is the long-term partner and collaborator of Armand Gatti. They have worked together since the 1960s on a range of community-based political theatre and film projects, and currently form La Parole Errante, which is based in the Paris suburb of Montreuil on the former site of Georges Méliès's film studio.

25 'Filmic memories–Chris Marker', *Film Quarterly*, lii/1 (Fall 1998), p. 66; also reproduced in the booklet that accompanies the dvd edition of *La Jetée* and *Sans soleil*.

26 Dubois, '*La Jetée* de Chris Marker'.

27 Roland Barthes, quoted in Hilliker, 'The History of the Future in Paris', p. 10.

28 In his researches into *La Jetée*, Philippe Dubois has discovered a print of the film in the Belgian Cinémathèque Royale, which opens with a conventional film shot of Orly Airport, rather than photographs. It seems that Marker eventually decided to remove this, so that the only shot with movement would be the one with the woman. See Dubois '*La Jetée* de Chris Marker'.

29 This passage is partly inspired by the analysis in Bruce Kawin, 'Time and Stasis in *La Jetée*', *Film Quarterly*, xxxvi/1 (Autumn 1982), pp. 15–20.

30 This is in marked contrast to the reflexive work on the nature of cinema associated with

the avant-garde tradition, which often explicitly seeks to assault or refuse the conventional expectations and pleasures of the spectator. The seduction of the woman's look as the film itself seems to awake in *La Jetée* makes a resonant contrast with the slashed eyeball of Salvador Dalí and Luis Buñuel's *Un Chien andalou* (1929).

31 Marcel Proust, *In Search of Lost Time, Volume 5: The Captive* and *The Fugitive* (London, 1992), p. 546.

32 From the account of the production of *A Valparaiso*, in Robert Destanque and Joris Ivens, *Joris Ivens, ou la mémoire d'un regard* (Paris, 1982), pp. 270–74 .

33 Marker also adapted the Dutch commentary written by Gerrit Kouwenaar for Ivens's film of 1966, *Europort: Rotterdam*, when the film was being prepared for French release. The other commentary Marker wrote for a fellow director during the 1960s was *Le Volcan interdit* (1965) for Haroun Tazieff, which documented a number of active volcanoes and included a trip into the crater of Mount Nyiragongo in the former Congo. Information from DiIorio, on-line filmography for *Film Comment*.

34 Chris Marker, *Commentaires 2* (Paris, 1967), p. 40.

35 Koumiko was actually a friend of one of the production assistants who worked on the film, Koichi Yamada.

36 Takemitsu composed the scores for more than 90 Japanese feature films from the 1950s onwards, including Hiroshi Teshigahara's *Woman of the Dunes* (1964), and Nagisa Oshima's *The Man Who Left His Will on Film* (1970) and *Dear Summer Sister* (1972). For Akira Kurosawa, he wrote the music for *Dodeskaden* (1970) and *Ran* (1985), and would appear in Chris Marker's documentary on the making of *Ran, AK*.

37 Susan Sontag, *On Photography* (1977; London, 2002), especially the essay 'In Plato's Cave', pp. 3–24.

38 See Catherine Gillet, 'Visages de Marker', in *Théorème*, 6, pp. 75–82, for further discussion of this look.

39 Sontag, *On Photography*, p. 70; Roland Barthes, *Camera Lucida* (London, 1984; first published in France as *La Chambre clair*, Paris 1980).

40 Chris Marker, 'Romancero de la montagne', *Esprit*, 135 (July 1947), p. 98.

4: A Grin Without a Cat

1 *Le Fond de l'air est rouge* exists in a number of different versions. In 1988 Marker produced a three-hour version for British television as part of Channel 4's '68 / 88' season, with a new coda registering some of the political events that had taken place since the original release, and the English title *A Grin Without a Cat*. (The original French title translates loosely as 'a touch of red in the air': a play on the expression 'le fond de l'air est frais', meaning slightly chilly weather.) Then in 1993 Marker issued another 're-actualized' three-hour version in both English and French to take account of events since the collapse of Communism. This is the version that was released in the United States in 2002. During 1997 a third French version was prepared for Marker's retrospective at the Cinémathèque Française in February 1998. As with *Le Joli mai*, Marker's reasons for updating the film are to take account of political developments via the coda, to remove some material that would have been easily understood by French audiences in 1977, but

which he estimated would make little sense to later viewers or those outside France (without extended explanation), and simply to shorten the film for the viewer's comfort. See 'A Grin Without a Cat/Le Fond de l'air est rouge', *Film Comment*, XXXIX/4 (July–August 2003), p. 49. Since this chapter will examine the film in terms of its original release in 1977, I have retained the French title, although my discussion is based on viewing the 1988 Channel 4 version.

2 In his study of *Sunless*, Jon Kear makes the useful point that the notion of Marker's 'return' with *Sunless* is a perception that tended to arise outside France, since very little of the work he had made since the mid-1960s circulated outside its borders. Within France, Marker remained a fairly constant presence, and critics and audiences were better placed to see the continuities between *Sunless* and the films he produced during the 1970s. See Jon Kear, *Sans soleil / Sunless* (Trowbridge, 1999), p. 45.

3 From an editorial in *Cahiers du Cinéma*, 203 (August 1968). Quoted in Sylvia Harvey, *May '68 and Film Culture* (London, 1978), p. 18.

4 For a concise account of the events in France of May and June 1968 and the Estates General of the Cinema, as well as the evolution of the theoretical debates on cinema that they prompted, see Harvey, *May '68*. For broader coverage of May 1968 and its impact in France, see Keith Reader, *The May 1968 Events in France* (London, 1993).

5 'Marker Direct', Chris Marker interviewed by Samuel Douhaire and Annick Rivoire, English translation in *Film Comment*, XXXIX/3 (May–June 2003), p. 39 (original interview in *Libération*, 5 March 2003).

6 Richard Roud's generally informative article 'SLON', *Sight and Sound*, XLII/2 (Spring 1973), pp. 82–3, credits Marker with starting the Medvedkin Groups with Godard and Mario Marret, and overstates the role of SLON in encouraging workers to get involved in filmmaking. Marker was certainly a catalyst for the formation of the Medvedkin Groups – collaborations between militant factory workers and sympathetic film technicians – but he was never a member of the groups (nor was Godard), or a collaborator on their films. William F. Van Wert, 'Chris Marker: the SLON Films', *Film Quarterly*, XXXII/3 (Spring 1979), pp. 38–46, presents Marker as the sole instigator of collective projects that actually depended upon the influence and activity of others besides himself. For a more accurate assessment of Marker's place in relation to these groups, see Min Lee, 'Red Skies', *Film Comment*, XXXIX/4 (July–August 2003), pp. 38–41.

7 Van Wert, 'Chris Marker', builds his analysis of Marker's SLON films around this geographical continuity.

8 Chris Marker, *Le Fond de l'air est rouge: scènes de la troisième guerre mondiale* (Paris, 1978), pp. 5–6.

9 Raymond Durgnat, 'Far from Vietnam', *Films and Filming*, XIV/5 (February 1968), p. 21.

10 R. Ritterbusch, 'Entretien avec Chris Marker', *Image et Son / La Revue du Cinéma*, 213 (February 1968), pp. 66–9.

11 Varda did shoot a fictional episode that was cut from the final version of the film, although her name remained in the credits to reflect her contribution to the collective. See *Varda par Agnès* (Paris, 1994), p. 92. An episode by Ruy Guerra was also cut. The other directors contributed blocks of documentary footage used at various points in the film. In William Klein's book *Close-up* (London, 1989), the director claims responsibility for all the footage shot in the United States. Lelouch provided the film of US aircraft car-

riers in the Gulf of Tonkin, and Joris Ivens that of North Vietnamese citizens in Hanoi preparing to resist the American bombardment.

12 See Gaston Haustrate, 'Du Vietnam à Besançon', *Cinéma 67*, 121 (December 1967), pp. 11–13.

13 Chris Marker, 'Les révoltés de la Rhodia', *Le nouvel observateur*, 123 (22–9 March 1967), pp. 26–8.

14 Mario Marret had made a series of political documentaries in Algeria, East Germany and Guinea-Bissau before *A Bientôt j'espère*. He had taught himself filmmaking while on a French scientific mission in Antarctica and made *Les Pingouins*, a film about penguins which won the Cannes prize for documentary in 1954, and which incidentally explains an otherwise cryptic remark that Chris Marker made about filming penguins during the debate with the Rhodia workers over *A Bientôt j'espère*. Marker later borrowed Marret's footage of the independence struggle in Guinea-Bissau for *Sunless*.

15 Confédération Français Democratique de Travail, the major Catholic trade union in France.

16 Organisation de la Radiodiffusion-Télévision Française, the French state broadcasting organization.

17 Transcript of the discussion at the Rhodiaceta factory, April 1968, courtesy of ISKRA.

18 *Classe de lutte* centres on Suzanne Zéda, one of the workers' wives featured in *A Bientôt j'espère*, who during the strikes of May 1968 was inspired to organize a union branch in the Yema watch factory where she worked. Chris Marker is named in the credits of *Classe de lutte* – as are Jean-Luc Godard and Joris Ivens – more as a gesture of solidarity than a reflection of actual involvement in the production, although Marker is thanked for 'occult' technical assistance.

19 For a contemporary account of the Medvedkin Groups, see 'Le Groupe "Medvedkine', *Cinéma 70*, 151 (December 1970), pp. 92–5. More recently, three members of the groups – Bruno Muel, Henri Traforetti and Georges Binetruy – have published reminiscences in the 'Parole ouvrière' special issue of *Images documentaires*, 37–8 (2000).

20 Confédération Générale du Travail, the main trade union grouping in France, closely aligned to the PCF.

21 Daniel Urbain, 'Cinéma "LIP"', *Cinéma 73*, 181 (November 1973), pp. 17–18. This is the only French response to *Puisqu'on vous dit que c'est possible* recorded in the comprehensive bibliography of Birgit Kämper and Thomas Tode, eds, *Chris Marker: Filmessayist*, CICIM 45/46/47 (Munich, 1997). The brief description of the film is adapted from the Marker filmography in *Film Comment*, XXXIX/4 (July–August 2003), p. 47; and 'Le conflit LIP', in Nicole Brenez and Christian Lebrat, eds, *Jeune, Dure et Pure! une histoire du cinéma d'avant-garde et expérimental en France* (Paris, 2001), p. 340.

22 Television sales were SLON's main source of revenue. Its initial capital came from the sale of *A Bientôt, j'espère*, both to the French state network ORTF and to the West German channel ZDF. Subsequent sales to West Germany, Italy, Belgium, Switzerland and Quebec sustained the work of the collective. See Lee, 'Red Skies'.

23 For contemporary accounts of SLON and ISKRA, see 'Le Groupe SLON', *Cinéma 70*, 151 (December 1970), pp. 88–92; 'SLON, un cinéma de lutte', *La Revue du Cinéma / Image et Son*, 249 (April 1971), pp. 44–54; Guy Hennebelle, 'SLON: Working-Class Cinema in France', *Cineaste*, V/2 (Spring 1972), pp. 15–17; Guy Hennebelle, 'Brève rencontre avec le

groupe "SLON"', *Ecran 73*, 13 (March 1973), pp. 36–8; and '"ISKRA": Le cinéma militant est une étincelle', in the 'Cinéma militant' special issue of *Cinéma d'aujourd'hui*, 5–6 (March–April 1973), pp. 35–42.

24 Harvey, *May '68*, p. 9.

25 See Guy Debord, *The Society of the Spectacle*, (Detroit, MI, 1983).

26 For an account of the cultural dimensions of the protests of May 1968, see Harvey, *May '68*, and chapter 5 of Brian Rigby, *Popular Culture in Modern France: A Study of Cultural Discourse* (London, 1991).

27 For a brief account of the *Cinétracts*, see 'Cinétracts', *Avant-Scène Cinéma*, 171–2 (July–September 1976), p. 54. A complete list is contained in Brenez and Lebrat, *Jeune, Dure et Pure!*, p. 333.

28 'SLON, un cinéma de lutte', op. cit., p. 46.

29 *Carlos Marighela* is not always listed as part of the *On vous parle* series – it does not have an issue number, or the generic title montage – but it is certainly part of it in spirit, if not in name.

30 The release date is often given as 1969, but the film itself refers to events that took place in 1970.

31 Semprun came from an aristocratic Spanish Republican background, but joined the French Resistance and the Communist Party during the Second World War and was deported to Buchenwald – experiences that formed the basis of his novel of 1961, *Le Long Voyage*. After the war he became a senior member of the Spanish Communist Party in exile and carried out a series of clandestine operations in Spain, but became progressively disillusioned with Stalinist party orthodoxy and was eventually expelled from the party in the mid-1960s. At the time Semprun was working on the screenplay for Alain Resnais' *La Guerre est finie* (1966, *The War is Over*), which drew on his militant experiences since the war, and he went on to write *Z* for Costa-Gavras as well as *The Confession*. Semprun was a close friend of Yves Montand, and in 1983 published a biography of the star, *Montand: la vie continue*.

32 Quoted in John J. Michalczyk, *Costa-Gavras: The Political Fiction Film* (Philadelphia, PA, 1984).

33 See Yves Montand (with Hervé Hamon and Patrick Rotman), *You See, I Haven't Forgotten* (London, 1992), p. 245, and the account of filming *The Confession*, pp. 361–71. For Simone Signoret, see her memoir *Nostalgia Isn't What It Used To Be* (London, 1978), p. 100.

34 This implied support for Costa-Gavras's brand of political fiction cinema is significant in the context of debates within French film culture after 1968. In Jean-Paul Narboni and Jean-Louis Comolli's landmark article, 'Cinéma/idéologie/critique', *Cahiers du Cinéma*, 216 (October 1969) and 217 (November 1969) (translated as 'Cinema/Ideology/Politics', *Screen*, XII/1, Summer 1971, pp. 145–55, and XIII/1, Spring 1972, pp. 120–31), the authors placed *Z* in their category D: films that 'have an explicitly political content . . . but which do not effectively criticize the ideological system in which they are embedded because they unquestioningly adopt its language and its imagery'. Between 1968 and 1972 the editorial position of *Cahiers*, along with the journal *Cinéthique*, was that bourgeois cinema needed to be attacked on the level of form as much as (if not more than) content, and Costa-Gavras's films were among those criticised for being merely 'political films', not 'films made politically' (to rephrase the famous expression used by Jean-Luc Godard).

35 Jacques Demeure, 'La canne, la mode et la révolution', *Positif*, 122 (February 1971), p. 40.

36 In the Photo zone of *Immemory*, Marker recounts a self-deprecatory tale of how he played his own small part in the failure of the *safra* with his inept efforts at cutting sugar cane.

37 Jay Leyda, *Kino: A History of the Russian and Soviet Film* (London, 1960), pp. 286–7. For first-hand accounts of Marker's meeting with Medvedkin, see Chris Marker, 'Le ciné-ours', *La Revue du Cinéma/Image et Son*, 255 (December 1971), pp. 4–5, and Anne Philipe's interview with Marker, 'Medvedkin, tu connais?' in *Le Monde*, 2 December 1971, p. 17. Pol Cèbe wrote an evocative short account of Medvedkin's meeting with the group that took his name, 'Rencontre avec Medvedkine', for the Medvedkin and *Happiness* special issue of *Avant-Scène Cinéma*, 120 (December 1971), p. 9.

38 Guillemette de Vericourt, 'Un "Bonheur" retrouvé', *L'Express*, 22–8 November 1971.

39 In 'Le ciné-ours', Marker touches discreetly upon the fact that the abuses and catastrophic failures of collectivization were beyond Medvedkin's horizon. He would return to this question in his sustained posthumous portrait of Medvedkin, *The Last Bolshevik* (1993).

40 At the time of this interview, Debray was newly released from prison in Bolivia, where he had been accused of aiding a guerrilla insurrection led by Che Guevara. In the late 1960s Debray was best known as the author of *Revolution in the Revolution?* (first published in 1967 by François Maspero) – an analysis of the rift in Latin American Communism between the traditional parties and the guerrilla movement – which was based on his extensive first-hand observation of Communism in Latin America and especially his close contact with Fidel Castro and the Cuban government.

41 John Pilger's and Simon Hattenstone's article 'Armed Only with a Camera', *The Guardian*, 12 February 1999, pp. 2–3, and 9, states that Marker paid for the film stock.

42 'Petite suite sur thème des chansons', *Esprit*, 179 (May 1951), p. 767.

43 Montand (with Hamon and Rotman), *You See*, p. 159.

44 Marker, 'Petite suite sur thème des chansons', p. 767.

45 The account of the genesis of *Spiral* is drawn from Paul-Louis Thirard, 'A propos de "La Spirale"', *Positif*, 180 (April 1976), pp. 25–9, which includes an interview with Armand Mattelart, and Valérie Mayoux's reminiscences in 'Dossier Chris. Marker', *Positif*, 433 (March 1997), pp. 94–5.

46 Marker, *Le Fond de l'air est rouge*, p. 5.

47 Mayoux, 'Dossier Chris. Marker', p. 94.

48 Marker, *Le Fond de l'air est rouge*, p. 5.

49 Marker, *Le Fond de l'air est rouge*, p. 7.

50 Among the commentators for the original French version were Yves Montand and Simone Signoret, Davos Hanich, Jorge Semprun and François Maspero, as well as Marker himself.

51 Paul Arthur, 'Making History', *Film Comment*, xxxviii/3 (May–June 2002), p. 34.

52 This discussion of the ambiguities of history and representation in *Le Fond* is partly inspired by Barry Langford, '"So Intensely Historical": Spectres of Theatre, Phantoms of Revolution in Marx and Marker', unpublished paper delivered at the conference *Chris Marker: The Art of Memory*, held at the Institute of Contemporary Arts, London, 16–17 November 2002.

53 See for example, Jean-Paul Fargier *et al.*, 'Table ronde sur "Le fond de l'air est rouge" de Chris Marker', *Cahiers du Cinéma*, 284 (January 1978), pp. 46–51; and Serge Richard, 'Un beau rouge, un peu noir . . . avec des "blancs"', *L'Unité*, 9–15 December 1977.

54 See Nicole-Lise Bernheim, 'Notre historie n'est pas la leur', *Le Monde*, 8 December 1977; Michèle Coulomb, 'Le Fond de l'air est rouge', *Histoires d'Elles*, 7 December 1977.

5: Into the Zone

1 'Terminal Vertigo', *Monthly Film Bulletin*, LI/606 (July 1984), pp. 196–7.

2 This description of *Quand le siècle a pris formes* is drawn from the entry in Birgit Kämper and Thomas Tode, eds, *Chris Marker: Filmessayist*, CICIM 45/46/47 (Munich, 1997), pp. 287–8.

3 Chris Marker, *Giraudoux par lui-même* (Paris, 1952) pp. 26–7. One of Marker's uncompleted projects is *Le Facteur sonne toujours Cheval*, a study of the Palais Idéal constructed partly from scavenged materials in southern France by a village postman, 'Facteur' Cheval, and much admired by the Surrealists. Photographs of the Palais Idéal by Denise Bellon are featured in Marker's latest film (co-directed with Yannick Bellon), *Le Souvenir d'un avenir*.

4 Marie Susini, *La Renfermée: La Corse*, with photographs by Chris Marker (Paris, 1981).

5 Krasna's letters are read by Alexandra Stewart in the English version, and Florence Delay in the French version. Stewart is an American actress who also recorded an English voice-over for *One Day in the Life of Andrei Arsenevich*. Delay is a well-known French stage actress who portrayed Joan of Arc in Robert Bresson's *Le Procès de Jeanne d'Arc* (1962). Photographs of both women feature among the 'Fées diverses' in the Photo zone of *Immemory*. *Sunless* also exists in German and Japanese versions. Sandor Krasna, with his brother Michel who composed the soundtrack for *Sunless*, turns up again in the credits of *The Owl's Legacy* – both are alter egos of the director.

6 'The Story' and 'The Characters', included in the original press dossier for *Sunless* and reprinted in English and French in the booklet accompanying the DVD edition of the film. Also in Jacques Gerber, ed., *Anatole Dauman: souvenir-écran* (Paris, 1989) pp. 172–3.

7 In Tarkovsky's film, the Zone is a derelict landscape created by an alien landing and navigated illegally by the Stalker, who takes a scientist and a writer there in search of a room where whatever they desire can be granted. Both Zones are 'non-places' outside the normal laws of space and time, which map human desires, imagination or spirituality rather than the physical world.

8 'The Story', op. cit.

9 Jon Kear, *Sunless / Sans soleil* (Trowbridge, 1999), p. 15.

10 Terence Rafferty considers the Koumiko connection in greater detail in 'Marker Changes Trains', *Sight and Sound*, LIII/4 (Autumn 1984), pp. 284–8; reprinted in Kevin McDonald and Mark Cousins, eds, *Imagining Reality: The Faber Book of Documentary* (London, 1996).

11 For a sustained discussion of the complexities of the female voice in *Sunless*, see Stella Bruzzi, 'The Woman's Voice: *Sunless*', in chapter 2 of her *New Documentary: A Critical Introduction* (London, 2000), pp. 57–64.

12 The sources of the borrowed extracts are Sana Na N'Hada (Carnival in Bissau), Jean-Michel Humeau (Ranks Ceremony), Mario Marret/Eugenio Bentivoglio (Guerrilla in Bissau), Danièle Tessier (Death of a Giraffe), Haroun Tazieff (Iceland 1970).

13 Marker expands his original reading of *Vertigo* in the essay 'A Free Replay (notes sur "Vertigo")', *Positif*, 400 (June 1994), pp. 79–84; English translation in John Boorman and

Walter Donohue, eds, *Projections 4½* (London, 1995), pp. 123–30.

14 In 1974 Marker had worked on the commentary of Yann Le Masson's and Bénie Deswarte's *Kashima Paradise*, a Marxist analysis of contemporary Japanese society which included sequences devoted to the campaign against Narita Airport, and had written a short text in support of the film. See *Ecran 74*, 30 (November 1974).

15 The restoration of the Meiji emperor in 1868 marks the beginning of modern Japanese history, when the country embarked upon a programme of rapid industrialization, modernization and increased contact and exchange with the West.

16 Chris Marker, *Le Dépays* (Paris, 1982), n. p.

17 Another intriguing variant on the idea of using the distant science-fiction future as a conduit for examining the social history of the past and present is Marker's unrealized project 'Maytrek 68' (from 1986), which takes up the time travel premise of the popular television series *Star Trek* and sends the crew of the *Enterprise* back to May 1968, where they observe events unfolding on television monitors and question the various protagonists. Many thanks to Min Lee for supplying this information.

18 Gilles Alexandre, 'Retrouvée par Chris Marker, une amie d'enfance', *Télérama*, 1896 (17–23 May 1986), p. 23.

19 *Thérèse Raquin* (Marcel Carné, 1953), *Police Python 357* (Alain Corneau, 1976) and *Thérèse Humbert* (Marcel Bluwal, 1984).

20 Pierre Goldman was a wanderer and petty criminal who in 1974, after spending four-and-a-half years in preventative detention, was sentenced to life imprisonment for the murder in 1969 of two pharmacists during a hold-up in Paris. The conviction was widely regarded as suspect and, in a parallel to the notorious Dreyfus case, motivated by anti-Semitism and political considerations, since Goldman was of Polish-Jewish extraction and had spend time during the late 1960s with the Venezuelan guerrilla movement. A campaign demanding a retrial was eventually successful, and Goldman's conviction was overturned.

21 In the full transcript of the interview with Alain Resnais published in abridged form in Kämper and Tode, *Chris Marker*, Resnais mentions that he and Marker worked on a short-lived television series in the early 1950s. Many thanks to Thomas Tode for supplying the transcript. Marker's early involvement with television is corroborated in the jacket copy for *The Forthright Spirit* (London, 1951), which notes that he has spent a lot of time since completing the novel writing for television.

22 The creation of La Sept was a product of the transformation of the French television landscape after 1982, when the broadcasting monopoly of the ORTF was ended, and the way was cleared for the creation of privately owned television channels.

23 The series was broadcast on Channel 4.

24 The titles come from the English-language version of the series, and do not correspond exactly to the French original.

25 Dombasle was a friend of Marker's, appearing briefly in *Sunless* and its 'Tokyo Days' annexe: one of the video loops included in *Zapping Zone*. She credits Marker (along with Eric Rohmer) as artistic advisor to her erotic drama of 1988, *Les Pyramides bleues* (*The Novice*).

6: Memories of the Future

1 Chris Darke, 'The Invisible Man', *Film Comment*, xxxix/3 (May–June 2003), p. 32.

2 See Chris Marker dossier in *Bref*, 6 (August–September–October 1990); Chris Marker special issue of *Images documentaries*, 15 (1993); Chris Marker dossier in *Positif*, 433 (March 1997); and 'Around the World with Chris Marker', two-part dossier in *Film Comment*, Part 1, 'Lost Horizons' in xxxix/3 (May–June 2003), Part 2, 'Time Regained' in xxxix/4 (July–August 2003). The main websites devoted to Marker are Adrian Miles's Chris Marker World Wide Web site, http://cs.art.rmit.edu.au/projects/media/marker which remains a useful source although it has not been updated since 1995; and Daniel Potter's informative and regularly updated site, www.silcom.com/~dlp/Passagen/cm.home2.html.

3 Letter from Marker quoted in Bill Horrigan, 'Another Likeness', *Silent Movie*, exh. cat., Wexner Center for the Arts, Columbus, OH (1995), p. 10.

4 Marker's response to a survey on the future of film by the Russian journal *Kinowedtscheskije sapiski*, quoted in Thomas Tode, 'Film–That Was Last Century!', unpublished paper delivered at the conference *Chris Marker: The Art of Memory*, held at the Institute of Contemporary Arts, London, 16–17 November 2002.

5 Marker quoted in Tode, 'Film–That Was Last Century!'. The phrase 'Sunday programmer' is from Raymond Bellour, 'The Book, Back and Forth', in *Qu'est-ce qu'une madeleine?: à propos du CD-ROM Immemory de Chris Marker* (Paris, 1997). The producer and director Michael Shamberg, drawn to the raw digital images that Marker was making in the 1990s, invited him to contribute computer graphics to his feature film of 1997, *Souvenir*.

6 Chris Marker interviewed by Dolores Walfisch, *Vertigo*, 7 (Autumn 1997), p. 38 (Interview originally published in *Berkeley Lantern*, November 1996). It bears pointing out that Marker's comment ignores significant sectors of the experimental and avant-garde cinema, particularly since the Second World War, where it is common for filmmakers to work in solitude with extremely basic equipment, and often to take responsibility for processing their own work.

7 See Raymond Bellour, Catherine David and Christine van Assche, *Passages de l'image*, exh. cat., Centre Georges Pompidou, Paris (1990). *Zapping Zone* is now part of the permanent collection of the Musée National d'art moderne, housed at the Pompidou. The complete installation was not on display there at the time of writing, but a number of its segments can be watched in the museum's video and multimedia space.

8 The different Zones up to 1992 were as follows: Zone Matta (*Matta '85*) – Zone Tarkovski (*Tarkovski '86*) – Zone Christo (*Christo '85*) – Zone Clip (*Getting Away With It*, music video for Electronic) – Zone Frisco (*Junkopia*) – Zone Sequences (extracts from *Le Fond de l'air est rouge, Sans soleil, Le Joli mai, La Sixième face du Pentagone, L'Héritage de la chouette, La Solitude du chanteur de fond*) – Zone Eclats (*Cocteau, 2084, KFX, Statues 1, Taps, Statues 2, Kat Klip, Alexandra, Vertov, Arielle, Chouettes, Zeroins, Moonfleet, Flyin' Fractals*) – Zone Bestiaire (*Bestiaire: chat écoutant la musique, An Owl is an Owl is an Owl, Zoo Piece*) – Zone Spectre – Zone Tokyo (*Tokyo Days*) – Zone Berlin (*Berlin '90*) – Zone Photos – Zone TV (*Détour. Ceaucescu*). In 1992 Zone Azulmoon replaced Zone TV, and *Coin fenêtre* was added to Zone Bestiaire. In 1994 Zone Séquences was re-edited; Zone TV was reinstated with *Détour. Ceaucescu, Montand* and *Belko Expo*; *Slon Tango* and *Bullfight / Okinawa* were

added to Zone Bestiaire; and Zone Bosniaque (*Prime Time in the Camps*) replaced Zone Eclats. See Filmography for a full list of component works and additions.

9 Raymond Bellour, 'Eloge in si mineur', in *Passages de l'image*, p. 169.

10 'Zapping Zone', *Film Comment*, xxxix/4, p. 49.

11 'Getting Away With It'

12 Discovered in the ISKRA archives. 'Canal Chris' is also a fascinating anticipation of Marker's retrospective of 1998, since it brings together his own works and those of his friends and associates, with a few personal favourites. It suggests some inspired double bills: Tarkovsky's *Solaris* (1972) and George Lucas's *THX 1138* (1970) as 'x Time', and *South Pacific* (Joshua Logan, 1958) with *Apocalypse Now* as 'America and its Wars'.

13 The complete interview with Hermlin was broadcast on Arte in September 1997, following the writer's death, as a feature in the *Metropolis* cultural news magazine programme.

14 Kristian Feigelson mounts a persuasive and well-documented historical argument that Marker's film effectively makes Medvedkin more of an exceptional (and even quasi-dissident) figure than he actually was within the Soviet Union. See 'Regards croisés Est / Ouest: l'histoire revisitée au cinéma (Medvedkine / Marker)', *Théorème*, 6, 'Recherches sur Chris Marker' (Paris, 2002), pp. 119–131.

15 *Silent Movie* showed at the Wexner from January to April 1995. It then travelled to the Museum of Modern Art, New York (June–September 1995), The University Art Museum and Pacific Film Archive, Berkeley, CA (January–March 1996), and the Walker Art Center, Minneapolis, MN (October 1996–January 1997). The installation was shown in London, with an accompanying film and video programme, at the Beaconsfield Gallery, London, May–June 1999.

16 Horrigan, 'Another Likeness', pp. 12–13.

17 Horrigan, 'Another Likeness', p. 12.

18 The *Silent Movie* catalogue, p. 36, gives a complete list of the ten film posters and the eighteen pieces of solo piano music that made up the soundtrack, which Marker collectively titled 'The Perfect Tapeur'.

19 Chris Marker, 'The Rest is Silent', *Silent Movie*, p. 17.

20 Marker, 'The Rest is Silent', p. 17.

21 See the discussion of 1920s film theory in Joe McElhaney, 'Primitive Projections: Chris Marker's *Silent Movie*', *Millennium Film Journal*, 29 (Fall 1996), pp. 42–50.

22 See 'La télé du camp', *Télérama*, 2273 (4 August 1993), pp. 36–7. Robichet explains in this report that the Roška team also exchanged tapes with other Bosnian refugee camps in Ljubljana that ran their own television projects, an aspect of their work that is not covered in *Prime Time in the Camps*.

23 Jacques Gerber, ed., *Anatole Dauman: souvenir-écran* (Paris, 1989), p. 151.

24 This retrospective assembly of Laura's diary by Chris is suggested by Ian Hunt, 'Okinawa Replay: Chris Marker's *Level Five*', *Coil*, 5 (1997), n.p.

25 Raymond Bellour 'L'Entre-image aujourd'hui: Multiple Cinemas–The Cinema Only', lecture delivered at Tate Modern, London, 23 May 2002.

26 See 'Chris Marker ne laisse pas souffler la vérité', interview with Catherine Belkhodja, *L'Humanité*, 19 February 1997) p. 21; and interview with Chris Marker by Dolores Walfisch, *Vertigo*.

27 Tode, 'Cinema–That Was Last Century!'.

28 Bellour, 'The Book, Back and Forth', p. 119.
29 From the introductory text to the CD-ROM *Immemory* (Paris, 1997), n. p. My translation from the French.
30 Tode, 'Cinema–That Was Last Century!'.
31 Quoted in the introductory text to *Immemory*.
32 Lev Manovich, 'Digital Cinema and the History of a Moving Image', in *The Language of New Media* (Cambridge, MA, 2001), pp. 293 ff.
33 'Phénomène (n.m.)', *Trafic*, 30 (Summer 1999), pp. 26–33.
34 Andrey Tarkovsky, *Journal, 1970–1986* (Paris, 1993), p. 404.
35 Tarkovsky, *Journal*, p. 400.

Bibliography

Readers seeking a comprehensive bibliography for Chris Marker (to 1997) should consult Birgit Kämper and Thomas Tode, eds, *Chris Marker: Filmessayist* (Munich, 1997)

Selected Works by Chris Marker

Books

Le Cœur net (Paris, 1949); as *The Forthright Spirit*, trans. Robert Kee and Terence Kilmartin (London, 1951)
L'Homme et sa liberté (Paris, 1949)
Giraudoux par lui-même (Paris, 1952)
Benigno Cacérès and Christian Marker, *Regards sur le Mouvement Ouvrier* (Paris, 1952)
Francis-Régis Bastide, Juliette Caputo and Chris Marker, *La Strada: un film de Federico Fellini* (Paris, 1955)
Coréennes (Paris, 1959)
Marie Susini, *La Renfermée: La Corse*, photographs by Chris Marker (Paris, 1981)
Le Dépays (Paris, 1982)

Short Stories and Poems

'Till the End of Time', *Esprit*, 129 (January 1947), pp. 145–51
'Chant de l'endormition', *Le Mercure de France*, 1067 (July 1947), pp. 428–34
'Romancero de la montagne', *Esprit*, 135 (July 1947), pp. 90–98
'La dame à la licorne', *Le Mercure de France*, 1024 (December 1948), pp. 646–8
'Les Separés', *Esprit*, 162 (December 1949), pp. 921–2
'Phénomène (n.m.)', *Trafic*, 30 (Summer 1999), pp. 26–33

Translations

Frederick Spencer Chapman, *La Jungle est neutre* (Paris, 1951)

James Thurber and Elwyn Brooks-White, *La Quadrature du sexe* (Paris, 1952)

James Earl Powers, *Le Prince de ténèbres* (Paris, 1952) [translated with Charles Antonetti]

Francis Stuart, *La Fille du vendredi-saint* (Paris, 1953)

Will Cuppy, *Grandeur et décadence d'un peu tout le monde* (Paris, 1953) [under the pseudonym Fritz Markassin]

Charles Haldeman, *Le Gardien du soleil* (Paris, 1965) [under the pseudonym T. T. Toukanov]

Konrad Lorenz, *Tous les chiens, tous les chats* (Paris, 1970) [under the pseudonym Boris Villeneuve]

Film Commentaries

'Les Statues meurent aussi', 'Dimanche à Pékin', 'Lettre de Sibérie', 'L'Amérique rêve', 'Description d'un combat', 'Cuba si', in *Commentaires* (Paris, 1961)

'Cuba si', English text in *Movie*, 3 (October 1962), pp. 15–21

'Les Hommes de la baleine', *Avant-Scène Cinéma*, 24 (March 1963), pp. 46–51

'Le Joli mai' (extracts), *Miroir du cinema*, 4 (January–March 1963), pp. 13–15; *Artsept*, 2 (April–June 1963) pp. 88–92

'La Jetée', *Avant-Scène Cinéma*, 38 (June 1964), pp. 28–35; English and French text in *La Jetée* (New York, 1992)

'A Valparaiso', *Image et Son*, 183 (April 1965), pp. 73–83

'Le Mystère de l'atelier quinze', *Avant-Scène Cinéma*, 61–2 (July–September 1966), pp. 73–8

'La Mer et les jours', *Avant-Scène Cinéma*, 68 (March 1967), pp. 61–6

'Le Mystère Koumiko', 'Soy Mexico', 'Si J'avais quatre dromedaires', in *Commentaires 2* (Paris, 1967)

'La Sixième Face du Pentagone', *Jeune Cinéma*, 35 (January 1969), pp. 2–6

'Le Train en marche', *Avant-Scène Cinéma*, 120 (December 1971), pp. 11–14

Le Fond de l'air est rouge: Scènes de la troisième guerre mondiale, 1967–1977 (Paris, 1978)

'Sunless', English text in *Semiotexte*, IV/3 ('Oasis' 1984), pp. 33–40; 'Sans soleil', *Trafic*, 6 (Spring 1993), pp. 79–97

'Broadway by Light', in *Anatole Dauman: Souvenir-écran*, ed. Jacques Gerber (Paris, 1989), p. 269

'A. K.', *Avant-Scène Cinéma*, 403–4 (June–July 1991), pp. 124–41

'Le Tombeau d'Alexandre', *Positif*, 391 (September 1993), pp. 49–54

Articles and Essays

'L'art noir', *Afrique Noire*, Collection ODE (Paris, no date)

'A propos du paradis terrestre', *Esprit*, 129 (January 1947), p. 158

'Une conférence de Louis Aragon', *Esprit*, 129 (January 1947), pp. 170–72

'En attendant la société sans classes? . . . ', *Esprit*, 130 (February 1947), p. 312

'Mais revenons au sérieux . . . ', *Esprit*, 130 (February 1947), p. 312

'Les vaches maigres; Les vaches grasses; Les vaches moyennes', *Esprit*, 130 (February 1947), pp. 320–21

'Importé d'Amérique', *Esprit*, 130 (February 1947), p. 326

'Nous avons un président', *Esprit*, 130 (February 1947), pp. 329–30

'Les trois petits cochons', *Esprit*, 131 (March 1947), p. 470

'Le musicien errant', *Esprit*, 131 (March 1947), p. 475

'Vox populi', *Esprit*, 131 (March 1947), pp. 482–3

'Deux petits negres', *Esprit*, 131 (March 1947), p. 488

'La mort de Scarface, ou les infortunes de la vertu', *Esprit*, 131 (March 1947), pp. 488–91

'Actualités imaginaires', *Esprit*, 132 (April 1947), pp. 643–4

'Actualités eternelles', *Esprit*, 132 (April 1947), pp. 644–5

'On le voit . . . ', *Esprit*, 132 (April 1947), p. 663

'L'apolitique du mois', *Esprit*, 133 (May 1947), pp. 808–12

'L'apolitique du mois II', *Esprit*, 133 (May 1947), p. 818

'Un prologue qui est tout un programme', *Esprit*, 133 (May 1947), pp. 824–5

'Newsreel', *Esprit*, 133 (May 1947), pp. 836–8

'Le sommeil de l'injuste', *Esprit*, 133 (May 1947), pp. 844–7

'La pain et le chien', *Esprit*, 134 (June 1947), p. 1089

'Pôles', *Esprit*, 134 (June 1947), p. 1092

'Actualités imaginaires', *Esprit*, 135 (July 1947), pp. 134–7

'Information', *Esprit*, 136 (August 1947), p. 285

'Das tägliche Leben ohne Queffélec', *Esprit*, 137 (September 1947), pp. 400–05

'Introduction à la représentation du "Mariage du Figaro"', *Doc 47*, 1 (September 1947)

'Grognements indistincts', *Esprit*, 138 (October 1947), pp. 562–5

'Sarter noster', *Esprit*, 139 (November 1947), pp. 751–4

'Le cheval blanc d'Henry Cinq', *Esprit*, 141 (January 1948), pp. 120–27

'La science et la vie', *Esprit*, 143 (March 1948), p. 472

'Sauvages blancs seulement confondre', *Esprit*, 146 (July 1948), pp. 1–9

'Newsreel', *Esprit*, 146 (July 1948), pp. 93–4

'Du Jazz considéré comme une prophétie', *Esprit*, 146 (July 1948), pp. 133–8

'L'affaire Tito vue de Yougoslavie; Lumière pour tous; Le Tito entre les dents', *Esprit*, 147 (August 1948), pp. 207–12

'Le male comportement de l'américain sexuel', *Esprit*, 147 (August 1948), pp. 226–9

'L'imparfait du subjectif', *Esprit*, 148 (September 1948), pp. 387–91

'L'aube noir', *DOC 49* (1949)

'Corneille au cinéma', *Esprit*, 153 (February 1949), pp. 282–5

'Fêtes de la victoire', *Esprit*, 156 (June 1949), pp. 862–3

'Les cent chef 'd'œuvres du cinéma', *Esprit*, 156 (June 1949), pp. 878–80

'Le passager clandestin', *Esprit*, 157 (July 1949), pp. 1097–9

'Le rosier de Madame Isou', *Esprit*, 158 (August 1949), pp. 297–9

'Cachez donc les poètes', *Esprit*, 162 (December 1949), pp. 967–8

'Orphée', *Esprit*, 173 (November 1950), pp. 694–701

'Croix de bois et chemin de fer', *Esprit*, 175 (January 1951), pp. 88–90

'Réunions contradictoires', *Esprit*, 178 (April 1951), pp. 599–600

'Petite suite sur thème des chansons', *Esprit*, 179 (May 1951), pp. 765–9

'Siegfried et les Argousins, ou le cinéma allemand dans les châines', *Cahiers du Cinéma*, 4 (July–August 1951), pp. 4–11

'L'esthétique du dessin animé', *Esprit*, 182 (September 1951), pp. 368–9

'Gérald Mc Boing-Boing', *Esprit*, 185 (December 1951), pp. 826–7

'Le chat aussi est une personne', *Esprit*, 186 (January 1952), pp. 78–9

'Une forme d'ornement', *Cahiers du Cinéma*, 8 (January 1952), pp. 66–8; and in *Images Documentaries*, 15 (1993)

'La Passion de Jeanne d'Arc', *Esprit*, 190 (May 1952), pp. 840–43

'Lettre de Mexico', *Cahiers du Cinéma*, 22 (April 1953), pp. 33–5

'Lettre de Hollywood', *Cahiers du Cinéma*, 25 (July 1953), pp. 26–34

'Le cinérama', *Cahiers du Cinéma*, 27 (October 1953), pp. 34–7

'L'avant-garde français: Entr'acte; Un Chien Andalou; Le Sang d'un poète', in *Regards neufs sur le cinéma*, ed. Jacques Chevallier (Paris, 1953), pp. 249–55

'Un film d'auteur: La passion de Jeanne d'Arc', in *Regards neufs sur le cinéma*, ed. Jacques Chevallier (Paris, 1953), pp. 256–61

'Cinéma, art du XXI siècle?', in *Regards neufs sur le cinéma*, ed. Jacques Chevallier (Paris, 1953), pp. 499–502

'And Now This Is Cinerama', in André Bazin, Jacques Doniol-Valcroze, Gavin Lambert, Chris Marker, Jean Queval and Jean-Louis Tallenay, *Cinéma 53 à travers le monde*, (Paris, 1954), pp. 18–23

'Hollywood: sur place', in André Bazin, Jacques Doniol-Valcroze, Gavin Lambert, Chris Marker, Jean Queval, Jean-Louis Tallenay, *Cinéma 53 à travers le monde*, (Paris, 1954), pp. 27–48

'Cinéma d'animation: UPA', in André Bazin, Jacques Doniol-Valcroze, Gavin Lambert, Chris Marker, Jean Queval, Jean-Louis Tallenay, *Cinéma 53 à travers le monde*, (Paris, 1954), pp. 136–43

'Une conversation sur la chanson entre un critique: Pierre Barlatier, un auteur: Francis Lemarque, un professeur: Solange Demolière, un folkloriste: Maurice Delarue, et un auditeur: Chris Marker', in *Regards neufs sur le chanson*, ed. Pierre Barlatier (Paris, 1954), pp. 16–24

'Demi-dieux et doubles croches', in *Regards neufs sur le chanson*, ed. Pierre Barlatier (Paris, 1954), pp. 79–89

'Petite Planète', in *27 rue Jacob*, 10 (Summer 1954), p. 1

'Adieu au cinéma allemand?', *Positif*, 12 (November–December 1954), pp. 66–71

'On the Waterfront', *Esprit*, 224 (March 1955), pp. 440–43

'Clair de Chine: en guise de carte de vœux, un film de Chris Marker', photographic supplement to *Esprit*, 234 (January 1956)

'L'objectivité passionée', *Jeune Cinéma*, 15 (May 1966), pp. 12–13

'Les révoltés de la Rhodia', *Le Nouvel Observateur*, 123 (22–9 March 1967), pp. 26–7

'Cinéma cubain: Che Guevara à 24 images/seconde', *Cinémonde*, 1832 (21 April 1970)

'Le ciné-ours', *La Revue du Cinéma/Image et Son*, 55 (December 1971), pp. 4–5

'Au Creusot un musée de question', *L'Estampille*, 42 (May 1973), pp. 37–40

'Kashima Paradise', *Ecran 74*, 30 (November 1974), pp. 74–5

'William Klein: peintre, photographe, cinéaste', *Graphis*, 33 (May–June 1978), pp. 495 ff

'Les gribouilles d'Antenne 2', *Libération*, 22 December 1983

'De l'ordre du miracle', *Libération*, 18 May 1994

'A free replay, notes sur 'Vertigo", *Positif*, 400 (June 1994), pp. 79–84; English translation in

Projections 4¹/₂, ed. John Boorman and Walter Donohue, (London, 1995)
'The Rest is Silent', in *Chris Marker: Silent Movie*, exh. cat., Wexner Center for the Arts,
 Ohio State University, Columbus, OH (1995); French text in *Trafic*, 46 (Summer 2003),
 pp. 57–62
'Marker mémoire (Cinémathèque Française, 7 janvier–1er fevrier 1998)', *Images*
 Documentaires, 31 (1998), pp. 75–85
'Filmic Memories: Chris Marker; Filmmaker', *Film Quarterly*, LII/1 (Fall 1998), p. 66

Interviews

Simone Dubreuilh, *Lettres Françaises*, 28 March 1957, p. 6
Francis Gendron, 'Le socialisme dans la rue', *Miroir du Cinéma*, 2 (May 1962), p. 12
Jean-Louis Pays, *Miroir du Cinéma*, 2 (May 1962), pp. 4–7; and in *Anatole Dauman: Souvenir-*
 Ecran, ed. Jacques Gerber (Paris 1989), pp. 157–9
R. Ritterbusch, 'Entretien avec Chris Marker', *Image et Son*, 213 (February 1968), pp. 66–8
Anne Philipe, 'Medvedkin, tu connais?', *Le Monde*, 2 December 1971, p. 17
'Terminal Vertigo', *Monthly Film Bulletin*, LI/606 (July 1984), pp. 196–7
Dolores Walfisch, 'Level Five', *Berkeley Lantern*, November 1996; and *Vertigo*, 7 (Autumn
 1997), p. 38
Jean-Michel Frodon, 'Je ne me demande jamais si, pourquoi, comment . . . ', *Le Monde*,
 20 February 1997
Samuel Douhaire and Annick Rivoire, *Libération*, 5 March 2003; English translation in *Film*
 Comment, XXXIX/3 (May–June 2003), pp. 38–41

Selected Works about Chris Marker

Books, Journal Special Issues and Catalogues

Chris Marker and Armand Gatti, *Miroir du Cinéma*, 2 (May 1962)
Chris Marker, *Image et Son*, 161–2 (April–May 1963)
'Chris Marker: film, photographie, voyage, écrit et aime les chats', retrospective brochure *20*
 ans de cinéma offensif, 20 ans de fictions documentairées/de documentaires fictionés, ed. Jean
 Perret (Geneva, 1982)
Chris Marker, *CICIM*, 8 (July 1984)
O Bestário de Chris Marker, Collecção Horizonte de Cinema, 14 (1986), Livros Horizonte-
 Festival Internacional de Cinema de Tróia, Lisbon, 1986
Passages de l'image, exh. cat., Musée nationale d'art moderne, Centre Georges Pompidou,
 Paris (1990)
Chris Marker, *Bref*, 6 (August–September–October 1990)
—, *Images documentaries*, 15 (1993)
Time and Tide, exh. cat., The Tyne International Exhibition of Contemporary Art, Newcastle,
 1993
Terence Rafferty, chapter on 'Chris Marker', in *The Thing Happens* (New York, 1993)
Chris Marker: Silent Movie, exh. cat., Wexner Center for the Arts, Ohio State University,

Columbus, OH (1995)

Video Spaces: Eight Installations, exh. cat., Museum of Modern Art, New York (1995)

Chris Marker, Catalogue of the XXXII Pesaro Film Festival, ed. Bernard Eisenschitz (Rome, 1993); selected French translations in *Trafic*, 19 (Summer 1996) and *Limelight*, 52 (September 1996)

Dossier Chris Marker, *Positif*, 433 (March 1997)

Qu'est-ce qu'une madeleine? A propos du CD-ROM Immemory de Chris Marker (Paris, 1997)

Birgit Kämper and Thomas Tode, eds, *Chris Marker: Filmessayist*, CICIM 44/45/46 (Munich, 1997)

Jon Kear, *Sunless / Sans soleil* (Trowbridge, 1999)

Chris Marker, Silent Movie and Selected Screenings, exh. cat., Beaconsfield Gallery, London, 1999

Guy Gauthier, *Chris Marker: écrivain multimédia* (Paris, 2001)

'Recherches sur Chris Marker', *Théorème*, 6 (Paris, 2002)

'Around the World with Chris Marker', Part I, 'Lost Horizons', *Film Comment*, XXXIX/3 (May–June 2003); Part II, 'Time Regained', *Film Comment*, XXXIX/4 (July–August 2003)

Articles

Anon., 'Chris Marker, ou le poète essayiste', *Radio Cinéma Télévision*, 485 (3 May 1959), pp. 47–8

Bob Baker, 'Chris Marker', *Film Dope*, 40 (January 1989), pp. 8–10

Raymond Bellour and Jean Michaud, 'Apologie de Chris Marker/Signes', *Cinéma*, 57 (6 January 1961), pp. 33–47 and 155–7

Ian Cameron, 'I Am Writing to You from a Far Country', *Movie*, 3 (October 1962), p. 14

Anatole Dauman, 'Chris Marker', in *Anatole Dauman: Souvenir-écran*, ed. Jacques Gerber (Paris, 1989), pp. 148 ff

Raymond Durgnat, 'Resnais & Co: Back to the Avant-Garde', *Monthly Film Bulletin*, LIV/640 (May 1987), pp. 132–5

Max Egly, 'Varda-Resnais-Marker', *Image et Son*, 128 (February 1960)

Guy Gauthier, 'Demarches de Chris Marker: éléments', *Image et Son*, 247 (1974)

—, 'Chris Marker: montage "cosmique" et imaginaire singulier', *CinémAction*, 72 (1994), pp. 75–81

Ross Gibson, 'What Do I Know? Chris Marker and the Essayist Mode of Cinema', *Filmviews*, 134 (Summer 1988), pp. 26–32

Jan-Christopher Horak, 'Chris Marker's Reality Bytes', *Aperture*, 145, Surface and Illusion: Ten Portfolios (Fall 1996), pp. 60–65

Gilles Jacob, 'Chris Marker and the Mutants', *Sight and Sound*, XXXV/4 (Autumn 1966), pp. 165–8

Chris Petit, 'Insane Memory', *Sight and Sound*, IV/7 (July 1994), p. 13

Terence Rafferty, 'Marker Changes Trains', *Sight and Sound*, LIII/4 (Autumn 1984), pp. 284–8; and in *Imagining Reality: The Faber Book of Documentary*, ed. Kevin McDonald and Mark Cousins (London, 1996)

Richard Roud, 'The Left Bank', *Sight and Sound*, XXXII/1 (Winter 1962–3), pp. 24–7

Roger Tailleur, 'Markeriana, description peu critique de l'œuvre de Chris Marker', *Artsept*, 1 (January 1963), pp. 47–62

Filmography

Full credit details for Marker's film, video and multimedia work may be found in Birgit Kämper and Thomas Tode, eds, *Chris Marker: Filmessayist* (Munich, 1997); and in *Théorème* 6, Recherches sur Chris Marker (Paris, 2002)

Film, Video and Multimedia Works

1952
Olympia 52
(16mm blown up to 35mm, 82 minutes)

1956
Dimanche à Pékin (*Sunday in Peking*)
(16mm blown up to 35mm, 22 minutes)

1958
Lettre de Sibérie (*Letter from Siberia*)
(16mm blown up to 35mm, 62 minutes)

1960
Description d'un combat (*Description of a Struggle*)
(35mm, 60 minutes)

1961
Cuba si
(16mm blown up to 35mm, 52 minutes)

1962
La Jetée
(35mm, 29 minutes)

Le Joli mai
(35mm, original version 165 minutes; current UK version 118 minutes)

1965
Le Mystère Koumiko (*The Koumiko Mystery*)
(16mm blown up to 35mm, 54 minutes)

1966
Si j'avais quatre dromadaires (*If I Had Four Camels*)
(35mm, 49 minutes)

1969
On vous parle de Brésil: Tortures
(16mm, 20 minutes)

Jour de Tournage
(16mm, 11 minutes)

1970
On vous parle du Brésil: Carlos Marighela
(16mm, 17 minutes)

On vous parle de Paris: Maspero, les mots ont un sens
(16mm, 20 minutes)

La Bataille des dix millions (*The Battle of the Ten Million*)
(16mm, 58 minutes)

1971
On vous parle de Prague: Le Deuxième procès d'Artur London
(16mm, 28 minutes)

Le Train en marche (*The Train Rolls On*)
(16mm, 32 minutes)

1973
On vous parle du Chili: Ce que disait Allende
(16mm, 16 minutes)

L'Ambassade (*Embassy*)
(Super 8, 20 minutes)

1974
La Solitude du chanteur de fond (*The Loneliness of the Long Distance Singer*)
(16mm blown up to 35mm, 60 minutes)

1977
Le Fond de l'air est rouge (*A Grin Without a Cat*, 1988)
(16mm blown up to 35mm, 240/180 minutes)

1978
Quand le siècle a pris formes (or *War and Revolution*)
(Installation: Video U-matic on 2 monitors, 16 minutes loop)

1981
Junkopia
(16mm blown up to 35mm, 6 minutes)

1982
Sans soleil (*Sunless*)
(16mm blown up to 35mm, 100 minutes)

1984
2084
(35mm, 10 minutes)

1985
AK
(35mm, 74 minutes)

1986
Mémoires pour Simone
(35mm, 61 minutes)

1989
L'Héritage de la chouette (*The Owl's Legacy*) [television series]
(Video, 13 x 26 minutes)

1990
Berliner ballade [television report]
(Video Hi 8, 20 minutes)

Getting Away With It [music video for Electronic]
(Video, 4 minutes)

1990 ff.
Zapping Zone (Proposals for an Imaginary Television)
(Installation: 14 monitors, 13 laser disc players, 13 speakers, 13 video discs, 7 computers, 7 computer programs, 4 lightboxes with 80 slides, 11 colour photos, 10 black and white photos, 7 photomontages)

Inclusions in *Zapping Zone*:
Matta '85
(S-VHS Video, 14 minutes 18 seconds)

Christo '85 (or *From Chris to Christo*)
(S-VHS Video, 24 minutes)

Tarkovski '86
(S-VHS Video, 26 minutes)

Eclats
(Video, 20 minutes)

Bestiaire: *Chat écoutant la musique* (2 minutes 47 seconds); *An Owl Is an Owl is an Owl*
(3 minutes 18 seconds); *Zoo Piece* (2 minutes 45 seconds)
(Total running time: 9 minutes 4 seconds)

Spectre
(Video, 27 minutes)

Tokyo Days
(Video, 24 minutes)

Berlin '90
(Hi 8, 20 minutes 35 seconds)

Photo Browse
(301 photos, 17 minutes 20 seconds)

Détour. Ceauceşcu
(Video, 8 minutes 2 seconds)

Théorie des ensembles
(Computer animation, 13 minutes)

Additions to *Zapping Zone*:

Azulmoon (1992)
(Video loop)

Coin fenêtre (1992)
(Hi 8, 9 minutes 35 seconds)

Slon Tango (1993)
(Hi 8, 4 minutes 15 seconds)

Bullfight/Okinawa (1994)
(Hi 8, 4 minutes 12 seconds)

E-Clip-Se (1999)
(Video, 8 minutes 13 seconds)

1993
Le Tombeau d'Alexandre (*The Last Bolshevik*) [television programme]
(Hi 8, 118 minutes)

Le 20 heures dans les camps (*Prime Time in the Camps*)
(Hi 8, 27 minutes)

1994
Three Video Haikus:
Petite ceinture (1 minute)
Tchaika (1 minute 29 seconds)
Owl Gets in Your Eyes (1 minute 10 seconds)

1995
Silent Movie
(Installation: metal stand, 5 monitors, 5 laser disc players, computer interface box, 5 video discs with 20 minute sequences: *The Journey*, *The Face*, *Captions*, *The Gesture*, *The Waltz*; 18 black and white video stills, 10 film posters, soundtrack 'The Perfect Tapeur', solo piano pieces lasting 59 minutes 32 seconds)

Casque bleu (or *Témoignage d'un casque bleu*)
(Betacam, 27 minutes)

1996
Level Five
(Beta-SP blown up to 35mm, 106 minutes)

1997
Immemory One
(Interactive CD-ROM installation: 2 video projectors, 1 video monitor, 3 computers)

1998
Immemory
(CD-ROM)

1999
Une Journée d'Andrei Arsenevich (*One Day in the Life of Andrei Arsenevich*) [television]
(Video, 56 minutes)

2000
Un Maire au Kosovo [unreleased]
(Video, 27 minutes)

2001
Avril inquiet [unreleased]
(Video, 52 minutes)

Co-Directed and Collective Films

1950–1953
Les Statues meurent aussi [with Alain Resnais]
(35mm, 30 minutes)

1967
Loin de Viêt-nam (*Far from Vietnam*) [collective film]
(35mm, 16mm and 35mm components, 115 minutes)

1968
Le Sixième face du Pentagone (*The Sixth Face of the Pentagon*) [with François Reichenbach]
(16mm, 28 minutes)

À Bientôt, j'espère [with Mario Marret]
(16mm, 43 minutes)

1972
Vive la baleine [with Mario Ruspoli]
(35mm, 30 minutes)

1974
Puisqu'on vous dit que c'est possible (LIP) [collective film]
(16mm, 47 minutes)

1975
La Spirale (*Spiral*) [collective film]
(35mm, 155 minutes)

2002
Le Souvenir d'un avenir (*Remembrance of Things to Come*) [with Yannick Bellon]
(Video, 42 minutes)

Collaborations

1955
Nuit et brouillard (*Night and Fog*)
(35mm, 32 minutes)
Directed by Alain Resnais; Assistant Director: Chris Marker

1956
Toute la mémoire du monde
(35mm, 22 minutes)
Directed by Alain Resnais; Collaboration: 'Chris and Magic Marker'

Les Hommes de la baleine
(16mm blown up to 35mm, 26 minutes)
Directed by Mario Ruspoli; Commentary: Jacopo Berenzi [Chris Marker]

1957
Broadway by Light
(35mm, 10 minutes)
Directed by William Klein; Introductory text: Chris Marker

Le Mystère de l'atelier quinze
(35mm, 18 minutes)
Directed by André Heinrich and Alain Resnais; Commentary: Chris Marker

1958
Les Hommes dans le ciel
Directed by Jean-Jacques Languepin and A. Suire; Commentary: Chris Marker

Le Siècle a soif
Directed by Raymond Vogel; Verse commentary: Chris Marker

La Mer et les jours
(22 minutes)
Directed by Raymond Vogel; Commentary: Chris Marker

1959
Django Reinhardt
(35mm, 22 minutes)
Directed by Paul Paviot; Commentary: Chris Marker

1960
L'Amérique insolite
(35mm, 86 minutes)
Directed by François Reichenbach; Commentary: Chris Marker
[Marker's commentary was adapted significantly, and he is not credited]

1962
Jouer à Paris
(35mm, 27 minutes)
Directed by Catherine Varlin; Editor: Chris Marker

1963
A Valparaiso
(35mm, 29 minutes)
Directed by Joris Ivens; Commentary: Chris Marker

1964
Les Chemins de la fortune
(42 minutes)
Directed by Peter Kassovitz; Completion assistance: Chris Marker

La Douceur du village
(47 minutes)
Directed by François Reichenbach; Editor: Chris Marker

La Brûlure des mille soleils
(25 minutes)
Directed by Pierre Kast; Editor: Chris Marker

1965
Le Volcan interdit
(79 minutes)
Directed by Haroun Tazieff; Commentary: Chris Marker

1966
Europort: Rotterdam
(20 minutes)
Directed by Joris Ivens; French adaptation: Chris Marker

1968
Cinétracts [collective]
(16mm)

1969
Classe de lutte
(16mm, 37 minutes)
Directed by Besançon Medvedkin Group; 'Occult' technical assistance: Chris Marker

1969–70
On vous parle de Flins
(16mm, 30 minutes)
Directed by Guy Devart; Camera and Editor: Chris Marker

1970
L'Afrique express
(18 minutes)
Directed by Danièle Tessier and Jacques Lang; Foreword: Boris Villeneuve [Chris Marker]

L'Aveu
(35mm; 160 minutes)
Directed by Constantin Costa-Gavras; Set photographer: Chris Marker

L'Animal en question
(16mm, 38 minutes)
Directed by André Pozner *et al.*; Assistant: Chris Marker

1971
Happiness
(35mm, 70 minutes; originally released 1934)
Directed by Alexander Medvedkin; Re-release soundtrack: Chris Marker

1971–2
El primo año
(90 minutes)
Directed by Patricio Guzman; French version produced by ISKRA
(delegated producer: Chris Marker)

1973–4
Les Deux mémoires
Directed by Jorge Semprun; Editors: Jorge Semprun and Chris Marker;
Sound: Chris Marker and another

1974
Kashima Paradise
Directed by Yann Le Masson and Benié Deswarte; Commentary: Yann Le Masson,
Benié Deswarte and Chris Marker

1975
La batalla de Chile
Directed by Patricio Guzman; Production assistance: Chris Marker

1978
Viva El Presidente!
Directed by Miguel Littin; French subtitles: Chris Marker

1988
Les Pyramides bleues (*The Novice*)
Directed by Arielle Dombasle; Artistic Advisors: Eric Rohmer and Chris Marker

1997
Souvenir
Directed by Michael Shamberg; Electronic images: Chris Marker

Acknowledgements

Much of the research for this book was undertaken in Paris, on visits funded by a Study Abroad Studentship from the Leverhulme Trust, and a Small Research Grant from the British Academy. A further award from the British Academy was made towards the cost of supplying photographic reproductions.

In Paris, I would like to thank the Archive Service of the Centre National de la Cinématographie, particularly fellow Marker enthusiast Ginette Lacasse; and Inger Servolin and the team at ISKRA, for access to their archives and to a number of Marker's films unavailable elsewhere.

The School of Humanities and Cultural Studies at the University of Surrey Roehampton granted me an indispensable and much appreciated period of research leave to concentrate on writing.

For their help and encouragement in the preparation of this book, thank you to Chris Darke, Albert Dichy, Patrick ffrench, Jane Giles, Roland-François Lack, Barry Langford, Ken Lyndon, James Quandt, Michael Temple, Thomas Tode, Michael Uwemedimo, Mike Witt and Nancy Wood, and to everyone who took part in the *Chris Marker: The Art of Memory* event, held at the Institute of Contemporary Arts, London, in 2002.

I particularly want to thank Min Lee for generously sharing her own research materials and for many hours of enthralling Marker conversation. My mother, and until his death my father, helped my work with immense generosity. Finally, Stephen Barber has been a constant source of support, inspiration and love.

Illustration Credits

Page 9 from Chris Marker's *Sans soleil* (*Sunless*) (1982), distributed by Argos Films (France) and bfi Collections (UK)

10 Marker and his Rolleiflex

11 top from *Sans soleil*

11 foot from Chris Marker's installation *Zapping Zone*, from the collection of the Musée National d'Art Moderne, Paris

21 from Chris Marker's *Lettre de Sibérie* (*Letter from Siberia*) (1958), distributed by Argos Films

22 top from Carl Dreyer's *La Passion de Jeanne d'Arc* (1928)

22 foot from Chris Marker's *La Jetée* (1962), distributed by Argos Films (France) and bfi films (UK); photo BIFI Collections

24 Bazin in his office at Travail et Culture

31 graffiti on the statue of Giraudoux

32 from *Sans soleil*; photo BIFI Collections

35 from *Les Statues meurent aussi* (1950-53), co-directed by Chris Marker and Alain Resnais, distributed by Présence Africaine; photo BIFI Collections

36 from *Les Statues meurent aussi*; photos BIFI Collections

39 from *Les Statues meurent aussi* ; photo BIFI Collections

42 from *La Jetée*

43 top from Chris Marker's *Description d'un combat* (*Description of a Struggle*) (1960), distributed by Israel Film Archive

43 foot from Chris Marker's CD-ROM *Immemory* (1998): courtesy of Exact Change Press

45 from Armand Gatti's 1956 book, *Chine*

47 from William Klein's *Broadway by Light* (1957)

50 Marker filming *Dimanche à Pékin* (*Sunday in Peking*); photo BIFI Collections

51 from Chris Marker's *Dimanche à Pékin (Sunday in Peking)* (1956), distributed by Argos Films

52 from *Dimanche à Pékin*

53 from *Dimanche à Pékin*

56 from *Lettre de Sibérie*

58 from *Lettre de Sibérie*